THE PEBBLE CHANCE

THE PEBBLE CHANCE

FEUILLETONS & OTHER PROSE

Marius Kociejowski

BIBLIOASIS
WINDSOR, ONTARIO

FIRST EDITION

Library and Archives Canada Cataloguing in Publication

Kociejowski, Marius, author
 The pebble chance : feuilletons and other prose / Marius Kociejowski.

Essays.
Issued in print and electronic formats.
ISBN 978-1-927428-77-1 (pbk.).--ISBN 978-1-927428-78-8 (epub)

 I. Title.

PS8571.O64P42 2014 C814'.54 C2014-902927-6
 C2014-902926-8

Edited by Dan Wells
Typeset by Chris Andrechek
Cover Designed by Kate Hargreaves

 Canada Council for the Arts **Conseil des Arts du Canada** ONTARIO ARTS COUNCIL CONSEIL DES ARTS DE L'ONTARIO

 Canadian Heritage Patrimoine canadien

Biblioasis acknowledges the ongoing financial support of the Government of Canada through the Canada Council for the Arts, Canadian Heritage, the Canada Book Fund; and the Government of Ontario through the Ontario Arts Council.

PRINTED AND BOUND IN CANADA

Contents

for
Eric Ormsby
&
Norm Sibum

Author's Note

T HESE ESSAYS AND FEUILLETONS are presented in no
particular order, and, barring the musical rhythm I
hope they will together create, they have no connect-
ing theme other than the majority of them are rooted in per-
sonal experience. They are, if anything, insufficiently disparate
in subject and tone. MK

A FACTOTUM IN THE BOOK TRADE

Y EARS AGO, IN MY very early twenties, I was an employee in a shop that sold wicker baskets and bamboo furniture. I was known to my friends as the Wicker King. The manageress who was in her thirties, who had as many syllables in her name as mine, would describe to me, in detail, her sexual escapades. She did so, I think, only because she was bored. At the close of each week, our pay in hand, away from the shop owner's eyes, we would demolish a basket, usually by placing it upside down on the floor and jumping on it, she one week, me the next. She put a run through her stocking once. At first we giggled maniacally but then, as habit evolved into ritual, we became more solemn. It was a quick cure for *tædium vitæ* and, besides, there's nothing sweeter than the smell of newly broken basket. Many years later, in another country, I got to know of a couple of booksellers who, for similar reasons, would take a volume of some author loathsome to them both, J.B. Priestley, for example, and use it to play a game of "bounce," the object of the exercise being not so different from skipping stones or what here is most charmingly called ducks and drakes.

So why begin with instances that are in themselves morally objectionable? It's to do with work, I suppose, not just its ritual absurdities, so often incomprehensible to people on the outside, but also the daily struggle to get through to the other side of it, the long hours we endure for just a bubble of free time. We

become oddities even to ourselves. Apparently, in some guide to bookshops in London, there is a photo of me putting books on the shelves outside the shop where I now work, Peter Ellis in Cecil Court, London. The man who informed me of this is a philosopher of some note. I have yet to investigate whether it's true. I'm not even sure I want to. Maybe it's not me but Peter Ellis himself and there has been a case of mistaken identity. It has happened before. Suppose it really is me, though, would this be anybody I'd care to recognise? Am I not, after all, somebody else? Only rarely is the daily hat one wears the hat one imagines for oneself. This said, the greater part of my working life has been spent in the antiquarian book trade, and now, as I go into decline, I am being asked to come up with some account of that time. I'm stumped. Once I asked a nomad in the mountains south of Isfahan what it was like to be a nomad. "Where are you from?" he asked me. "London," I replied. "I've never met anyone from there in these hills before," he said. I did not make further enquiries. So here I am, face to face with myself, as one who knows my own terrain perhaps a little too well to be able to describe my journey through it, similarly nonplussed. Surely a man with a pickaxe is more the stuff of literature than he who sells it, unless, of course, the latter falls prey to the former. Many booksellers are, after all, born murderees.

I am not, in the fullest sense, a bookseller, which is to say an independent one, although the opportunities for me to become one did arise. The choice was between selling books and writing them. I couldn't do both. One would not allow for the other. I am not so sure I can consider myself a book-shop assistant either, and maybe this is because I am deluded enough to believe that a man clutching a rare volume is some-how, if only for minutes at a time, bestowed with a pedigree. The book world is, however, a world in which one might keep one's face. There are less dignified ways to survive. A *factotum* is how Bernard Stone described me once, and so, all right, I will accept this limited, rather limiting, definition of myself.

Before I continue, I have a confession to make: I know far less about books than I did, say, even a decade ago, which would suggest my own basket is beginning to unravel. I need to be jumped upon, bagged up, all evidence of me quickly removed. Very soon I shall know nothing at all, not even the issue points for the 1923 Hogarth Press edition of *The Waste Land*. The other day I got Samuel Johnson and Ben Jonson in a muddle.

So what brought me to this bookish state?

Well, books actually. When I was a child, in Canada, I'd go to the annual church sale in the village and always be the first at the book table. In truth, there was nobody with whom to compete so I could go through the volumes at leisure. (It was not like a certain annual jumble sale here in London where a regular figure, his head the shape of a bullet, would sway in a circular fashion in front of the book table, arms akimbo, his elbows jutting into the ribs of anyone nearby and with what seemed to be a third arm, for such was the perfection of his technique, put his finds in a pile. Once he carried off an entire set of Anthony Powell's *A Dance to the Music of Time*. Maybe they were not first editions, but I'm almost certain they were. A kind of halo hovered over them.) But, to go back to my childhood, a separation has to be made here between the books my parents gave me or the magical Rupert Bear annuals my grandmother sent me from England and the books which I grabbed from the church sale table. The buyer and the reader were not necessarily the same creature. I would go home with an armload of books, collectively priced at little more than what I'd have to pay for an ice cream, and which were chosen not so much for their contents as for their tactile qualities. Among them, I remember, were a fine copy of W.J. Ghent's *The Road to Oregon*, which I suspect was unreadable, and a ragged copy of some Christian missionary's account of going to the South Seas and putting clothes on naked savages. Alohaekaunei with her bare breasts suddenly, by the grace of God, became Gladys

in a frock. Despite the musty tinge of Protestantism that clung to almost every volume, those books seemed to have value. Although I could not have said so at the time, there must have already resided in me some element of the mercantile.

When I settled in London, in 1974, there were second-hand bookshops everywhere. One could walk from Earls Court to Notting Hill Gate, which is only a bit over a mile, and take in six or seven. They are all gone. One could step into even the smallest shop and there was always the sense of an inner sanctum to which only the elect had admittance. This is important to note. At that point, and it would still be the case later, a bookseller was deeply ensconced in a culture of secrecy. One simply did not speak of the inner workings of the trade. Now, of course, the guts are all over the place. One may poke through them at one's leisure. There are no more secrets: one speaks openly, shamelessly, of one's gains and one's losses. Anyway, to go back to those little bookshops and their secret zones, all the books one most desired were in those cubbyholes, just beyond one's reach, or so one imagined. Money was not the key to them nor could a smile move the misanthropic hearts of those crotchety old men in their small dark shops. (What man of feeling, though, would not choose the misanthrope over the indiscriminate lover of his own species?) Selling a book was never uppermost in their thoughts, and indeed there was much pleasure to be had in *not* selling a book to someone thought undeserving of it. It was a great shame when booksellers began to have to sell books in order to survive.

I WAS IN A SENSE PRESS-GANGED into service at a lunch at the Zanzibar on Long Acre with George Lawson, one of the directors of Bertram Rota. Lawson has the most delicate hands I'd ever seen on a male, one of his fingers bearing a ring that belonged to Mary, Queen of Scots. On occasion he would apply most of those fingers to the clavichord he kept in his office. I had been plied with just enough drink that when he said he'd expect me

to report for duty the following morning I was too flustered to say no. I had not realised I was being interviewed and in fact I had given a rather dubious account of myself, sufficiently so, I think, for him to feel I might fit into a world made for people suitable for nothing else. I was there for the next fourteen years. And then I moved, thrice. I hope not to have to move again.

Bertram Rota was one of the last old establishments, dynastic, oxygenless, and its directors quite oblivious to what was happening on the street outside, which was already teeming with barbarians, the independent dealers and book runners, who would soon break up the empire. The grand firms moved too slowly to notice. The barbarians, Peter Jolliffe among them, were already busy sharpening their blades. We had to wear ties.

One of my first tasks was going with George Lawson to a West London address to collect approximately five hundred books, none of them rare, actually the sort of nondescript volumes one might pick up from the outside shelves of any second-hand bookshop. A lover of intrigue, Lawson gave me no indication as to what they were, and as I loaded them into the car I wondered to myself, *Why these?* My job for the next week or so was to insert slips of paper into the books wherever I spotted a dot in the margins of the pages. The original owner of these books when he spotted a phrase he liked would prick the margin with the tip of a finely sharpened pencil. I was not to miss one. There was one title in particular, again of no value in itself, which described common walks along the seashore … *dot, dot, dot* … the lines beside them containing phrases which later I discovered the dotter had lifted whole for his own purposes. Plagiarism? No, not quite. What one finds on the beach is for one to take. There weren't really that many dots. Put together, they would not even fill the circumference of the pencil that made them, but we sold those dots for many thousands of pounds. Whole manuscripts of books, often entire archives, went for considerably less. What gave this lot value was that most of the books were rubber-stamped "JJ" on the

front pastedowns and, incredibly, had been kept together ever since their original owner made use of them in Trieste.

A few years later, I handled the diagonally striped blue and white tie, which the same author presented to the printer of his rather thick book, telling him he would like the covers done in the same Greek-flag blue. Also there was a porcelain lion, a punning gift that he gave to the French translator of his book, Paul Léon, a French Jew who, a few years later, disappeared into one of the Nazi extermination camps. The most incredible thing was that the library containing these objects had escaped the clutches of a SS officer who knocked at the door of Léon's apartment in Paris. He asked Madame Léon where her husband was and she told him he was in a rather better position to tell *her*. The SS officer was a collector of James Joyce and was aware of the likelihood that his French translator would have treasures. At the beginning of the war, Léon had the foresight to hide the entire collection and it was this which I unpacked from boxes newly delivered from Paris, before they were sent on to Tulsa, Oklahoma. What a strange place for them to end up. Scarcity and value have never intrigued me as much as the journeys books and papers make.

As assistant to the brilliant John Byrne, I catalogued numerous archives, among them the P.E.N. archive, and Basil Bunting's library and papers, or, rather, as much as he allowed to survive. I catalogued the letters the novelist Henry Green wrote to the scholar and Chaucer translator Nevill Coghill, in one of which he described, in the most exquisite prose, the panicked flight of a bird in the factory where he worked. (It just happened to be his father's factory, of course.) And then there were the letters which Patrick Leigh Fermor wrote to Lady Diana Cooper, in which he could not describe crossing a field without making of it a verbal paradise. There were also the letters Walter de la Mare wrote to Leonard Clark who during the war would send eggs to the author of *Peacock Pie*. Once I catalogued the archive of a writer whom I so detested that at lunch break I'd go to the

National Gallery and stand in front of Piero della Francesca's *The Nativity* in order to regain my mental composure. The author was someone who combined the elements of all that I most despised in writing, with heavy lashings of Sigmund Freud. One of his notebooks was a cold, extremely clinical account of his sexual conquests and failures, which, holding it by the corners between my thumb and index finger, I returned to him, saying I was sure he had included it by mistake. Oh, he chuckled, he had; but I knew he hadn't because in authors of a certain calibre there is a fatal tendency to expose themselves. Anyone who works with literary archives has to wash his hands at times. I was secretly delighted when this turned out to be a very rare case of an archive that didn't find a home, and this at a time when archives were easy to sell.

AND THEN THERE WERE THE PEOPLE.

There was Philip Larkin who had been put in the awkward position of having to assemble a collection of his own works for Hull University Library where he was librarian, and who, when he asked after the price of a copy of *The North Ship*, moaned, "What, for *that* rubbish!" A purchase was not made. There was Graham Greene, who one day stood in the doorway with pickled rage in his eyes and then stormed out. I never did learn why. There was Dame Peggy Ashcroft, whom I went to see in order to collect some Samuel Beckett letters, who insisted I stay for a while and who, without revealing anything of herself, schoolgirlishly put her hands together in her lap and said, "I want to know everything about you." She blinked like a startled bird at every remark I made and I understood why it was that men so madly loved her. There was the poet Elizabeth Jennings who when she felt a book coming on would compose hundreds of poems at a time, filling notebooks with them, and then she would sit down to write the poems that would comprise her next collection. The incredible thing is that these warming up exercises, the majority of them in rhyme, many of them decent

poems in their own right, would be for discarding. There was John Ashbery who, when he paused at a copy of Algernon Blackwood's *A Prisoner in Fairyland*, said in his campest voice, "Hmm, I wonder what *this* is about," and I turned around and said, "Oh, you know!" and sang to him, to the tune of the hit song from *Kismet*, "Take my hand, I'm a prisoner in fairyland." There was the Spanish novelist Javier Marías who was as yet an unknown quantity in this country and who sought the obscure pamphlets of the forgotten poet John Gawsworth, whom he later, in his novels, turned into a mythic figure. There was the attractive woman with a gentle Scots lilt who came in one day asking me for a copy of Edith Sitwell's poetry collection *Gold Coast Customs*, which she wanted to set to music. I asked if she were a musician and she said yes, and I asked her if she had a band and she said yes, and I told her how I, too, once tried my hand at music and never made the grade and that I knew how hard it was, and she agreed, and then I wished her all the luck with her band and her music and she said thank you and when she left my colleague turned to me and said, "Didn't you realise that was Annie Lennox?" I didn't. Our best mistakes are made in innocence. One day I looked up from my typewriter to see a young woman, her hair roughly scissored, asking me for the women's room. Knowing that as a euphemism "the ladies" had recently fallen into disfavour, I took her downstairs, told her to go to the end of the aisle, turn left and she'd find it there. I went back to my desk and forgot all about her. Anthony Rota went downstairs and returned with a red face. "What was the idea?" he said. "There's a woman downstairs in a rage. She came in looking for a copy of Marilyn French's *The Women's Room* and you showed her the way to the toilet."

And then there was Bruce Chatwin who lived in one of the flats above the shop. Recently I read an article which poses the question: *Who reads Chatwin anymore?* It is a question that only a few years ago would have been inconceivable, for he appeared to be as secure in his literary position as the great

travel writer Robert Byron was in his. When he died in 1989, aged 48, he was already considered the most important travel writer of his generation. Doubtless Nicholas Shakespeare's biography, unintentionally perhaps, did more to weaken than to enhance his reputation, revealing as it did that so much of what Chatwin wrote was simply untrue. Admittedly I had no idea who he was. When I asked him if he wrote, he ran upstairs and a couple of minutes later presented me with a paperback copy of *In Patagonia*. At that point it never entered my mind that I myself would one day write a couple of books in that most doubtful of genres.

Chatwin was at least two people, and never did they meet in my presence. One was the boyish adventurer, the adrenalin rushing through his veins as he spoke of his projects. One day he announced he was going to write on the dwarf-kidnapping trade in the Middle East. The most excited I had ever seen him, though, was when he rushed down to say he had just spoken to Nadezhda Mandelstam on the telephone. He had not realised one could simply phone her in Moscow. He had a habit, when he spoke enthusiastically, of hammering his knees with his fist. When he was writing *On the Black Hill* he came down to ask me if I could think of any lines of poetry on the theme of friendship and I gave him the lines from Ezra Pound's translation from the Chinese of Li Po, "What is the use of talking, and there is no end to talking, / There is no end of things in the heart." They appear near the end of the novel.

This was the Chatwin I liked. The other was insufferable—the social climber, the snobby aesthete—and it was this side that would not allow for him to be anything more to me than an acquaintance. When he came into the shop with the likes of David Hockney or Stephen Spender, suddenly you were invisible. The boyish adventurer had been displaced by someone who altered even the way he walked and spoke. At the end of his life, when he was dying of AIDS, he went through bouts of complete madness. Confined to a wheelchair, he would go

up and down Old Bond Street, buying paintings and antiques, sometimes spending millions at a single go, while behind him, at some distance, a friend would follow and undo his purchases. By this point he was no longer living upstairs. One day he phoned and told me he had some rare books he wished to sell and that he was about to put them in a cab. A cardboard box arrived, and I looked inside to see a random selection of books, mostly review copies, of absolutely no value. I phoned him. "Well," he asked excitedly, "What do you think?" I took a wild gamble. I told him that I very much hoped he would not be disappointed in my offer of a million pounds. Chatwin mulled it over for a minute, said, "Fine!" and nothing more was heard of it. At the time his entire archive had been deposited with us, which included all his travel notebooks and correspondence. We all knew he had not much time left and it was an unspoken assumption that in all likelihood we would have the handling of it. One day, on what would be the last occasion we ever spoke, he phoned to say he was wrapping up a collection of essays, the one that would be posthumously published as *What Am I Doing Here*—I always wondered at the absence of a question mark— and that he would like access to his papers. I found myself in a quandary because I knew perfectly well the firm's hopes for the future handling of the archive. Also I had absolutely no say in such matters, which made me wonder why he was asking me rather than one of the directors. I could tell he was having one of his increasingly rare periods of perfect lucidity. Suddenly I twigged. One writer was addressing another writer on matters of a writerly nature. "Send a cab," I told him, "I'll help load it up." It was the last we ever saw of the archive. Strangely, the reprimand I felt sure would come never came. A few months later, Chatwin, arguably the greatest prose stylist of his generation, a figure never handicapped by a desire for truth, was dead.

THERE ARE OTHER WRITERS of whom I could speak, but the impression I'd give would be the wrong one. What about the

collectors or those from whom I made purchases? They are, in many instances, more interesting than the authors they collected. I am wary of those who speak of *how things used to be*, and yet when it comes to speaking of the clientele I cannot help but feel something has gone out of the life of the trade. There are very few collectors left who are driven by their own instincts, who delve into the nooks and crannies of literature. Today they collect what most other people collect, which is to say the usual suspects. When they get bored with and decide to sell their books, they feel they've been burned. So be it: they are victims of their own want of imagination. The best libraries are those whose owners bought the books they love. There are some people, albeit not that many, with invaluable libraries that mean little to them outside their monetary value. There is no pleasure to be derived from selling a book to them. They are the ones who quibble most over the matter of condition. And then, the other extreme, there are those in whom a genuine love of books, books of any description, place them in a circle of hell from which there can be no escape.

The most tragic case of bibliomania I have ever encountered was when I was called in to investigate the library of a man whose obsession for buying books was such that unless he got rid of them his wife would leave him. I would in most instances recommend discarding the wife, the latter being more easily replaceable. When I got there I found an overweight, profusely sweating man who sat in a small clearing surrounded by tens of thousands of books, all of them stacked on the floor. All the rooms were similarly filled—there was a mattress floating on a sea of books, a toilet barely accessible, a kitchen about to go up in flames. The man sat there, a pleading look in his eyes, awaiting his execution. "They've got to go, all of them," he whispered. The books were so thickly stacked one could see only the spines of some of them. After a couple of hours of quarrying through them, I realised there was not a single book one could purchase for resale. Maybe there was at the centre of one of

those piles, if only one could get at it, but it seemed unlikely. One develops an instinct for such things. It was a graveyard not so much of the unreadable because, after all, surely there was something to be gleaned from any number of these volumes, but of the unsellable. This was the dark obverse of the book trade, the dank basements full of books whose authors are completely forgotten. And yet what joy and celebration must have attended the publication of each of these volumes. I promised the man I would call in a general second-hand dealer. There were enough books to fill at least two shops. A couple of weeks later, I saw this dealer and asked him how he got on. It was Ike Ong of Skoob Books. He looked at me and replied, not without a hint of annoyance, "Were you playing with me?" I never did learn of the sweaty man's fate.

One of the most sweetly melancholy experiences I had was when I went to purchase the library of Sir Roger Chance, who lost an arm in the Great War and who had now gone blind. As brave in old age as he had been in youth, he was philosophically resolved to the loss of his books because he knew they would pass into hands that appreciated them. With each volume I pulled from the shelves, he would ask what the title was and say a word or two about the book. This was his way of saying goodbye to them. I acquired one of those volumes, an 1881 edition of *La Divina Commedia* with a vellum spine and a leather title-label, which although of no value in itself has great value for me. Loosely inserted in the book is a letter addressed from an M.G. Jeffreys at the Villa Aschiezi to Lady Chance, commenting on a passage in the *Purgatorio* and closing, "I will expect you here on Wednesday after you have seen off Miss Strachey." (*Which* Strachey, I wonder.) A couple of months later, my mother, visiting from Canada, almost as if guided by some compass within her, walked over to my shelves, took the volume down and seeing the name of the addressee on the letter asked me from where I got the book. It transpired the Chances were childhood neighbours of hers in Rottingdean. She played

with their children. She probably played in front of the shelves that contained the very book she singled out on mine.

One of the strangest figures of all, who formed half of the composite figure of J. Leper-Klamm in Iain Sinclair's *White Chapell, Scarlett Tracings*, was John Hale, who looked like he was carved from the wood of an ancient oak tree, and whose eyes looked as though they could pick out ghosts in broad daylight. John Hale collected fantasy literature, or what he preferred to call "weird," the more obscure the better. One day he walked into the shop with a fine copy in dustwrapper of the first English translation of Kafka's *The Trial*, a book that nowadays commands something in the region of £3000. We had spoken about Kafka on occasion, he being an author who fit into John Hale's idea of the weird and fantastic, so he knew of my enthusiasm for him. This copy, his second, was for sale. I said I would show it to one of the directors and he said, no, he had come to sell it to me. I laughed and said it was quite beyond anything I could afford. "I haven't yet told you what my price is," he said. It was £25. I said this was absurdly low, but no, this is what he paid for it and it was the price I was to pay him, but only on condition that I would never resell it. John Hale died a couple of years ago. I had not seen him for a long time. The last I heard of him he had retired to a village in Yorkshire. When I look at my shelves and I see the stark black lettering against the yellow of the spine of the dustwrapper, I remember the strange, very strange, smile John Hale produced whenever he made a discovery the substance of which he would reveal to me only after he had made the purchase.

AN ELF, FED ON THE RIGHT SUBSTANCES, becomes a demon in no time at all. Such was the experience I had after I left Bertram Rota to become, ostensibly, the manager of Bernard Stone's Turret Book Shop, for what was to be both the wildest and the cruellest year of my working life. A legendary figure in the poetry world, Bernard Stone the public man was generous to the point

that a good number of poets owe him not just their gratitude but also the beginnings of their careers. Any history of the 1960s and '70s poetry scene would be incomplete without reference to him.

The private man was another tale. I was brought in to manage the shop, the only one in the country devoted to poetry, and to oversee its move to a new venue. The move was made, to a lovely space in Great Queen Street. The book launches and readings were revitalised to such a degree that the nearby Poetry Society withdrew into its bureaucratic shell, and the wine flowed. It was the only bookshop in London to have a piano. And because Bernard was old enough to be relatively harmless and because he was free enough with his money, attractive women, one of whom once did a striptease in the shop, would flock to him. This was the prince who had become a toad, toadiness being the secret of his attraction.

As a business the shop might have worked, just, but I was frustrated at every possible turn by the man who supposedly I was there to rescue from the infirmities of old age and a daily bottle of vodka. The fact is, I had been warned; the fact is, I ignored the warnings. A hero to the world outside Bernard may have been, but from the inside his greatest pleasure was in waging psychological warfare. One day, early on in my working for him, he counted two hundred pounds into my hand and asked me to hide them somewhere. I took the money to the basement book storage, which was always kept under lock and key, and hid it behind a row of books. A month later, he said, "Remember that money I gave you? Could you get it for me?" I went to the place where it was hidden and to my horror it was not there. I pulled row after row of books from the shelves, thinking I must have misremembered where I'd put it. After about half an hour of this, I went back upstairs to say it had gone. All he did was quietly chuckle. This was the first salvo of many that were to come.

The situation continued to deteriorate. One day a priest came into the shop whom I already knew to be an avid collector of

poetry. As we dealt in both new and old books, he gave me his card, saying he would like to open an account with us. Over the next hour or so, he made a stack of books, at which point Bernard rolled in. I showed him the card, saying we had just made a valuable customer. He grabbed the card and staggered up to the priest, saying to him, "I bet you pick up little boys with this." The party was over.

Over the final couple of months, he gave me pay cheques that much to his amusement bounced. A year or two after I left him, or, rather, after I was forced to leave, I was standing at a bus stop in front of Charing Cross Station. It was a windy day, with newspapers blowing about through the air, one sheet of which tumbled across the street and spread out in front of me, right way up, and because I have a primitive urge to go looking for signs and wonders, for messages that might be destined for me, I looked down at my feet only to see Bernard Stone's face staring up at me from the obituary page. So even in death he hounded me. I did not actually pick up the newspaper but stood there, my body at an angle, reading it as it lay on the ground, when another gust of wind took it elsewhere.

MY NEXT MOVE WAS TO ULYSSES in Museum Street, which was a partnership between Peter Ellis, Joanna Herald, Gabriel Beaumont and Peter Jolliffe. I shall close off with a few words on the last-named.

Chubby, sweating profusely, prematurely bald, a somewhat intergalactic look in his eyes: this, from some point in the 1980s, is my earliest memory of Peter Jolliffe. I had something he wanted, Seamus Heaney's first pamphlet, and he had something I wanted, Geoffrey Hill's Fantasy Press pamphlet. We did a swap and I think we each felt one had lorded it over the other. What I saw then was a man with a passion for books, soft-spoken, polite. At that point he was a free agent, the proverbial turtle who always won the race. Wherever books appeared, so would he. But little did anyone realise the man

with beads of sweat on his forehead, clutching his plastic bags, was the one who probably did more than anyone to alter the face of bookselling in this country. Whether he realised this himself is a moot point because he was driven first and foremost by a love of books. If he had one principle it was that one should be prepared to pay dearly for what one loves.

The fact I later worked with him for almost five years does not mean I had special access to his character, and indeed I might have got to know him less than when I hardly knew him at all. A man with no close relatives, no loves, Jolliffe was completely alone; the only family he could claim was the books with which he surrounded himself. Was there ever anyone for whom books were so totally *the life*? This was all the more pronounced when he was thrust into a social occasion, when he bore the fidgety look of one who did not quite "get" the human race. And yet, on a one-to-one basis, especially when one touched on an enthusiasm of his, some poet whose work he admired, R.S. Thomas, for example, he could be all sweetness. A babyish rage, a horrid whine, was the flip side. So great became his desire to obtain a scarce title that he would be prepared to take a financial loss on it, and if he failed then the mood he got himself into was terrible for others to have to endure. A missed book could haunt him for years; a book secured might go into a cupboard and be quickly forgotten. Success could make him as unhappy as failure, for then he would be full of remorse about the purchase. What defined him was not therefore loss or gain but the quest, and in this respect he was the most obsessive of bookmen. What made him a great bookman was not deep knowledge, which, after all, is the province of many booksellers, but the fact there was no separation between books, the transit they made through the world, and the workings of the soul. It was a state as terrifying as it was sublime.

There was no period when Jolliffe was more dangerous, more unpredictable, than during the Soft Fruit Season (SFS). He would buy vast quantities of the most expensive strawberries,

cherries, blueberries, more than he could possibly eat, which he would then distribute in bowls throughout the shop. Woe to the customer who thought the fruit was there for the taking. I remember a collector of some note extending a hand towards a strawberry, when from the other end of the shop Jolliffe bellowed, "Don't touch them! They're mine!" The man fled. Needless to say, we never did see him again. Once SFS was over it would be a standard fare of green grapes, again the most expensive he could find, and Pink Lady apples. I was among those who made a sport of stealing his grapes. One day, when he walked over to inspect them, he found several missing and, in what later became known as "the grapes of wrath" incident, he took the bowl and hurled it down the stairs. The scattered grapes and broken shards remained there for the next week or so. Another incident involved the Pink Ladies, when he discovered one of them had been replaced with a banana. This took him to a zone beyond rage. He kept returning to the offending banana, staring at it, walking away and then coming back. He spoke not a word, for words could not possibly give voice to his incomprehension, which was on the order of a psychic disturbance. The culprit I discovered later was my young daughter, who having heard from me about the Pink Ladies, dropped into the shop on the pretence of coming to see me, and made the switch.

After the partnership broke up, I stayed with Jolliffe for another couple of years. Without the checks and balances that a partnership imposed—and probably his uncontrollability was the biggest factor in its breakdown—he increasingly lost command of the situation. The once-beautiful shop deteriorated, and from all over there came the smell of rotting food. Mice would appear and not even bother to flee. It might have been the first bookshop in history to be closed down by the Health Department. Although he inherited his family's house in Eynsham, outside Oxford, he spent hardly any time there. He lived in the shop. He did not own a bed but slept in a chair, his slumped figure often drawing the attention of the police or,

more worryingly, young hoodlums, who would peer through the window, taunt and terrify him. Those nights must have been strange. All day long, he saw night creatures. As time went on and his health worsened, he became increasingly erratic, often alienating the best customers. As for my role as factotum, it was becoming less and less sustainable. When I came into work in the morning, often the work I had done the day before had been undone by him during the night. I think he could not bear another person's knowledge, anything that might intrude upon his own. It got so I could no longer stay with him and I made my escape. Afterwards he grew again in my affections. One could appreciate him only at the distance which he put between himself and the world. Any attempt to move up close would only result in exasperation. Shortly before he died, I saw him sitting at his desk, surrounded by boxes of books, too weak to get at them, breathless, his face a deathly blue. A few weeks later, his lungs collapsed and he was taken from the shop into hospital where he died. I wish he could have made his departure in his chair, in the bookshop, surrounded by his treasures. Peter Jolliffe was one of the worst booksellers who ever lived. One might be tempted to say he always shot himself in the foot, but for the fact he always missed. But then Peter Jolliffe was the greatest bookman of our times.

So yes, after so many gripes about writing this piece, and despite a deep reluctance to say anything at all, I find I have only just managed to scrape the surface of a life that has not been wholly objectionable. I have handled extraordinary books and manuscripts and, more importantly, I have met and worked with remarkable people. Maybe I should have taken notes. Maybe I'll go and see if that photo really is of me. Or maybe I'll simply take to the hills, go nomadic.

A Copper Gazelle

GABRIEL LEVIN IS A POET and translator of the recently published poems from the *diwan* of the mediaeval Andalusian Hebrew poet, Yehuda Halevi. Adam Thorpe, novelist and poet, is author of one of the best opening lines of any novel in recent literature: "The incident with the gorilla remained with my mother for the rest of her life, as certain tiny wounds do on the face." One might wish the novel stopped there, upon this most sublimely absurd of notes, but then I would urge the reader to discover why it was the gorilla made such a vivid impression. *Pieces of Light* is, I think, his masterpiece. This morning I introduced them. The meeting was a fortuitous one, not just between a man of letters and a man of letters but also, in some parallel literary universe where all the men and beasts one encounters in books finally reside, between gorilla and gazelle. A gazelle runs all the way through the pages of Halevi's *diwan* and, as we shall see, into his most recent translator's house in Jerusalem.

We sat in the brilliant May sunshine in the massive courtyard of Somerset House, which is the closest the English come to a particular form of Gallic elegance. Its late eighteenth-century architect, Sir William Chambers, presumably studied French architecture, and even the postmodernist fountain, a computer-generated fifty-five-jet "grove" springing out of the flat granite surface, has a sister in Lyons. The fountain is too much at odds with its surroundings to be truly jarring, for there is no

relationship to be destroyed—they tolerate each other like the couple in a not-so-well-arranged marriage. What is distinctly unFrench, though, and heartbreakingly English, is that the tea and coffee are served in paper cups. We spoke of our respective families, more specifically of Gabriel's grandfather, Adam's Polish-Jewish father-in-law, and my father, all of whom, it transpires, had been in Edinburgh during the war at roughly the same time. As I stared into Gabriel's eyes, which are a surprising blue when his complexion would seem to call for green, I wondered then if we might not be re-enacting another meeting from over half a century before, if perhaps all three relatives had not crossed paths or had sat at a similar table. After all, given how closely the Poles hung together, it is not entirely impossible. And then, as if my thoughts were being answered, a single gust of wind swept all the paper cups from all the tables in the courtyard of Somerset House. There's much to be said for the solidity of proper china.

There is a leopard skin in *Pieces of Light*, which, when I first encountered it, mentally derailed me. Suddenly, after not thinking of it ever, I remembered the leopard skin from my childhood. The skin was brought to Canada by my Polish grandfather who, after being released from a Soviet concentration camp, was stationed, or, rather, dumped, by the British in Uganda. A shameful relic not altogether easy to excise from our lives, it was removed to a shed where it would be allowed to disintegrate. I used to lie on it there, my arms and legs pressed to its legs, and, as if entering into some weird parody of the Crucifixion, I'd poke my finger through the rent in its side, presumably made by a hunter's spear. After a while the skin became so mangled and dirty it was consigned to the garbage dump, out of memory's way, only to reappear more than four decades later in Adam's prose.

A GAZELLE—SOMETIMES MALE, sometimes female—runs through most classical Arabic and Hebrew poetry, mainly as an image of desire for the elusive, in both the secular and religious

senses. At times I am tempted to shoot that gazelle, so repetitive are its appearances, and in fact I am drawn mainly to those poems that are gazelle-free. But in Gabriel's renderings of Halevi, the tender-hipped, wide-eyed creature pulls a few surprises. One of the most intricate poems in the book is the panegyric the poet addresses to his friend Shlomo Ibn al-Muallim. The poem is, in fact, a response to one that al-Muallim sent Halevi, welcoming him to Granada. There is an erotic prelude that need not necessarily be interpreted as a homoerotic one (the oriental imagination frequently tends towards extravagance), and which then leads to a discussion of al-Muallim's handwriting, whose beauty exceeds even that of the gazelle.

> The hands that adorned the parchment surpass
>> in skill those which rouged the gazelle's face.
> Such writing threads pearls on a necklace
>> and furtively kindles Egyptian enchantments.

The gazelle here is male, a male with a rouged face, whereas in the poem "Graceful Doe, Pity This Heart" it is most definitely female, for "this gazelle defies God's laws with her eyes." Other times, as in "Asleep in the Wings of Wandering," the gazelle is brought from the secular into the religious sphere. One could chart its appearances, initiate a kind of Gazelle Watch, placing ticks in the columns that indicate "M," "F," "Secular," "Religious" and "Cupbearer," this last being identified with the attractive boy who serves the wine at banquets and who is a Platonic image of desire, emblematic of the friendship between two males.

An oblong bas-relief of a stylised gazelle, in hammered copper, adorns the cover of the Halevi book. The Hebrew

inscription it bears, *Ratz k'zvi* ("runs as a gazelle"), draws upon the final verse of *The Song of Songs*: "Make haste, my beloved, and be thou like a roe or to a young hart upon the mountains of spices."[1] The figure runs from left to right but its head, perched upon a strangely elongated neck, is turned back in the direction from whence it flees. It may be that the sculptor slightly misremembered the earliest allegorical interpretation of *The Song of Songs*, which is found in the *Targum*, an important seventh- or eighth-century Jewish text written in Aramaic, probably in Palestine. Here, the intense eroticism of the *Songs* has been somewhat dampened, if beautifully so, to represent a dialogue between God and the Jewish people.

> In that hour shall the Elders of the Assembly of Israel say: "Flee, my Beloved, Lord of the Universe, from this polluted earth, and let your Presence dwell in the high heavens. But in time of trouble, when we pray to you, be like a gazelle, which sleeps with one eye closed and one eye open, or like a young antelope, which as it runs away looks behind. So look on us and regard our pains and afflictions from the high heavens, until the time when you will be pleased with us and redeem us and bring us up to the mountain of Jerusalem and there the priests will offer us before your incense of spices."

A gazelle with the head of an antelope, could that be possible? The bas-relief was made in the early 1920s by Gabriel's maternal grandfather, Marek Szwarc, who, in the photos I've seen of him, bears a startling resemblance to his grandson, although, really, one should speak of them in reverse. Still, the chronologically false may be poetically true. Szwarc, born in Poland in 1892, went to Paris in 1911 where he studied at the École des Beaux Arts and while there joined the "La Ruche" colony of artists,

[1] A roe was the closest the English translators could come to a gazelle, probably because they had never actually seen one. And so, when reading the King James Bible, for "roe" and "hart" one must *think* gazelle.

whose company included the young Modigliani, Chagall, Soutine and others. He returned to Poland in 1914 and, soon after his marriage in 1919, he and his wife became Catholic, out of deep conviction rather than for convenience's sake.[2] In 1920 they went to Paris where they became close friends of the French Christian philosopher Jacques Maritain. In 1924 the bas-relief of the gazelle was displayed in an exhibition in Łódź, in Poland, and was there sold to a Jewish collector. When war broke out, Szwarc, already in his late forties, enlisted as a volunteer in the Polish Army in Exile. When the Germans invaded France, he escaped to Edinburgh where, in my imagination, he sat at a table with Adam Thorpe's father-in-law and my father.

After the war ended, Szwarc returned to Paris. One day, in 1948, walking along the rue de Seine, he spotted in the window of an antique shop the very bas-relief of the gazelle that he had made over twenty years earlier. The shop owner, when Szwarc enquired after its provenance, said that a German officer had sold it to him during the Occupation. One need not exercise the imagination too hard to figure out how it got into the hands of the officer in the first place, but that it should have made the journey from Poland to France, that is, from where it was sold back to where it was made, is in itself remarkable. Szwarc then purchased his own bas-relief, which now hangs on the wall of my friend's house in Jerusalem. "It is as if the gazelle were orbiting the earth," Gabriel told me, "and awaiting re-entry."

That it should now so handsomely grace the cover of the Halevi book is not merely appropriate but is also emblematic of the translator's own poetic journey. Gabriel's own poetry is neither Jewish nor Israeli but is, rather, *of* the Levant to which it so eloquently gives voice. And what poet could be more appropriate to his needs in these troubled times than Yehuda Halevi, who was the product of an age when all three religious

[2] Szwarc's daughter (Gabriel's mother), Tereska Torres, published a moving account of the trials he had to endure: *The Converts* (Alfred A. Knopf, New York, 1970).

traditions met, when a Jewish poet might write in *qasidas*, when Christians absorbed oriental styles, and when a Muslim might write a panegyric to a Jewish friend.

As a seller of antiquarian books, I am fascinated by the journeys objects make, which their original owners would have found quite unimaginable. And I am struck, too, by how often they make a kind of poetic sense. I have in front of me a dagger with a studded bone handle. This beautiful object was presented to my great-uncle when as a young man he travelled among the Caucasian tribes. I would guess it was already old when it was given to him. If, as I suspect was the case, there was a story attached to this dagger, which would have made of it rather more than a souvenir, it is forever lost. All I know is that certain objects seem to carry within themselves a dark core of significance. There are three notches on the flat top of the blade that may testify to a history best left to the imagination. This dagger was not made for opening envelopes or peeling oranges.

The path this object made through the world in no small way reflects my paternal family's fortunes. The Russian Revolution forced them to flee the Western Ukraine where Pole and Jew alike were thrown live onto the flames. The dagger would have followed them to what briefly was part of a free Poland before it was once again absorbed into the Soviet Union, seemingly forever, and then it would have followed them to the Poland that has somehow managed to survive its history's many vicissitudes. It is one of the very few objects to have survived the war and my family's dispersal to the Gulag, Siberia, Belsen and elsewhere. After the war, many years later, it was given to my father who took it with him back to Canada, a country where he never felt at home, and now it has followed me to England, which for me is the closest anything will ever come to being a home. And so my journey ends here, with a Caucasian dagger, a leopard skin and a copper gazelle.

Girls, Handsome Dogs &
Stuffed Olives

SIBUM AND I VISITED one of Montreal's more fashionable drinking venues, and no sooner did we begin to discuss poetry than our thoughts fell instead upon the barmaid whose every physical move was a small miracle. I can see her still, her lovely hands positioned behind her neck in the most improbable of attitudes, as though choreographed from above. A member of the Ojibwa tribe, she was professional enough to understand that in a place such as this, which caters to the crook, the senator and the poet, intimacy is an illusion involving mirrors and distance. She poured the wine and spread her smiles with equal measure. The Italian writer, Aldo Buzzi (not to be confused with the Italian writer, Aldo Busi), when describing his visit to Djakarta reduces his experiences there to a single glimpse of a woman's bare feet, finding in them a strong case for the existence of God, more convincing, say, than the ontological argument of Saint Anselm. Yes, God is in the details, and that night, in Montreal, He was in that girl's exquisite hands. A sensible woman will read this and guffaw, and she'd be perfectly entitled to do so. What is man but a walking compendium of his own follies, about to fall flat on his own face? If, however, he is unable to ascribe to the barmaid a fair portion of the universe, what chance will his poetry have? After all, poetry comes from the same doubtful region as one's gaucheries, where clumsiness is a constant companion

to grace. As for Montreal, if there's an image that sums up my feelings for the place, that best conveys its sense of separateness, its subtle attractiveness and slightly grudging allure, it is the image of her, high priestess to this Bacchanalian temple. Soon enough, I think, she will be, if she is not already there, in one of my friend's poems. Norm Sibum, in his writing, employs all that he hears and sees.

I have been looking for the superlatives that might wing his most recent book, *Girls and Handsome Dogs*, into a complete stranger's hands, but every time I reach for Roget's Thesaurus my mind is whisked elsewhere. Some years ago, I woke up one morning and realised I knew nothing about poetry whatsoever. Now, while this might have induced in others of my acquaintance a serious crisis, I felt I had been disburdened of a terrible weight I had been carrying for years, which is that there is nothing about poetry I can truthfully relate, that to attempt to do so would be merely to seek to construct a second set of wings for the blackbird that at this moment of writing sings outside. I am not making any claim of superiority here, for poets are, by and large, better equipped to discuss poetry than anyone else. Well, at least *some* of them are. Quite simply, I do not have the critical language with which to reveal a poem's deeper mysteries, nor can I replicate the system of pulleys by which means a group of words may be hoisted above ordinary language. I will set my seismograph to record the wobble of a branch beneath the blackbird's footfall, this, being suggestive of the chord a fine poem strikes in me. A line from one of Sibum's poems impresses me as deliciously ludicrous: "She was a citizen of one of Saturn's moons / Or maybe Nova Scotia, here on a cultural exchange."[1] There is nothing in my mental store that can possibly explain the sheer magic of that line, but what I do know is that those words put together strike the most improbable of attitudes. The collection as a whole contains what for me is one of the essential ingredients of poetry: *surprise*.

[1] I've been to one of those two places, in 1970, on a bicycle.

I should be wary here of spreading too thickly my praise. When she of the exquisite hands brought the Merlot, an antidote to the plonk that remained at the bottoms of our glasses, which, almost imperceptibly and with a knowing glance, she removed and replaced with fresh ones, Sibum and I groped our way back to the realisation that we are the two greatest poets in existence. This is an affliction of the mind not wholly unknown to writers who operate in a vacuum, which they themselves cultivate. It is the blackest of all literary black holes and, as in Dante's *Inferno*, full of sorrowful cries. I conceded that soon enough my friend would produce a poem half as good as the slightest of mine. And he had similar predictions for me.

I should relate how this absurd state of affairs came to be. In 1993, we gave poetry readings in Manchester and Bolton. I wouldn't say we were competitive, but there was between us, in the matter of literature, something resembling a Teutonic sword's serrated edge. Sibum had the greatest difficulty in granting others admittance to his literary universe; I had already allowed him into mine. And then, as now, we found ourselves enthralled by a young woman of considerable grace. We went on a tour of the John Rylands Library in Manchester, conducted by one Stella Halkyard. She was archivist as ballerina. When she led us into one of the darkened manuscript rooms, she did a finely executed pirouette towards the light switch, that single movement of hers unforgettable. At the end of the tour we were shown the Library's greatest treasure, believed to be the earliest extant fragment of the Holy Bible, dating from the first half of the second century AD. It comprises a few words from *St. John's Gospel*, more specifically the verses relating to when Christ is brought before Pontius Pilate. At a point when visitors have been known to suffer religious ecstasy, sometimes physical collapse, all we could do was to stare in wonderment at Miss Halkyard and all Miss Halkyard could do was to return an admonishing smile.

That evening we read our poems to a group of students arranged in a semicircle, which, in the fairground funhouse of mirrors that literature has become, is a way of making a small audience appear larger than it actually is. Afterwards, we repaired for a meal and then had a few drinks in the hotel bar where we fell into conversation with a couple of Scottish lorry drivers. As soon as Robbie Burns entered the conversation, as the measure of all that poetry should be, I felt a terrible weight pulling at my eyes and decided to go to bed, leaving Sibum to continue with the discourse. A couple of hours later, he stumbled into the darkened room and I, still awake, pretended to be asleep. As he navigated his way towards his bed, he made the following utterance.

"Well, Marius, I guess we're the two greatest living poets."

I lay there, in the darkness, in doubtful silence.

About five minutes later, I answered him.

"*We*, Norm?"

I was too late though; the second greatest poet in the world was already fast asleep.

I SPENT EASTER DINNER IN MONTREAL with my Polish cousin's Italian in-laws. There is, in the marriage between Italian and Pole, a resolution such as I have never found between any other two cultures. What it is, I think, is that the Italian removes the Pole from the terrible, historic condition of being a Pole, while from his side the Italian is rewarded with the gravity he so often loses in his constant quest for grace.

"So you write books, huh," Wanda's father-in-law said to me. "I tell you something. You take my life, I've got *lotsa lotsa* stories. You put them together they make a book like this." He spread apart his hands to the width of an opened concertina. "So how much money would I get for a book this big?"

"You must be a very bad man," I said, "for your stories to fill so much space."

"No, I tell you," he replied, "I'm not a bad man 'cos I never been to prison."

He described to me how in 1951, when he was in his early twenties, he and his young wife left their village in Italy and took a boat to Canada. They arrived in Halifax and upon going ashore to catch a train to Montreal he put on a white shirt and she her prettiest dress, determined to meet an uncertain future in their best clothes. The train was hot and stuffy so he opened the window, only for the sooty smoke of the train's engine to blow in from outside. What he remembers now was his shame and sorrow at arriving in Montreal with his white shirt blackened. Would this story have moved me so much had we not been standing, as we spoke, in front of an old photograph of him and his wife in the new clothes they purchased with their first earnings? I sought in the overweight man in front of me the thinner, younger one, his eyes beaming with hope.

"I tell you," he told me, a sick man amid his hard-earned fortunes, "if I knew then what I know now I'd never have come here."

Easter dinner was fabulous, and I am tempted to pause for a while at each course, for at least a moment or two, say, at the sheep's brain quivering on its plate, which I would not have touched had it not been for the copious amounts of wine I had already consumed. What I'll do instead is focus on the stuffed olives that are the local specialty of the village in central Italy from where my host and his wife originally came. I had one stuffed olive and then, quite uncontrollably, I reached for another. I did not resist when the bowl was pushed towards me a third time. You will not find the Ascolane stuffed olive for sale anywhere, nor can you order it in any restaurant, and very few young Italian wives, especially those of the professional classes, will now devote the many hours it takes to produce these culinary masterpieces. A large green olive is stoned, its centre scooped out and then stuffed with three different meats, pork, chicken and veal, finely ground and mixed with the herbs whose identities were not revealed to me. This is a painstaking operation and must be done so as to enlarge the

olive, but not to breaking point. The whole is then dipped into a batter which forms, when deep-fried, a paper-thin crust. What is especially pleasing to the eye is how the green of the olive shows through the brown at various points, which brings to mind a visual memory I have of an illustration, in a child's guide to the universe, of the planet Mars long before satellites ever got up there. I signalled my approval to the *signora* at the far end of the table and she acknowledged my praise with a grave nod of her head. She knew that nobody in the world could ever come close to her in the matter of producing these delicacies. The stuffed olive, although very much of this world, brought with it the memory of a vanished one. I remembered my Syrian friend in London, Zahed Tajeddin, a dealer in antiquities whose specialty is rare beads, particularly those Phoenician and later Roman ones unearthed in Asia Minor and the Levant. There was one bead in particular Zahed showed me, a mosaic bead so intricate, so fine its making could only be described as a seeking to achieve the impossible. "Whoever made this," he told me, "must have done so as a form of prayer, perhaps even as a challenge to himself to become God. It may even explain the connection you find in many cultures between beads and prayer."

When I saw Sibum again I told him about the Ascolane olives. And I told him about Zahed's mosaic bead. I told him the olive and the bead were almost exactly the same size. And both of them as intricate to make. And I *almost* but in the nick of time did *not* extend their example to the making of verses. What was left unsaid was perhaps a matter so delicate that to give it utterance at all was to risk irking the Muse.

"MONSIEUR, LE CHAT EST MORT!"

A THINLY BEARDED, RATHER DAPPER American whom I'd put in his late seventies came into the book-shop where I work, irritated at not having found a copy of the poem he had spent much of the day looking for. Apparently nobody he spoke to had ever heard of it. Gruffly, despairingly perhaps, he asked for the poem by its title. When, a bit too enthusiastically, I proffered the author's name, in a manner that might have been interpreted by him as a query and not as an answer, he retorted, "Well, *of course* it is. *Who else?*" I was much too intrigued by him to take offence. I found him a copy of the *Selected Poems* by the said author, which contained the work in question. The poem had first appeared on its own, in 1920, in a limited edition of two hundred copies, and as such is exceedingly rare. I did sell a copy once to a man who presented it to the mop-topped drummer of the last millennium's most famous rock band.

"I haven't got the poem on its own," I said, "but it's in here."

The American softened, made the purchase, and then we spoke for a while. I learned he was related to the author of the poem which, when I first read it in 1971, had such a powerful effect on me, and which I still look upon as one of the cornerstones of twentieth-century literature. "Well, I'm *his* cousin," he told me. If the connection would later prove

somewhat more remote, the blood argued otherwise. As if both had been hewn from the wood of the same tree, the man before me bore a striking resemblance to his distant relative. I think, too, there was something similar in the voice even, a certain rustic crackle. It could well be, of course, that I was too easily prepared to dissolve the differences, or that by virtue of having two eyes, a couple of ears, a mouth and a nose one man is as good as another, especially if they both sport a bit of grizzle.

A resident in London since World War Two, Thomas Busha—for that was his name—told me he was from one of "those crazy rectangular states," which struck me as a lovely turn of phrase. I had never met anyone from Montana before, not knowingly, but if I were asked to picture such a being, then this gentleman in his three-piece suit will remain for me a pleasing image of all things connected to that geographical wedge. Thomas Busha cuts a dandyish figure. (I saw him not so long ago wearing a cloak fastened at the neck with a small gold chain.) Also, he loves opera, Mozart in particular.

He related a story concerning a creature native to the state of Montana and how, a few years after its capture, it came to acquire, for him at least, a posthumous literary existence. The story grabbed me, not because of any light it shed on the history of Modernism, but because I relish synchronicity. I wondered if the story had appeared in print before. When Busha replied in the negative, I asked whether he would consent to my interviewing him. "Well," he hesitated, and then, with a chuckle, "why not!" It would be some weeks before that conversation took place, but in the meantime, as a form of preparation, he gave me a copy of a rather extraordinary photograph in his possession.

What is there to prevent this image turning up on the wall of a steakhouse? It would be, were it not for the story attached to it, an amusing curio, a buffoon's charade devoid of significance. The photograph dates from 1921, probably in the late summer of that year. We know this because the creature in the middle, a Montana bobcat that only recently had been taken captive, would be in Paris, France a few months later. The gentlemen depicted here are war veterans: the man on the left of the photograph, looking just a little self-conscious in his cowboy clothes, is Thomas Busha's father, Charles Thomas Busha, Jr. (1890-1956), who served as captain in World War One and afterwards practiced law in Washington, D.C., where, very much in line with the democratic principles of his abolitionist forebears, he defended Indian territorial claims; the man on the right is believed to be his law partner, Roy Molumby; the man in the middle, in the aviator's get-up, smiling as though he were the proud father to the creature he cradles, is the pilot Earl Vance, of whom we shall hear more later.

Another photograph, too deeply set in its frame to reproduce here, depicts, on the left of it, Charles T. Busha, this

time in uniform, and beside him, in the middle, dressed in a racoon fur coat and *képi*, Marshall Foch, head of the Western allies, and to the right of him his aide-de-camp, Capitaine L'Hôpital, "the very picture of Gallic insouciance," as the current Busha describes him, for he is blowing tobacco smoke at the camera. The Marshall was, at the behest of the American Legion, on a tour of the United States in the autumn of 1921, and wherever he went veterans flocked to him in droves. According to one of his biographers, "the greatest Chief of the greatest Army in the world" confined his addresses to an effulgent expression of gratitude. When Foch came to Montana he was there presented with the bobcat, which was then shipped back to Paris and installed, presumably none too happily, in the Jardin des Plantes.

Some weeks later, when I again had the pleasure of Busha's company, he spoke to me of his Montanan ancestors, of whom there is many a colourful figure. One stands out in particular, his grandmother, Ida Lillian Busha (1858–1949). She was the daughter of Albert Elijah Pound, whose brother, Thaddeus Coleman Pound, was the father of Homer Loomis Pound, who, together with his wife, Isabel née Weston, produced, in neighbouring Idaho, a son called Ezra, who later produced the poem *Hugh Selwyn Mauberley*, a copy of which, some three months before, Thomas Busha came into the shop looking for, not a little chagrined at having failed to find one.

"My grandmother, who I always thought of as being older than God, she was as big as a minute, but could jump over an irrigation ditch. A tiny little thing, she had ten children, my father being the eldest of five boys. She had come to Montana in the early 1870s on a paddle steamer called *The Far West* that came up from St. Louis, Missouri to a place called Fort Benton. She was then put on a wagon train going to the part of the state where she was to teach school. She'd go to that school on horseback with a shotgun across the saddle to defend herself. She had to worry about the rather truculent Indians of

the time. She went there from Philadelphia, bringing with her this piano, an enormous concert grand, which is still in the family. When the wagon train got to Musselshell River, they set down the piano flat on the prairie, legless, and she played for them down on her knees. Schubert, I think. She was very musical. The piano had its own room on the ranch. It was a part of my growing up. I remember staying with her on the ranch, in a house with chinks between the logs, and sleeping in the Saddle Room, so called because the house had been used once upon a time by a gang of rustlers who, when returning from their adventures, would throw their saddles through the window into the room that would one day bear its name. She would never leave the ranch and she was alert to everything happening on it. She could run us kids ragged. She always wore her skirt down to the ground, was always dressed in a strange way, as a Victorian woman would dress, which probably had something to do with her living a very exiguous and economical life."

She did, however, take a brief vacation once.

"One thing they were all very keen on in the aftermath of the First World War was aviation. Earl Vance had been an aviator during the war. My father was himself part owner of the airport at Great Falls and Vance had his own aircraft, one of those open cockpit things. Ida said she'd be very glad to try out this business of aviation but only if she could do so in such a way that she'd be back at the ranch, in her own bed, so to speak, by evening. So Vance put his mind to it and he decided it would be a simple thing to land his aircraft on her property and take her for a ride. She sat in the cockpit, behind the pilot, as you did in those days, with the wind in your face, and saw the state of Montana from the air and was back in her own bed that evening. Otherwise she never left the ranch, never, never, never."

She did make one final journey of a kind, though, which Busha recounted to me in his inimitable fashion.

"She ended her life with the pixies. She was in her nineties, a bit gaga, I suppose, but it was a curious kind of eccentricity. My aunt told me one day Ida packed a little basket full of things, handkerchiefs, etcetera. When Aunt Beulah asked her what she was doing that for she replied, 'I'm going to the Crazies.' The Crazy Mountains, at the back of this little village, Big Timber, Montana, are a fairly high range, and even in summer there is usually snow on the peaks. The name derives from some Indian legend, concerning a woman who went mad there many years before. Anyway, this was where she was going, to the Crazies, and, sure enough, later that day she was sitting at the piano and suddenly fell from the stool and died in the arms of my Uncle Willard who was visiting at the time."

THE PICTURE THOMAS BUSHA gives of Ezra Pound is one that we get elsewhere, of a man declaiming from his armchair in "a very disjunct and rambling sort of monologue," to use Busha's words.

"I always regarded him as a member of the family rather than as a towering figure in English literature. When I first met Ezra, which was sometime in the late forties, at St. Elizabeth's, it was with the thought that he was part of the family. It was an odd sort of thing because my father took no interest at all in the matter. I'm sure his own mother, my grandmother, would have been delighted if she ever had the chance to meet E. P. because she had some correspondence with him. Frankly, I can't remember the exact dates and particularities. I was young, although a veteran of the second war by that time. I am now seventy-eight years old. When I first met Ezra, I was already perfectly aware of his stature, so aware, in fact, that occasionally I was a little bit disturbed that he seemed to regard me as a person who was of interest to him only in terms of my being a student of law and politics, things that he also was interested in. Although he often referred to 'Fordie,' 'Hem,' and, very occasionally, Eliot, he would never single me out for any kind

of talk on literary matters. This Major Douglas [the economist whose ideas Pound followed] didn't ring any bells with me. I have often said that Ezra was the most American person I have ever met in my life. That is sometimes met with a certain amount of caution, and I don't think everyone is entirely convinced. He would be in a vast, long rectangular room, which had windows on each side, and he would make himself a little corner, where usually there would be four or five people that Dorothy asked to appear. Sometimes they would be people of note. It was a period during which Washington was plentifully provided with elderly, rich women who found their way somehow to the great poetic figure. Ezra would arrange the furniture in such a way as to isolate himself from the other inmates, many of whom were seriously disturbed. They'd be babbling away and coming up and trying to make talk of some kind and Ezra would be very curt with these people and shoo them away and then come back to his guests."

It was these verbal snapshots of Pound which Busha was best able to relate.

"The other thing I want to mention to you concerns a filial side to Ezra. He was much more attached in a sense, more thoughtful of his father than certainly I was of mine. I sometimes found that rather disconcerting. One of those occasions was in Rapallo when Ezra said to me, 'I'd like to go with you to Campo Santo, to the graveyard.' There is a portion of the Italian graveyard, the Protestant side, where both Homer and Isabel, Ezra's parents, are buried. We quickly found this headstone on which there was a death mask. I remember Ezra was somehow moved by the experience of being there, and he reached out and put his hand on the forehead of this death mask and just then there was something going through his mind. I shouldn't for a moment consider it anything akin to a prayer, but nonetheless for me it was an example of his attachment and the care with which he regarded his father. A decade or so later, I was in Rapallo and decided to go on my own to

the cemetery. I simply couldn't find the headstone. Finally I went with my two words of Italian to the attendant and said I was looking for a particular headstone that I knew to be in the Protestant cemetery. We went back and he couldn't find it either. We prowled around and finally we found what had happened was that ivy had grown up and completely covered the headstone. And so, separating the ivy from the stone, we finally revealed the death mask in time, otherwise we would have gone away and concluded it had been removed. I was flabbergasted that it wasn't visible."

What of the bobcat, though? The story, as related by Pound to Busha, is a sorrowful one, although, according to the latter, there was no want of amusement in the speaker's voice. As we know, it was taken to France, and it was at some point between 1922 and 1925 that Pound, together with his wife, Dorothy, went to the Jardin des Plantes, which was then a zoo, to see the famous creature. They arrived there only to be informed by the keeper, *"Monsieur, le chat est mort."*[1]

The story of the bobcat relates also to my final meeting with William Cookson, editor of *Agenda* magazine, who died tragically, on January 2, 2003 while I was in Prague, on the very day I made a pilgrimage to Kafka's grave. Strangely, this prose seems at every turn to lead to a tombstone. I will not say I *knew* Cookson because, in truth, I found him the most difficult of men to converse with. On the other hand, our relationship was never anything but affable. Cookson was loyal to what he believed, unswervingly so. Certainly this was the case with Pound, on whose behalf he was prepared to defend the indefensible, even the notorious radio speeches, until finally he himself was quite without defences. Stubbornly, absurdly even, he was prepared to rewrite the history of the Second World

[1] Sadly, on the very day I completed this piece, our cat Phoebe had to be taken to the vet. She was diagnosed with a massive stomach cancer, which required an immediate, and painful, decision on our part. When we brought her home to bury her in the garden, I carried her past my desk where the title of my newly completed piece was all too visible.

War in order to accommodate Pound's more bizarre homilies. I couldn't see why he was prepared to put his own reputation on the line, not when Pound had already redeemed himself through his verse. What are those haunting final *Cantos* if not an expression of the regret of one who tried "to make a paradiso terrestre?" Still, I could never join in the mounting criticism of Cookson, because I have a natural inclination to side with those who fight losing battles.

A story I have heard is that when people went to visit Pound in Rapallo and later in Venice, Olga Rudge would sort out those who were serious from those who were merely curious by asking the hopeful visitors to recite from memory a single line of Pound's verse. If they passed the test they would gain admittance. Cookson would have got in many thousands of times over, for he knew the whole of the *Cantos* by heart, such that one could start him at any point and he could continue from there. I do not believe for a moment that he set out to memorise them, but rather that his love of Pound's work was so deep, so profound, that they entered his bloodstream. Cookson's death was, perhaps, the death of a species of one. If there was something of a blur in his nature, he was the sharpest authority on anything touching upon his beloved mentor. When I last saw him, on the evening of September 17, 2002, I asked him, without ever telling him why, if he could remember a bobcat appearing anywhere in the *Cantos*. I had it in mind to contribute a prose piece, the substance of which I have related above, to his magazine. Who could have guessed it would bear this sad coda. I was rummaging for the information that would help me spring a surprise. It seemed to me highly improbable that Pound would pass up the opportunity to place himself, poetically at least, at a juncture in twentieth-century history, not when a member of his own family, the Great War, Marshall Foch, a Montana bobcat and the Jardin des Plantes occupied a single vortex as it were. I was mistaken. Cookson stood for about a minute, mentally running through

the whole of the *Cantos*, which goes some way towards demonstrating the speed at which a mind driven by love can move. "No," he replied, "but there is a lynx in Canto LXXIX." "Oh, really?" I said, hoping, for a silly moment, that perhaps the bobcat had undergone some kind of literary change. The metamorphosis was, of course, of another kind altogether, that of woman into creature: *O Lynx keep watch on my fire*. Cookson seemed annoyed. "Well, *of course* there is!" he snapped. It was the last time we ever spoke.

As for Thomas Busha, I know not where he has gone.

Can I be sure I ever met him?

"Do Not Expect Applause": W. S. Graham in Performance

I FIRST MET W. S. GRAHAM in 1976, on the occasion of his reading to mark the publication of *Implements in their Places*. I had been asked, because astonishingly nobody else was available, to introduce him at the Poetry Society in Earls Court Square. Admittedly I didn't want to: I knew nothing at all about him or his poetry and I've never been one to fake enthusiasm. Graham was, at that point, an unknown quantity for most poets of my own generation, and already he was in danger of being forgotten by the one that came before. There were a small handful of supporters, though, Harold Pinter among them, who would not let his boat slip its moorings. Samuel Beckett added, from afar, his monosyllables of praise.

Why did I expect a rather stuffy figure? What devil of misinformation could have been in the air? Imagine, then, how ill-prepared I was for the man who arrived that evening, his face like an angry tulip, ruddy with much too much booze. We shook hands and Graham, raising his hand as would a pup its wounded paw, held it in mid-air for a moment, wiggled his fingers a little, and then said in a shocked voice, "Why, you've gone and broken my flute finger!" This, of course, was the famous Graham stance, all blarney and mock belligerence.

I introduced him, clumsily I'm sure, and Graham shuffled his papers, staring with a kind of pinched fury at the audience. As soon as he started to read, and, dear God, he took his time

getting there, my ears began to tingle. This was poetry, "wow wow," of a most unique calibre. What is difficult to describe is that extraordinary delivery of his, one that made complete sense of his line. The gruff and the gentle, strange whisperings nowhere in the text, odd bellows, dangerous pauses and even missed lines, these were just some aspects of his performance, added to which was a lyricism that seemed quite often at war with itself. A poem should not depend upon its maker for its survival—with this I'm sure Graham would agree—but I do feel that anyone never having heard *this* particular voice is missing an important dimension in the work. After all, the voice (and by this I naturally include the *ear*) has precedence over the printed page.

Even if he drank heavily, reportedly because of stage nerves, he was too consummate an artist to *throw* the poems, although I heard later in Oxford he threw a whole reading once. If the frame was wrecked, the canvas was intact. As his recently published letters, *The Nightfisherman*, demonstrate, his was a life wholly dedicated to his Art; if poetry were religion to him, he was one of its priests. And he would starve for it if need be. I think, too, it is worth noting that the speaking voice already there in those early letters of his would later become his poetic voice, after he managed to winkle himself loose of the word-drunkenness that mars his earliest work. It needs to be said, though, he never rejected many of those early poems and often included them in his readings. Whatever their faults, they are matched by virtues; they are full of *dare*. And daring was a quality he brought to his late readings. Certainly he could and did bungle at times; he would lose his way terribly, asking for help from his wife Nessie; other times he would threaten the audience, on one occasion hissing, "Stop looking at me. Will you stop looking at me!" and on another, "I will cut off all your heads." This was his wild, defensive humour, of course, rendered in oh-so-gentle a voice, but heaven help the poor poet who had to read with him. I saw him once not so

gently put down an Irish poet at his side. I wonder, though, if it would not be too fancy to suggest he was also taking on the demons within himself, if not actually taunting them sometimes.

I have seen him read five or six times in all, and they were among the most thrilling poetry events I have ever attended. I shall attempt to explain why they were so. After all, they were so close to being each time a complete shambles. "What is the language using us for?" begins his poem of the same title, and in this, perhaps, one can get a sense of his approach, that of a man caught in the teeth of not just the obdurate language but also its opposite, "the terrible shapes of silence," this predicament being one of his major themes. The poems, when he read them, were full of punch. The sense was of a poet out to surprise himself. Graham did not dramatise his poems, however; rather, he had a gift for being able to recreate, right there and then, the dramatic impulse that gave them their original *raison d'être*. Another way of putting it is that in performance he was able to reconstruct the rooms, or the spaces, if you like, in which the events of those poems originally took place. Always he appeared at first to struggle with the poem, reading it word by word almost, and with such nervous tension one wondered if he would get to the end of a line, much less the poem. This was nothing any reader of his own work could or would wish to fabricate. This was the poet on a tightrope. And because of the risks he took, or even because of the mistakes he actually made, the successes were that much more dramatic, as if by the end of any poem he had effected his own brilliant rescue.

An English audience is a relatively harmless one until someone injects it with a single drop of madness. After that, there is no telling which way it will go. On that first occasion, in 1976 sometime, shortly after Graham started reading, there was a rustle of paper in one corner of the room. A dark voice came from the corner diagonally opposite, "Who crinkled that piece of paper?" Harold Pinter ran his eye over the cornered

section of the audience. "Come on, who was it?" he barked. "It was you, you bitch, wasn't it! Throw her out of here!" The unfortunate lady's husband stood up to protest, "How dare you address my wife that way?" Within seconds there was pandemonium, trouble sprouting all over the place. Graham, meanwhile, flapped his arms like a heron about to take flight, shouting, "Whoah, whoah! What's this, a fucking football game?" It was rather too late for me to intervene.

Graham was now all nerve, the atmosphere electric. This was probably the condition in which he best functioned, where everything acquired an uncertain edge. Almost halfway through the reading he whispered to me, saying he would read one more poem and then, perhaps, "We could all have a *wee* break." He finished the poem and I stood up to announce the reading would recommence in twenty minutes, at which point he wheeled towards me. "Will you no sit down, laddie. I will not be cheated out of my time!" Graham read another three poems. "I am not mock humble," he said once.

During the interval, people clamoured to have him sign their copies of his book, but he focused instead on a Chinese woman of my acquaintance, and slowly, slowly, painfully even, wrote a lengthy inscription to her in mock Chinese characters. There were, as far as I could see, no other copies inscribed that evening. Years later, his widow Nessie said to me, "What he had was a necessary sense of the ridiculous." Graham had it in abundance. Quite by chance, some years later I met his brother, Alastair, and his wife, who described an occasion when Graham came to supper at their place. She was preparing a fish dinner and, discovering she was lacking a certain ingredient, slipped out to the shops. She returned, a few minutes later, only to find he had taken a hammer and nailed the fishes, all three of them, to the kitchen wall. "Ah," she said, "you couldn't help but love him all the same."

I believe he ended the evening with "Johann Joachim Quantz's Five Lessons." In later readings he would usually close

with his hauntingly beautiful "To My Wife at Midnight," the last great poem he would write, but on this occasion I feel certain it was with "Quantz." And now, as I draw this memoir to a close, I will slip into a somewhat different mode—that of commentator, of listener, section by section, to one of the great dramatic monologues of recent times. All of the Graham magic can be found there. I have put on a recording made of his December 1979 reading at the Poetry Society. There is, in fact, another recording he made for radio, straighter and more prettily done, but somehow I prefer this craggier version. Despite the several mistakes he makes, so profound is his reading here of the Quantz poem, so powerful his sense of line, that in a perfect world, one respectful of silences, it would be cut and released as a single. I spoke earlier of his uncanny ability to reconstruct a drama or a space; the "cold high room" of this poem is rendered in as clear a light as that which any Dutch or Flemish master ever painted. This is Graham's wobbly preamble to the Quantz poem, and, so as to give a better sense of his voice and character, I indicate just a few of the lengthier pauses. Remember, though, the poem was written in and for a sober voice.

> Can I speak about the music?... Now, this is a longer poem ... We'll finish this and if you would like to have a drink after this, I don't mind ... There is a man called Quantz, there was ... My dear, could you tell, Charles [Monteith, editor at Faber & Faber], please, tell them who Quantz was. [*CM:* "A teacher of the flute, a teacher of great influence."] ... The point is, not only a teacher of the flute—he taught Frederick somebody and all that—but he represented his time ... In doing that, God, I don't know, I'm not a great ... Bugger the whole thing! Well, he played the flute anyway, he played the pipe ... And I would like to begin it. Hark! You see the lovely thing, as far as I am concerned ... Now this man wrote the definitive book about playing the flute, which still exists as

the definitive book about playing the flute. A great man, even at that time ... Well, you'll have to hear this or I'll kick your teeth in. I can see I am ... am I deteriorating? [*laughter*] Do you know why I am saying this is because the beginning of it, for anybody here who is interested in verse, in the way you write ... I made the beginning of this from the prose—now, I know this is terrible!—from the prose of whoever translated it. Why are you all sitting there? I'll kill you all. Where am I now? Keep your wee drums, your ears, and you will find something to your advantage. Am I correct? ... Hold it, kid! [Graham searches for the poem; somebody in the audience tells him it is on page 222.] You will have to forgive me, I really will have to ... I know the beginning of it. Here comes a beauty... see ... OK, psst! psst! Take it. How does it begin, Ness? Psst! Where is the first line? Ah, *grazie, grazie*! Pay no attention. Such a lovely poem. Now, if I do this we can all have a wee rest, eh? [*laughter*] For this is a beauty.

1

THE POEM BEGINS IN BREUGHEL'S winter, a painter's name already setting the scene. We already know this world from those unforgettable images of his. And later, when we look down from Quantz's window, we will see the canal from a Breughelish angle. Quantz, the great teacher of the flute, is addressing his new student for the first time. Well, shall we say he does? It is very late at night or else very early in the morning, "I speak in the small hours," not a regular time for a music lesson, and Quantz, setting the conditions of engagement between teacher and student, speaks from the other side of language—although, sadly, here, in his reading of the poem, Graham misses a vital line. The student, if he exists (but surely he does), is in his own time and must listen from his side. The opening words of the poem, Graham reminds us

in his preamble, come directly from the English translation of Quantz's book; these are the preliminaries with which he probably addresses all his pupils. What do we hear in the background, beneath the surface of the language? The Guild clock strikes the hours in real time. The Guild where? Where are we? Quantz is German, Breughel Flemish, but the scene feels as Dutch as painted wooden shoes. The student, Karl, has yet to be addressed by name.

> So that each person may quickly find that
> Which particularly concerns him, certain metaphors
> Convenient to us within the compass of this
> Lesson are to be allowed.

These are not easy lines to read aloud and Graham manages them in a brisk, perfunctory fashion, straight from the page of Quantz's book. They are in their separate places, teacher and student, both physically and in time. The first personal note struck is that with which Quantz closes the section, "I blow my fingers." The rest of the poem will be the story of a Great Thaw, which comes of a student learning his lessons well.

2

As if five lessons could be enough for anyone to be able to play the flute! Surely there have been quite a few already, in *real* time, between the first and second lessons of the poem's *imagined* time. It is morning, the world is all edge, and the ghostly student of the small hours, whom Graham has sought out in his imagination, has put on flesh. (We will see him later, more clearly, in the final section of the poem, "a lout from the canal / With big ears.") Karl enters. "Good morning, Karl. Sit down." Quantz now addresses his student by name, remarks on his progress, and decides he has made a significant advance

in his studies, telling him, "Karl, I think it is true, / You are now nearly able to play the flute." Naturally enough, Karl is feeling the impatience that comes of a little knowledge. And rightly so, admits Quantz, who sees in him "the rare gift of application." After speaking of "the terrible shapes of silence," Graham quickly dismisses them from Quantz's mind, for these are, of course, not his but the poet's musings on language.

> Enough of that. Now stand in the correct position
> So that the wood of the floor will come up through you.
> Stand, but not too stiff. Keep your elbows down.
> Now take a simple breath and make me a shape
> Of clear unchained started and finished tones.

We are in the real world now and a musician must bring to it great physical discipline if he is to "make the cylinder delight us."

3

> Karl, you are late. The traverse flute is not
> A study to take lightly. I am cold waiting.
> Put one piece of coal in the stove. This lesson
> Shall not be prolonged. Right. Stand in your place.

"STAND IN YOUR PLACE." What Quantz means, presumably, is that Karl must also remember his place in this increasingly fragile relationship, where the boundary between teacher and student begins to, and will ultimately, dissolve, like the ice in the canal outside. Karl is late; Quantz is cross. If today's lesson is *not* to run overtime, presumably it means a good many others have. Karl has abused the faith Quantz has invested in him and must therefore pay a small price, even if it means doing the chores. "Put one piece of coal in the stove." In a tone

reminiscent of the poem's opening lines, Karl is instructed to play—to the letter of the Book, one supposes. It's only when once again Karl proves his abilities and is warned "Unswell your head," which is also the poet's warning to himself, that Quantz permits another piece of coal to be put on the fire. "Stop stop Karl," says Quantz, imploring him to be not mechanical in his playing but to enter, as if for the first time, the spirit of the piece: "Play it as you first thought / Of it in the hot boat-kitchen." And which, of course, is how the poet here, in order to persuade, must re-enter that old scene. Quantz now warms towards Karl sufficiently to allow himself, most unusually for a teacher, a performance on the flute.

> Give me a shot at the pipe.
> Karl, I can still put on a good flute-mouth
> And show you in this high cold room something
> You will be famous to have said you heard.

Prior to this, though, in his reading of the poem, Graham stumbles; instead of "I can see I am making you good," he says, "I am making you *a* good," and, realising his error, falls into a terrible silence. The tape runs and runs. We feel the awful dimensions of the room, where Graham struggles, balloon within ourselves. And then, making up for lost time, he skips the next line and a half. One should be wary, though, of reading too much into a mistake. It may be impolite to do so, but what I wish to remark here is the terrible fragility of a Graham performance.

4

"You are early this morning," begins the next and, in real and poetic time, penultimate lesson. There is no longer any need for Karl to play his exercises for, as Quantz admits, "I

think you are good enough / To not need me anymore." All that is left for Quantz to impart is the most important lesson of all, to make Karl appreciate his role "as a little creator / After the big creator." This, then, is where the artist's true humility comes in, in understanding his position in relation to his Art, Art with a capital *A*. What moves beneath the language, though? There is in Quantz the painful awareness that soon his student, surely his favourite, must leave. Also, are there not intimations of death here, in that one day Quantz will leave his student? There is an almost unbearable poignancy in his avoidance of the issue, as they both, with their glasses of Bols (the drink is Dutch, too), stare out the window at the barges that now begin to move. Incredibly, though, in his reading Graham misses out these two lines, the one with the barges and the following one, which so shrewdly reflects Quantz's inner sorrow.

> Come and look. [Are the barges not moving?
> You must forgive me. I am not myself today.]
> Be here on Thursday. When you come, bring
> Me five herrings. Watch your fingers. Spring
> Is apparent but it is still chilblain weather.

Above all, that flute finger of his must not be damaged. "Why, you've gone and broken my flute finger!" (Often musicians worry more about their hands than they do their lives.) And by all means let him, let Karl, bring those five herrings, but for God's sake hide the hammer and nails.

5

"REMEMBER JOHANN." Well, fancy that! Would it be too much to assume that this is the first time Quantz, as teacher, refers to himself by his Christian name? This Karl must be not at

all bad on the traverse flute. When, in this final section of the poem, the time comes for departure, Quantz, remembering his Art, maintains his composure.

> One last thing, Karl, remember when you enter
> The joy of those quick high archipelagoes,
> To make to keep your finger-stops as light
> As feathers but definite. What can I say more?

And Graham, fully inhabiting, fully back in control of, the poem, asks, "What can I say more?" The answer follows immediately in the final two lines that in themselves form the keystone to this masterpiece.

> Do not be sentimental or in your Art.
> I will miss you. Do not expect applause.

Above the desk of any who would create, whether it be poetry or music, those last four words of the poem should be writ large. DO NOT EXPECT APPLAUSE. There is at the end of the hissing tape a mighty applause. We wondered if he would make it. And, by Jove, he does. "Wow wow," as Graham would say, when expressing pleasure in his own verses. May he hear our clapping still from wherever he is, on the other side of language.

My Father's Silver Horse

O N MONDAY, JUNE 16, 2003, while I was at the barber's, my father died. Such were certain of the peculiarities he imported into the English language, which he never corrected, that he would always refer to the hairdresser as the "high dresser." As a boy I hated being taken to the "high dresser" and I suffered then, as I still do, on occasion, *as I did that very morning*, from a condition I have never discovered in anyone else: I begin to go faint in the chair. Call it, if you like, Samson's Syndrome. The Greek Cypriot barber I go to, who usually asks me if I have been on holiday because he knows there's little point in discussing with me the latest football game, asked me nothing at all this time. I must have been carrying something heavy in my face. What can one hide from the barber, though, who is so close to the brains of those whom he emasculates? Such foreboding as I had then, which I couldn't give a name to, was to be realised in a few minutes' time. (What will I say next time I see him, when he asks me if I have been on holiday? I will answer him in the affirmative, or maybe I'll dodge the issue, create a diversion, and ask him about the most recent game. There will be no major disclosures because that, too, is part of barbershop etiquette. One deals only in opinions there, in surfaces, never in dead certainties. One must be *briskly* masculine.) Such were my trepidations that bright morning in June when my hair fell in grey

semicircles to the floor, when my hands gripped at the ends of the armrests, and when, in a different time zone, in darkness, my father cooled to the world's temperature.

A couple of days later, in Kemptville, Ontario, the most unlikely of places, I scattered over his plain wooden coffin the red and white roses that are Poland's colours, as well as some Polish soil which he had brought back with him many years before for precisely that purpose. As a child I dreaded the day this substance would be put to use and had not looked at it since. The earth, which I remembered as black and moist, had now ossified into irregular shapes of pale brown. When I speak of the most unlikely of places, what I mean is that it seems impossible that his journey, which began in the turmoil of revolution, should have ended here, where hardly anything ever moves. The Bolsheviks had put an end to the Polish Ukraine and only a few years later they would annex the part of Poland to which my father's family made their escape, so that yet again they would have to flee. This handful of soil was of shifting provenance. Some years before the war, my grandfather was approached by a gypsy who offered to read his fortune. A man not at all given to the occult, he consented, perhaps with a sceptical smile. The gypsy told him that there would be a world catastrophe, which would result in his family being spread over the globe, but that, against the odds, they would all survive. This turned out to be the case, most unusually for a country in which barely a family did not suffer human losses. Some of the family were sent to Siberia, a couple to Belsen, and my father elsewhere. The path that took my father to the Lubyanka Prison in Moscow, then to one of the Gulag concentration camps north of the Arctic Circle, and from there, by a circuitous route, to England, bore no signs that it would take him, *enfin*, to Canada. Strangely, perhaps, this last was for him the hardest to endure. Suffering has its own peculiar logic, which manifests itself not always in degrees but, rather, in their accumulated absences, and because nothing in the soul is

measurable and because one rejects any form of cure, as if to cure would be to remove the thing one loves, the only answer is to go forth in bitter silence; and it is this, more than the vicissitudes of culture, politics or economics, that is the miserable lot of the exile. Years later, when the world had thawed a little, he returned to Poland on a tourist visa and brought back from there the soil that fell to me to distribute. Actually my thoughts were not on the coffin before me, which seemed too small to contain him, but on the crotch of my trousers where, on the drive to the cemetery, water had seeped from the stems of the roses. Would the Holy Father notice?

Over the days that followed, bereft of the consolations of religion, I kept looking for somewhere upon which to settle my terrible feelings of absence. The death of a parent is quite unlike the death of anyone else. One feels like the ground from which an enormous root has been pulled. I had not felt his presence at the graveside, nor did I feel it elsewhere; it was as if he were hiding somewhere. The tricks death plays on the mind are curiously infantile.

It was only later, when I unpacked the box of personal effects returned from the nursing home where he spent his last days, and I came across the chessboard over which we played many a game, that paradoxically I felt his presence. A chessboard, after all, demands the company of two people. The chess pieces had gone missing but perhaps, just as he was, they were merely invisible. Where do the objects of this world go? Where, for example, are the toys of one's childhood, so many of them indestructible? What would be the fate of those missing chess pieces and of one of the figures in particular? My father, in his memoirs, describes a chess set that he and his fellow inmates concocted in prison, which was made of the clayish bread that was their chief means of sustenance. Almost immediately it was confiscated, as if the moulded figures presented a serious challenge to the Soviet regime. Years later, in Canada, when he was still too poor to buy a chess set, he carved figures from

black rubber stoppers that he brought home from his place of work. One side was left black while the other he painted industrial silver. The figures were purely symbolic and by this I mean the carving of them was crude. The significance they had, however, is beyond artifice. There are so many ways by which one may make a stand against hard times. Also he badly missed his game. These rubber pieces were later replaced by wooden figures, and when the wooden horse from the new set went missing, the silver rubber one was called back into service. And there it remained, an anomaly of sorts, the single trace of a rough beginning. The horse did not closely resemble a horse. It was, rather, the *idea* of a horse. An alert reader will now say to me, "*What* horse? *Where's* the fool horse? Surely you mean the *knight!*" Such was another of the semantic peculiarities my father imported into the language. The English knight is the Polish horse. I will not, milord, be deflected in the perpetuation of a good mistake. I wish now I could recover that silver horse. (There is, incidentally, a Polish film called *A Year of the Quiet Sun*, which contains a remarkable scene: a Polish woman tells her much younger American lover of the death of her mother, I believe, and as she speaks he gallops his fingers over the blanket at the bottom of the frame, the departed soul a runaway horse.) Our playing chess was a means of communication, one which remarkably he preserved when other means, such as ordinary discourse, had fled him, which goes some way towards demonstrating the intricacies of his mind, a mind mathematically astute but no longer capable of grasping the poems of his beloved Jan Kochanowski, a volume of which lay untouched at his bedside.

WHAT CAN I SAY THAT WILL preserve a necessary distance? All manner of demons keep pushing from beneath the page. I will not divulge their identities, but of his faults I will say they were mostly the consequence of much pain working upon a terrible solitude. There were times when he was subject to bad

nerves, when silently his lips would move to the shapes of a language he was never able to teach me. I had as much cause for my resistance as he had for his insistence, an equation that, to some degree, is at the root of all our smaller tragedies. The bigger ones we make for ourselves. And of his virtues, generosity chief among them, many issued from the same sorrowful place. The great pleasure he took from his reading of history was manifested in how easily he was able to hear ancient voices. What pained him was that he had so few people with whom to share those voices. I remember once he and a neighbour chopping wood, my father talking all the while about a passage he had read in Herodotus and the neighbour interjecting now and then, saying, "Yes, for sure!" It was, I believe, my first lesson on the true nature of solitude. Joseph Conrad would teach me more. Solitude is a Polish eagle. When my father spoke of voices historically nearer in time, his baffled audience failed him utterly. It could not carry for him the bleeding Christ that was *his* Poland crucified. Such were the demands he made on people that anything less than full agreement on the matter of his country's fate was a slight, which rapidly became an insult to everything he held true. The irony is that the country in which he had spent so little of his life was to a great extent a fictional one. When we went together there once, it was as if I were his magnetic needle. Sailor that he was, I was the one who had to navigate. So much of what was truly grim he was blind to, and such beauty as he saw he raised to a level beyond what was sustainable. I remember standing with him at the edge of a small lake rimmed with white birches. "Where else in the world can you find such beauty?" he cried. I refrained from saying it could be found also in the country where he now lived.

The rest is mostly private.

Ah yes, my father's best joke. We were standing in front of Uccello's *Saint George and the Dragon* in the National Gallery in London. The reader of this piece will probably have a

mental image of the painting but may not remember the detail of a fine leash running from the dragon's neck to the hand of the oddly impassive maiden who looks a bit like Olive Oyl in *Popeye*. Meanwhile, Saint George on his horse drives his lance into the dragon's nose. Uccello employs his newly won ideas on perspective to the full here, the dragon's head being the focus of massive force. Blood spills from its jaws. The pale maiden is saying something, or perhaps her open mouth is merely a weak gasp of surprise. She offers the palm of her hand in an accompanying gesture, as if holding forth on the virtues of animal welfare.

"Hey," my father cried, taking up the maiden's cause, "what are you doing to my dragon?"

Over the last two years of his life, his mind continued to deteriorate, settling for a while in one plateau before descending to another. At times, most cruelly, he was back in the Arctic wastes or in the Lubyanka. One day the British army landed on the roof of his nursing home. Other times he was where nobody could reach him, such as when he spoke to me once of the intricacies of the English as opposed to the Chinese language. The latter was not one, I hasten to add, with which he had even the slightest acquaintance. Sometimes he was absolutely *of this world*, a condition that was near to unbearable. The pills removed him elsewhere. All too quickly he was demoted from the main dining room to another where, in what must be one of the most terrible words to mark our decline, he had to be given *assistance*. The people there sat four to a table and often the scene was not pleasant to describe. There would be spewing, coughing and moans, a cacophony of unmoored voices. The impression was of being trapped in a loop of film running the same images over and over, the same shouts and cries. On my final evening with him, my father sat before his meal, which he wouldn't touch, in dignified silence. Of late he had been going through a particularly bad patch and had spoken not a word for perhaps two or three days.

Suddenly, apropos of nothing, he asked, "Can you tell me where Napoleon is buried?" A girl sitting opposite was feeding a deeply unfortunate man, blended food running down his face. I said to her that she had better listen up because my father knew a great deal about history and that she could expect to learn a thing or two. (Yes, I did say "listen up," slipping back into the local vernacular of my childhood.) She had a slightly panicked look on her face, that of a student who had failed to do her revision.

"Aw gee," she replied, "I don't know much about history, Moby Dick and all that stuff."

I asked my father whether he considered Napoleon a good thing or a bad thing. "Both," he replied before sinking back into another quarter of an hour's silence. I wheeled him back to his room in order to say my final goodbyes in private. I explained I'd be back as soon as possible. (It was barely a couple of months before I did return, my hair newly cut but sadly not for him to see.) What he did in response was to slowly raise his shaking arm and, pointing to his bed, he spoke what were to be his last words to me.

"Is that Napoleon's bed?"

A FIRST VISIT TO THE GRAVE is perhaps the most difficult to make. I stood before the patch of newly turned earth, admittedly troubled at not being able to derive meaning from it, as if this were a black page upon which no ink would ever be visible. I was troubled also at not being able to equate the man I knew with the coffined stranger down there. Those final words he spoke to me, they contained, I believe, a logic that can't be fully grasped with prose. *Death. Bed. Napoleon. Grave.* The sun was going down. Would that I could find an arrangement of words, a clicking of vowels and consonants, to explain the alchemical process by which means the sun did so differently that night than ever before. A strange thing happened just then, although were it not for the parlous state of my nerves I

might not have taken note. A car pulled up and, like the wings of an enormous bug, or rather, perhaps, like the wings of *two* enormous bugs in the act of mating, all four doors opened at once. A family—a husband and wife and their two children—got out, and, with military precision, marched single file to a freshly dug plot a few yards away from where my father was, all four of them holding before themselves, at precisely the same level, strawberry ice cream cones. I couldn't help but wonder, as I studied them in profile, whether this was not some ritual they had devised for themselves. Could it be that this was the keeping of a date they had made with the deceased, to come at such and such an hour bearing ice cream cones? Could strawberry have been the deceased's favourite? I was, in my sorrow, amused and, in my amusement, further saddened. Was I not witnessing here the repetition of something that had been played out many millions of times before, but which, in this guise, was unprecedented in the history of our species? This couple and their two children, observed in profile, seemed to have slipped both out of and into time. And they did seem to me, as they walked towards the grave, a Sumerian parade.

The Testament of Charlotte B.

1

England is the paradise of women, the hell of horses
and the purgatory of servants.

—English Proverb

"THERE IS NO SUCH THING as chance," Schiller writes,
"and what seems to us merest accident springs from
the deepest source of destiny." A woman salvaged
from another time, and the story she relates—one of rape,
dark intrigue and abduction—may seem a touch familiar, may
even produce a doubtful smile, but, as much as can be proved
it happens to be true. I do not think I exaggerate when I say
that what follows had a decisive influence on my thinking with
regard to how—on occasion and *for a while only*—we enter
curious intersections of time and space. While not given to
spiritualism or parapsychology and, indeed, inclined to run a
mile at the sound of those words, I do think there is in this uni-
verse of ours something more powerful than chance. There is
even, I suspect, an area where poet and physicist think and act
as one. After all, what is the making of a fine simile but a brief
habitation of some kind of interstice? I am reluctant, though,
to allow my thoughts on the matter to congeal into theory,
preferring, as Keats does, "to move between uncertainties."

Should one, in what purports to be the investigation of a historical document, resort, as I'm about to do, to the personal pronoun? My defence is this: the issues raised by certain events of a couple of hundred years ago are resolved in the present *and in the present only*, and, necessarily, *through me*. A haunting is what they comprise and, as in all ghost stories, a ghost is not a ghost until it has a living audience. Also, there needs to be an outcome, a place where all the loose strands are neatly tied together and these, for better or worse, required my presence. Should events have proved otherwise, had these papers fallen into hands other than mine, what follows would have been the analysis of a social document, another sheaf for the department of eighteenth-century studies. I would suggest that circumstance has turned them into something else. On the other hand I do not wish to mystify, stump or bamboozle, because to do so would be to drain a good story of a potency that is found only in the real. I'm not out to produce atmospheres.

I used to work for the antiquarian bookseller, Bertram Rota, a distinguished London firm that had its origins in the person of Bertram Dobell, he it was who established the authorship of a manuscript that came into his possession. It was the work of the Elizabethan poet and mystic, Thomas Traherne. I will make no such claims for the manuscript that came into my hands, but it was through my happy association with this firm that I was more modestly rewarded. The history of the book trade is one of remarkable discoveries. A bookseller is not quite as surprised as he ought to be by the way objects move, seemingly of their own accord. Perhaps it is because he is, by virtue of what he does, a net lowered into the water, the bigger the fishes he catches the better, the more profitable. On May 13, 1988, during preparations for a change of premises, my colleague Peter T. Scott called me over to look at some papers that had just been exhumed from a cupboard where they had been lying for some fifteen years.

Should they be kept or jettisoned? Actually, an experienced bookseller, he had caught from the papers before him a whiff of importance. These were originally in the stock of another bookseller, "Dusty" Miller, and when he retired, the firm I worked for acquired them. This happened when I was still living in Canada with no thoughts of either staying there or of moving to England. It was only by chance or, rather, over a bottle of wine, perhaps two bottles, that some years later I came to work for this most English of companies. I had been working there almost a decade when the present discovery was made. I relate all this as a demonstration of unlikelihood. The papers that are about to concern us here had been lying under my nose during all that time.

They included:

1. Several military commissions, signed by George III, in the name of Captain John Hitchcock;
2. An account of expenses, totalling £53 15s. 1d., incurred by Hitchcock's funeral in 1823;
3. A blank Gretna Green marriage licence;
4. A letter, dated February 26, 1821, written by "Charlotte B—" and accompanying this, in the same hand, a manuscript of several folded leaves, which had once been sewn together to make a booklet of twenty-eight pages;
5. Another letter, which, judging from the contents and style, probably dates from the turn of the century, and is from a man, possibly a notary (his surname is illegible, but he shall be remembered by his first and middle names, Edward Tyrell), to a Reverend J. B. Watkins of St. James's Rectory, Dover; the letter, of which only the second page survives, describes the above items.

Edward Tyrell makes mention of "a curious feminine manuscript," which he might have read through were it not, he claims, that his eyes gave out by the end of the second page.

He feels assured enough in his doubts, however, to state that what he is now sending Reverend Watkins is "an imitation of the stories which eighteenth-century novelists used to incorporate in their stories—e.g., the *Memoirs of an Unfortunate Lady of Quality.*" It was to this feminine manuscript that my attentions were directed. It was, incidentally, only inches away from the open mouth of a refuse sack into which was flung anything of unimportance.

The covering letter, headed "Private," begins:

> I fear, my dear General, your first impression on opening this packet will be that I am making you an extraordinary present & that I am taking a liberty with you which an acquaintance so long suspended does not authorise.—To this I have nothing to plead but the gratification I *myself* feel, & though I am aware this could be no plea to your reason or your justice, I think it will be one to your friendship & kindness: for you have told me you still take an interest in my happiness & I am no longer of an age to be the object of *professions*—I *must* believe you—I should not, however, have chosen this time to offer you the resemblance of a form once dear to you, but for the very precarious state of my health & the desponding notions I entertain of the future.—Since I last wrote I have rapidly declined, I took cold after bathing (which it seems neither habit nor precaution will enable one to do in this Climate with impunity) & my Cough is daily becoming worse—I have not passed a spring in England since 1814 & both the opinion of my Physicians & my own feeling make me look forward with considerable dread ... God knows then how this may end—the Doctors say my lungs are as yet untouched, but that they are in so very delicate a state as to give grounds for apprehending the result of the next three months if I am exposed to the usual vicissitudes of an English climate. When my letter reaches you all this will be decided, I shall

either have escaped—or I shall be gone to that other, that *better world* where it is soothing to me to imagine I shall again meet the person I have most loved in *this* ... You have filled a large space in my humble existence—you were the first object of my affections—you have in some shape or other interested me during my whole life—if the afflictions or the dissipations of the world, my domestic duties, or my literary amusements have often banished you from my thoughts, they have never banished you from my heart. At my years & with the prospect of surviving a very few months, I can have no reason for sacrificing truth to compliment—neither have I now a sentiment of female pride to combat—in my situation these considerations fade away & I tell you with the sincerity which becomes a last assurance, that I have never felt for another what I have felt for you. I will not say that the original romance of my nature might not have some share in this strange constancy—to love without *hope*—an *object*, a Being who was become almost an imaginary one to me—one of whom I could hear only through the voice of fame; to cherish a secret passion for a man whose character & profession were well calculated to associate enthusiasm with mystery—was not only a very seducing state of mind to a girl of my disposition—but it was the most fortunate turn I could have taken—yes, my dear General, I owe to this affection that the most dangerous years of my life were protected from Vice & that I have through so many difficulties & disadvantages raised myself to a situation in society which if not splendid is honorable—& that with a very moderate fortune I enjoy more consideration than many who are great & affluent. My fear, my hopes, my wishes have followed you through a long & glorious career & there was a something of exaltation in this interest which would of itself have preserved me from debasement.

The style is pleasing enough, the sincerity of feeling unassailable, but it was not until my perusal of the following passage that something like a shudder moved through me.

> I should vainly attempt to describe the anxiety I suffered during the Mahratta War of 1803. I never could read a dispatch from India without trembling—never could I venture to read one in the presence of any third person—I believe I may reckon amongst my happiest moments that in which I once saw your name [appended] to a short report (I think of killed & wounded but I forget from whence)

for it assured me of your safety—nor did I suffer less during the Wars of the Mysore.—I now sufficiently admire the Duke of Wellington—yet when he was in India I almost hated him—I had a thousand fancies about him too silly & too womanish to communicate, but it would indeed have been difficult to satisfy me because I was at once solicitous for your glory & your preservation—I dreaded your being placed in Posts of danger—& yet if I did not hear of your being employed I was indignant—I suppose my notion was for you to acquire distinction & honors without *fighting* or *risk*—I remember being very well pleased on reading in some account that you were left with the Emperor at Delhi instead of going to Agra. Yet these were only transient accesses of Cowardice—for no woman was ever more sensible to military glory than myself—your reputation has always been as dear to me as your Welfare.—During the greater part of the years 1814–15 I was in Holland— Germany—Italy—Switzerland—God knows where & did not hear of your Campaign, nor its results till the Spring of 1816 ... The Hero of Nepaul little imagined that his early friend was on the 15th of May 1816 giving a Ball in celebration of the anniversary of his treaty after the reduction of Malown, to some of the prettiest women in Paris—But forgive me—I have wandered half over your Peninsula in recalling the tender & Constant concern I have ever felt for your safety & your fame.

It was as if the post had arrived over a century and a half late. I knew immediately from the historical details and dates, all of which were precise, *exactly* to whom she was writing. There is a single detail later in her manuscript, where proof would be absolute, where she had scratched through the recipient's name, which when held up to the light is clearly visible. "The being she idolized" was my great-great-grandfather on my mother's side, Sir David Ochterlony. Some months earlier, I had stood

beside Ochterlony's crumbling mausoleum in the haunting European cemetery at Meerut, north of Delhi, and for the past year or so I had been gathering materials on his life.

Ochterlony is one of the most fascinating historical figures to have never had a biography fully devoted to him. Although I had accumulated notes on his military career and in particular his victory over the Ghurkhas, the man himself remains one of those enigmatic figures of whom history leaves little more than a silhouette. The so-called "twilight era" of Anglo-Indian history of which he was such a fine example has only barely been touched upon by historians. The focus has been mainly either on the earlier period, Clive, for example, or the later, the Raj, but for me no period fascinates more than this one, when there was an extraordinary fluidity in relations between the English and the various peoples over whom they had economic rule. The men who ventured there in the second half of the eighteenth century were not only commercial figures but Byronic adventurers and romantics, many of whom had a love and knowledge of the culture, spoke the languages, and wrote learned books about what they saw and experienced. They included the likes of John Malcolm, Mountstuart Elphinstone and Sir Charles Metcalfe, any one of whom deserves a biography. Metcalfe, with whom Ochterlony shared a fine house at Shalimar Gardens in Delhi, and who later became Governor-General of Canada, never travelled anywhere by horse, saying it was so much easier to read a book on the back of an elephant.

I will deal briefly with the historical references in Charlotte's letter. The Mysore War of 1780–3 against Hyder Ali (and, subsequently, the French) was Ochterlony's first military action, during which time he was twice wounded and imprisoned. Under the command of Col. Thomas Deane Pearse, he had made a gruelling thousand-mile march from Bengal to Mysore, through what Pearse describes in his journal as "the shreds and fragments of a world, in Dame Nature's shop, producing nothing but sand and craggy rocks, brackish water,

and pestiferous winds." There is a gap of some twenty years before we hear from him again. In 1802, the English ousted the French adventurer, General Perron, from Delhi, where he had held considerable sway over the Mughal emperor, Shah Alam II. Shah Alam was a truly forlorn figure, a man whose position was, in Percival Spear's words, "one of vacillation punctuated by alternate lamentation and resignation to the will of God." *Twilight of the Mughuls* (Cambridge, 1951.) It is a clue to Ochterlony's character and statesmanship that when he was made Acting Resident at the emperor's court he showed every mark of observance to a man who was, in fact, his charge. Shah Alam died in 1806, still believing power was his. The defence of Delhi in October 1803 by three-thousand men against a Mahratta force of fifteen-thousand led by Jaswant Rao Holkar was without doubt a brilliant achievement. Some allowance must be made, however, for Holkar's penchant for brandy and women, for it was in pursuit of both that he paused in his march against Delhi, giving Ochterlony just enough time to strengthen the city walls. Ochterlony took the unprecedented step of personally delivering sweetmeats to his Indian troops in order that their spirits might be rallied. The Indians remembered this. When during the Great Mutiny of 1857 (Ochterlony died in 1825), the insurgents swept through Jaipur burning the British residences, the house he had lived in, one of several houses he owned, was spared as a mark of respect. The greatest achievement of Ochterlony's career, one that made him a legend in his time, was his conquest of Nepal. The running battle between him and the magnificent Ghurkha leader, Amar Singh, is worthy of an epic, or would be, were it not that such estimation is now despised. The Treaty of Malown, signed on May 15, 1815, was but an intermediary stage in a war that did not reach its conclusion until the following year.

I must confess that it is another side of Ochterlony that appeals to me more. The earliest biographical portrait I have

found of him is in Captain Thomas Smith's *Narrative of a Five Years' Residence at Nepaul* (1852), in which he writes:

> I am still less qualified to decide the moral and the theological question, which has been raised on the more delicate point of his domestic connexions. Some virtuous and well-meaning persons of both sexes, imperfectly informed on the subject, have blamed him for setting an example of what they deemed vice to the young men of the army.

When I first read this my thoughts ran to places they need not have gone. *Vice?* There is a famous Indian miniature of Ochterlony in the India Office, in London, which depicts him dressed in Indian robes, smoking a hookah and surrounded by dancing nautch girls. It is the image most commonly referred to when the discussion turns to those Englishmen who went "native." Captain Smith continues, "He retained ever afterwards a relish for nautches, and the performances of the singing men of India, which could be accounted for, in one of his general taste, only on the supposition that they awakened associations of the spring-time of life." In *The Making of the Indian Princes* (London, 1943), Edward Thompson writes: "Tradition has preserved a picture of Ochterlony's thirteen wives on thirteen elephants, every evening taking the air in Delhi, heavily veiled—a story which almost seems to carry us across the borders of folklore." I have not been able to pursue the story to any earlier sources, but I did go through the records of baptism, which are preserved in the India Office, and discovered rather more children than any one, two or three wives were capable of producing at any one time. (I was especially pleased to find a Roderick Peregrine.) It was not in the interests of officialdom to preserve the names of their Indian mothers. One name that does keep cropping up elsewhere, however, most specifically in Ochterlony's Will, is that of Beebee Mahruttun Moobarruck ul Nifsa Begume, and

it is on account of the name alone that I should like to think she was my great-great-grandmother. Also, I have always suspected there is Muslim blood in me. It is a moot point whether it was she to whom Charlotte refers when she writes, "If you married the lady who cost me so many bitter moments, whose name I could never hear without inexpressible anguish, she will scarcely be displeased at your possessing the Portrait of me at this age." I would be greatly surprised if she actually knew of the Beebee. It was not at all unusual for Englishmen to take on at least several wives, and in fact they were encouraged to do so. After all, many members of the East India Company were domiciled there for life and European women were scarce. In the early 1800s, when the English women (*memsahibs*) went out to India in droves, social mores had begun to change. The idea of an Englishman with Indian wives became unmentionable, and the likes of Ochterlony were being swept aside and the origins of their Anglo-Indian children heavily disguised.

I possess a painting of him in full military dress, probably painted at around the time Charlotte writes her letter. There is nothing much revealed in the face, a certain vulnerability perhaps beneath the stiffness of the pose, something a bit glazed across the eyes, but this could be a fanciful reading. In truth, it is probably little more than a likeness. There is a copy of the painting, which I saw exhibited not so long ago at the National Army Museum. The note beneath it stated the subject never married. I protested. I was not listened to. Accompanying my painting are portraits of two young women, presumably his daughters. The written labels on the back of them describe them as having being born the Princesses Gorgii of Greece, a country that did not exist at the time. The Greek served to disguise the presence of Indian blood, which, ironically, is easily enough discernible in the paintings themselves. A military gentleman, now deceased, who began to write a biography of Ochterlony, showed little interest in the information I had to offer him, which related to his subject's domestic affairs. I feel

sure it is an area of the life he was not prepared to counte-
nance. When I first broached the subject with my great-aunt,
in whose possession the paintings then were, informing her we
had an Indian ancestor, she expressed delight at the idea, add-
ing, "I wouldn't want to be of mixed blood, though." "Aunt
Helen," I said, "you *are*." "Oh," she replied, bringing the con-
versation to a close. I had released all thirteen elephants from
the family closet. Although the temptation, if one is a male,
is to mentally project oneself into the harem, it ought to be
remembered that in the real world of eighteenth-century India
husbands were expected to take responsibility for their wives.

When Charlotte writes her letter to Ochterlony in 1821,
and believes herself to be dying, he, nearing the end of his life,
is already a sad figure, prone to terrible depressions. There are
accounts of him quitting the dinner table in tears. The sim-
ple fact is that British rule in India had cast him to the side.
Already he had begun to become unhinged, both physically
and mentally, and in the following year he suffered a major
collapse. Also, he was crippled with severe gout. There is an
unforgettable portrait of him in Bishop Heber's *Narrative of
a Journey through the Upper Provinces of India* (1829), where
the author records a chance meeting on a bleak plain in the
middle of Rajputana. The date was July 27, 1824.

> We passed Sir David Ochterlony and his suite on his road to
> Bhurtpoor. There certainly was a very considerable number
> of led horses, elephants, palanquins, and covered carriages,
> belonging chiefly, I apprehend, (besides his own family),
> to the families of his native servants. There was an escort of
> two companies of infantry, a troop of regular cavalry, and I
> should guess forty or fifty regulars, on horse and foot, armed
> with spears and matchlocks of all possible forms; the string
> of camels was a long one, and the whole procession was what
> might pass in Europe for that of an eastern prince travelling.
> Still, neither in numbers nor splendour did it at all equal my

expectation. Sir David himself was in a carriage and four, and civilly got out to speak to me. He is a tall and pleasing-looking old man, but was so wrapped up in shawls, kincob, fur, and a Mogul furred cap, that his face was all that was visible. I was not sorry to have seen even this glimpse of an old officer whose exploits in India have been so distinguished ... He is now considerably above seventy, infirm, and has been often advised to return to England. But he has been absent from thence fifty-four years; he has neither friend nor relation—he has been for many years habituated to eastern habits and parade, and who can wonder that he clings to the only country in the world where he can feel himself at home.

Ochterlony was in fact only sixty-six years old and had been in India for forty-six years. A year later he was dead. It is melancholy to observe in what contrasting lights Charlotte imagines him.

I began to read through the pages of the manuscript to see what I could glean of Ochterlony's life, and as my disappointment rose what emerged in the absence of any news of him was a narrative of considerable power. It was now Charlotte who claimed me, and I wondered at these two lives which were linked together as though by means of a most delicate clasp. The "Unfortunate Lady" is, judging from internal evidence, approximately sixty years old at the time of writing. She believes she is dying, probably from consumption, and is now writing to the first love of her life, a boy she knew when she was barely sixteen and whom she has not seen since. The letter is studiously composed, whereas, as we shall see, the accompanying manuscript shows signs of having been hastily put together, as though the writing of it were a battle against the writer's reluctance to do so. What the manuscript lacks in the epistolary grace of the former it makes up for in directness, almost modern in tone, which gives her story its particular emotional drive. And what a story it is. Although Charlotte may not, as she claims, have conquered vanity (she loves dropping names—Lord Harris, the Duke

of Wellington, Mr. Pitt, "this vixen of a Queen [Caroline]," etc., etc.), she is, as she approaches death, free of the strictures polite society places upon her. She is remarkably frank. She has improved her station in life, through a good marriage we may suppose, but it is to where innocence took a tumble, the years 1779 to 1784, that she now returns. She wishes to make her case clear. The audience she chooses is both near and far enough to make this possible, and the audience also happens to be famous. What we have here is not simply the case of a female suppliant seeking a hero, for although she may be in awe of him, in this remembrance of someone she once knew having risen to fame there is a vindication of her own worth. We know more than she does, however. She is spared the knowledge that she is writing to a broken man. Charlotte speaks of the miniature of herself that she sends him. "You will find, dear General, that time which adds new verdure to the Laurel is fatal to the bloom of the Rose, & that while you have been gathering immortal wreaths for *your* brow, every charm has faded away from *mine*." She pictures him again as passing his life between "glory & pleasure," "between the cares of the Camp & the luxuries of the Palace." Against this she contrasts her own fate:

> With me it is very different—those days comprised the greatest felicity & the greatest misery I have ever known—when you *loved me* & when you *left me* are epochs to which I have never ceased to turn—they have been my points of comparison under every good & every evil which have befallen me—it will therefore (I repeat) be very pleasing to me to know you possess an object which may remind you of me when I am no more, & if as Gray says "even in our Ashes lived their wonted fires" my spirit will be soothed should it be conscious that I am not entirely forgotten.

The rest of the covering letter is written in some confusion and the tone becomes a touch shrill at times: "Good God,

what you must think of me, to believe that I who could so young & inexperienced resist the object of my first my fondest affections, & when I was eighteen months older, with my understanding more cultivated & a perfect notion of the consequences, voluntarily throw myself into the arms of a Libertine half mad & half fool—& who has been my ridicule and aversion." She refers a couple of times to a "Mr H—," but whether he is the above-mentioned Libertine is not immediately clear. The main thrust of her concluding remarks concerns her virtue:

> I doubtless have had many [faults] of both omission & Commission, yet it is most true—that no woman ever had more strictly the virtue of the sex than myself. I thank God that I am naturally cold—my passions have been all in my heart—an ardent love of literature—constant occupation— early disappointment—early calamity—have tended to give me a sort of disgust—to the relations of love (as it is called) & Gallantry which I have seen possess in the world ... You will see, my dear General, that I have through my life held in great dread the violent passions of men ... & such has been the impression made on me by such scenes that I never heard a profession of love however respectful & decent without shuddering & repugnance.

I took the manuscript home and began making a typed transcript straight from the page, and it was in the slow fashion, word by word, that an incredible adventure took shape.

2

> England has been stiled the Paradise of women; nor can it be supposed that in a country where the natural rights of mankind are enjoyed in as full an extent as is consistent with

the existence and well-being of a great and extensive empire, that the interests of the softer sex should be overlooked. A nation of men characterized for bravery, generosity, and a love superior to mean suspicions, must consider the happiness of women as inseparably blended with their own.

Laws Respecting Women, 1777

"IT WAS ABOUT EIGHTEEN MONTHS after your departure," Charlotte writes, "that I concluded if you had been disposed to write I might expect to hear from you." Ochterlony sailed out of Portsmouth Harbour on the *Lord North* on July 15, 1777. This much I had learned from my earlier researches. This is the date upon which we may construct a chronology of all that happens to Charlotte. She assumes, correctly, that the average run to India and back was eighteen months, and that the *Morning Post* to which she later refers would publish details of ships" arrivals and departures. She was not to know, in this month of January 1779, that the *Lord North* had sailed on to China and that it would be some weeks yet before news of its return to England. Charlotte describes how she applies for help from a Mrs. Green, the wife of a small timber merchant. We know she lives south of the Thames because she speaks of their crossing the river to go to No. 5 New Palace Yard where, Mrs. Green told her, she would find a file of *Morning Posts*. A boy meets them at the door and Mrs. Green explains to him that the man at whose house they are is a family friend and that their purpose is to see the *Morning Posts* that are kept upstairs in the drawing room. She then leaves Charlotte to go through the papers, saying she has to go to Bridge Street to do some errands.

I had not the slightest suspicion. Lights & Coffee were brought by the Boy & the Coffee being already poured out I took some—almost immediately after I accidentally opened a Book (for at that time I was ignorant of all the etiquettes

which forbid looking at Books) & to my great terror I saw
Mr H—'s name—Still I did not suppose I was in his House
(for I knew he lived in Parliament Street) yet I was alarmed
& began to examine the room—on the chimney piece was
a trinket which I had refused the day before—I no longer
doubted where I was—my Head began to be heavy, & bewil-
dered & terrified I flew to the door with the intention of
getting away—at this instant this wretched man entered—I
screamed dreadfully & I know not how it happened but in
a violent effort to reach the door I struck my head: in an
instant I was deluged with blood from my nose & the blow
& the Laudanum together deprived me of my senses—oh
General—what monstrous passions must a man feel who
could abuse such a situation—I never think of this without
an indescribable sensation of disgust & horror—.

Within the space of a few lines Charlotte describes not only
her rape, by the aforementioned Mr H—, but also her acci-
dental opening of a book. I do not wish to muffle the terrible
blow she receives, but the aside is a fascinating one. The read-
ing of novels, and especially "fancy works" as Charlotte calls
them elsewhere, was not recommended for women. Steele
notes, "insensibly they lead the Heart to Love. Let them there-
fore […] be avoided with Care; for there are elegant Writers
enough on Moral and Divine subjects." The *Spectator* warned
women against reading novels, which, along with chocolates,
and especially in the month of May, were believed to inflame
the blood.

It was many hours before I became sensible of the outrage
I had suffered—on first coming to myself—I was strongly
convulsed—my Head was swollen—my white dress cov-
ered with blood & torn to pieces—my ankle sprained, one
of my arms bruised—it is impossible to imagine a more
pitiable object—my mind was a chaos of misery & I was

in extreme bodily pain—I recollected too the alarm of my
poor Mother—I was distracted by every sort of anguish—
but I was helpless—I could not even turn on the soffa
where I was placed—I sank again into a state of torpor &
was put to Bed by a woman who I found afterwards had
been in no way accessory to my sufferings—I saw no one
else & Mr H— did not venture to approach me—but he
began to be terrified at the state I was in—yet did not dare
to call in medical aid.

She describes in some detail how over the next few days she
sinks in and out of consciousness and is then removed, by
carriage, to another place where she is tended to by medical
people. She recovers just enough for her to be able to decide
she will inform the physician of her plight, but no sooner is
she ready to do so than he is mysteriously discharged.

While I was planning some means of escape Mr H— came.
It was a dreadful scene—he deplored his violence—offered
every sort of reparation—acted one moment like a Madman
the next like a person really penitent—he had brought a small
Bible with him & Pistols—protesting if I would not take an
oath to conceal what had passed that he would shoot him-
self—this I refused—but said if I should have some Books &
work I would remain & consider of it. The Books & needles
& threads were brought me & after cutting out capital letters
to compose Mr Beaufoy's address I sewed them on a blank
leaf—together with my own name—& a sentence descriptive
of my situation cut from the Prayer book which I had desired
to have. This paper I found means to give to the Apothecary
who I learned after was a Mr Saunders of St James's Street—
he had probably remarked something extraordinary & read-
ily went to Mr Beaufoy—proper authority was immediately
obtained—& Mr B—'s carriage & Housekeeper was sent to
take me away—for the people of the house made no resistance.

What follows is a lengthy description, fascinating to any student of legal history, of the charges that are brought against Mr H— and how the prospect of seeing him hanged, together with the humiliation she would feel in becoming an object of public scrutiny, results in the charge being changed from a criminal to a civil one. Mr H— is made to give his word of honour that he will never attempt to see Charlotte again. And now follows a "peaceful" interlude during which time her mother dies. Charlotte is provided with a servant and she resumes her studies. What happens some months later is enough to make the sceptical reader scratch his head a little.

One Evening about ten o'clock just as I was preparing to go up stairs—the servant made a pretext of some Household want for the morning to go out & returning hastily she said there was a great fire up the street which she believed was at Mary Belson's the woman who had nursed me & of whom I was very fond—instinctively almost I put on my cloak & ran out with the maid—there was in fact the light of a fire but at a great distance—but she drew me to the water side saying it was quite *visible* from thence—in an instant I was muffled in a Boat cloak—put under a tilt & rowed off into the Thames—the whole was so rapid—so sudden—that I am not sure I even screamed & I had [reached] Westminster Bridge before I could disengage my Head & mouth—so as to beg the men to put me on shore—they were very brutal fellows & only muttered something about "Women running away from their Husbands"—the only person in the Boat besides the rowers I could discern was a Mulatto who kept telling me I should not be hurt. I was excessively terrified, for my idea was that they were going to drown or to murder me in some way—it was in vain I cried & entreated—there were no Boats about at that Hour & when at last I was landed in a lone place I expected no other than that the Mulatto was going to assassinate me—so that when I was hurried into a

carriage it was rather a relief to me [than] otherwise. A few minutes brought me to the back entrance of a large Mansion situated in the midst of pleasure grounds—I saw no inhabitants but a grey headed man & his wife who took me up stairs in a state of passive terror—for I was really as much astonished as frightened—I had made an attempt to call for assistance in coming from the water side but if you recollect the *locale*—you will know it must have been useless ... A paper was put in my hand which I saw was Mr H—'s writing, conjuring me to tranquilize myself for the night & protesting I should meet with no molestation—I found there was no remedy & hoping to get away in the morning & my cloaths being very wet & draggled by my struggling in landing I consented to go to Bed & have them dried. The room was covered with a sort of fresco paper representing the ruins of Ancient Rome & after fastening the Doors carefully I lay down, & worn out & harassed I sank into an uneasy slumber—but I had scarcely forgotten myself when I was awoke by the opening of a Door at the Head of the Bed—it formed the representation of an Archway in the Campo Vac[c]ino & unless closely inspected was not visible—so that it had escaped my search—you will imagine—what it would be so painful for me to trace. Suffice it to say that towards morning in some effort to escape I was thrown from the Bed on the corner of a chair & one of my ribs broken—I fainted from suffering & was for three months attended by a surgeon, a Mr Churchill (the brother of the poet) in a nervous fever.

It is time to take a pause. Although I believed what Charlotte wrote—in the way one senses a story too outlandish to be true must be true—the many questions raised here demanded answers. I would accept nothing I believed. It was fortunate that Charlotte provides so many clues, for there is barely a page of her manuscript on which she does not mention a name or a place. These I realised would need to be verified.

A hundred facts do not constitute a true story, however, and truth may be composed of many smaller fictions. It would be the rare author who did not, to some extent, reinvent his own life; verity becomes version; yet in Charlotte's account there is remarkably little speculation. The events she describes are dramatic enough to survive her own interpretation of them. Charlotte is at the mercy of "a libertine half mad & half fool" whom she refers to throughout as "Mr H——." What she gives us with much economy of language is a character so exquisitely demonic as to make us wonder whether she did not invent him. Fortunately, she provides the two addresses where he lived—5 Palace Yard, Westminster and Peterborough House near Parsons Green, which was then outside London. She mentions in passing that this last, her "magnificent Prison," was once "the haunt of Pope & all the Wits of that day." If I were to prove her story true much depended on my being able to identify the inhabitants of these two houses. The local history library in Fulham was the obvious place to go.

I asked the librarian in Fulham about Peterborough House. She looked through her records and found a small file. I asked her where the house was, for I was determined I should visit the place, but she informed me it had been demolished. She pulled out some descriptions of the place, first John Bowack's in his topographical guide, *The Antiquities of Middlesex* (1705), which describes Peterborough House thus:

> This seat is a very large, square, regular pile of brick, and has a gallery all round it upon the roof. 'Twas built by a branch of the honourable family of the Monmouths and came to the present Earl in right of his mother, the Lady Elizabeth Carey, Viscountess De Aviland. It has abundance of extraordinary good rooms with fine paintings, etc., but is mostly remarkable for its spacious gardens, there being above twenty acres of ground enclos'd: the contrivance of the grounds is fine, tho' their beauty is in great measure decay'd. And the large

cypress shades, and pleasant Wilderness, with fountains, statues, etc., have been very entertaining.

A watercolour of the house, done in 1794, which the librarian showed me, suggests that the house had not changed much by Charlotte's time. The walls were sparkling white and the roof a handsome blue. It was there that Charles Mordant, Earl of Peterborough, lived until his death in 1735 and, yes, entertained most of the literati and wits of the time including Addison, Swift, Pope, Locke and Bolingbroke. Swift makes reference in several of his letters to the hospitality he received there and even wrote a poem beginning,

> Mordanto fills the trump of fame,
> The Christian world his deeds proclaim,
> And prints are crowded with his name.

In 1727 Voltaire spent three weeks there, and, to make matters curiouser, it was only a stone's throw away from the villa where Samuel Richardson lived from 1758 until his death in 1761. The depiction of oppressed heroines was, of course, Richardson's forte. I asked the librarian who lived in the house.

"Why, the Earl of Peterborough, of course."

The fourth Earl, also named Charles, lived at Peterborough House until his death in 1779. It seemed just then that Charlotte's story was about to collapse.

"No, wait a minute," the librarian said, pulling out some further bits of paper, which included an advertisement for the house, now owned by Robiniana, Countess Dowager of Peterborough, to be sold by private contract by Messrs Robson & Harris of Lincoln's Inn.

A Freehold capital Mansion House
with the spacious and convenient outhouses, offices, stabling for 12 horses, dairy, dog kennel, very extensive pleasure

grounds tastefully laid out, and large kitchen-garden, well cropped and planted with the choicest fruits, hot-houses, green-house, ice-house, and fruit-house, with exceeding rich meadow lands, close adjoining; the whole containing above 40 acres.

"Yes," the librarian continued, "it says here that Peterborough House was sold in April 1782 to Richard Heaviside, a timber merchant. He lived there until 1795 and he sold the house, in 1797, to a John Meyrick who demolished it and replaced it with a second Peterborough House."

Heaviside, *Heaviside*.

The name was almost too good to be true, the very stuff of Restoration comedy. "H" for *Heaviside*. I must allow for coincidence, I reasoned, and besides, the dates, according to my first calculations, fell a little late. I had reckoned the year of Charlotte's first misadventure to be 1780 and her second one a year or so later. My next step was to check the Fulham rate books, and there, in the column for July 27, 1781, Heaviside makes his first appearance. So he had been living there, possibly as a lessee, prior to the sale. According to the rates he paid, £17 16s. 6d. (a figure exceeding even that exacted from the bishop), he must have been one of the wealthiest men in the borough. The rate book for the previous year indicates "empty or occupier," so Heaviside could have moved in at any point after July 1780. It should be noted, too, that the names of ratepayers were entered in the books well in advance of monies being collected. I now had a Mr H— in the right place at the right time; all I had to do now was check the Palace Yard address. The Guildhall Library holds old business directories. A 1782 edition lists Richard Heaviside, timber merchant, Palace Yard, Westminster. Also, during these researches I identified many of the people she mentions in her narrative, Mrs. Green who led her to Palace Yard, for example. The *London Business Directory* for 1778 lists Thomas Green, timber merchant, of

Cuper's Bridge, Lambeth, which would have been very close to where Charlotte lived. Mark Beaufoy, a Quaker from Bristol, was a vinegar merchant in Cuper's Garden. He began his career by distilling hard liquor but was so appalled by Hogarth's depictions of Gin Lane that he turned to the making of "mimicked wines" and vinegar. John Dunning was one of the most outstanding lawyers of the day. The poet Charles Churchill gave his younger brother, John, financial assistance to train as a surgeon. These are just some of the names that I was able to identify over the following months.

I had identified Mr H— more easily than Charlotte may have wished anyone to. Perhaps justice has been done. Does she spill more clues than she means to, or is she mischievously spreading them? I suspect that she is, despite the years closing over her and despite her obvious intelligence, uncommonly naive. It is this very combination of strength and vulnerability that makes her so attractive a figure. There is no secret that so breaks as the one most tightly reined in, but we must remember she is writing not for literary detectives but privately for a man she once and perhaps *still* loves. She struggles with the problem of what not to include in her narrative—that which most pains her, that which the world should not accidentally see and that which would mean little to someone as far removed as Ochterlony is. The joke on her is that she unstitches her own secrets while making them.

So where did we leave Charlotte?

> Surely General, sorrow does not kill or I must have sunk under these accumulated afflictions—I can hardly imagine a more desolate, a more forlorn creature than I felt myself at this time—I no longer complained—I no longer wept— my heart was half broken—the elasticity of my mind destroyed—& helpless & despairing I submitted to whatever was deemed necessary for my preservation. Mr H—'s mother was extremely kind to me, Mr Churchill really acted

like a father, he brought his daughters to see me, & so interested one of the most respectable families in the Vicinage for me … all this while the evil genius of my life behaved very decently—never attempting to see me alone, & I lingered on in this strange situation till I was confined. On my recovery my position was changed & I now had a new embarrassment—I knew not where to go or what to do—I confess to you, though it is contrary to all experience, all one has read or heard of, that this offspring of fraud & violence did not inspire me with the maternal tenderness of which I *have* an idea—it was associated with degradation & misery & what I felt for it was rather pity than fondness & I deemed it a moral duty to preserve it if I could (for it was a female) from being as wretched as myself. I did not nurse it—& it was only brought to the House occasionally—I had bribed the woman who nursed me to send letters to my father & Mr B— but I could receive no answers, for I found after that the woman had betrayed me. Not knowing this I concluded I was given up—and at last I made a species of arrangement with Mr H— by which he agreed never to intrude on me, or to bring me any visitors—I had a wing of the House to myself—sombre groves & bright Parterres—music— Books—whatever I desired … I was become wild, savage as it were, & could not often be induced to receive anyone.

Clearly, she was living in a strange situation. With time, however, Heaviside returns to his old tricks.

I was at times also subject to frantic intrusions from Mr H—. He was leading a very dissipated life—he endeavoured I believe to forget me & the atrocity of his conduct together, but it is certain he entertained a passion for me little short of insanity & which probably my coldness & aversion tended to encrease. He was once dangerously ill & made a Will by which he bequeathed me the whole of his property but

THE PEBBLE CHANCE 

nothing could conquer the dislike, the horror (I may say)
with which I beheld him.

What are we to make of Heaviside? What is his problem?
A man so absolute in what he does is not without interest,
possibly charm. This is not to excuse him, his crimes are hei-
nous, but the risks he takes to secure Charlotte are so immense
that in the end even her father is silenced. Heaviside must
be judged in his time, and although the noose might have
spared Charlotte much sorrow, there is little doubting his
ardour. He lies, he cheats, he breaks bones, but otherwise he
is prepared to give Charlotte what he thinks she desires, even
the education she so highly values. Dissipated he may have
been, but Heaviside manages to keep the books balanced. He
was an immensely successful merchant, and as such was part
of a social phenomenon then taking place. The merchants
quickly rose to power, social barriers were broken, and upstart
traders moved into grand houses. Heaviside, about whom I
learned little, was born in 1754 in Bishopsgate. His father was
a saddler of some repute. The son moved into timber. And
into politics too. In the 1780 General Election he ran in two
constituencies and lost in both. At some point he was made
Justice of the Peace, a position that had more to do with local
prestige than actual justice. In 1800 he married Elizabeth Ann
Proctor. A son was baptised in 1804. Richard Heaviside died
in 1815. He was, in terms of the social framework we have put
him into, typical of the age. Whatever else he was, Charlotte
has made him flesh and blood.

Now comes a critical turning point in her life:

> In this way I went on for more than two years till the Child
> died & I had no longer any reason for remaining ... I then
> began to affect a desire to see plays & operas & to have val-
> uable trinkets to appear at them—I pretended fancies for
> things which I had never worn or wished to wear, until in the

course of a few months I procured enough for my purpose. Being now so far supplied as not to have the appearance of wanting to beg or borrow, I related the whole of my story (which they had never heard from me) to Mr & Mrs S— & entreated their assistance in finding me some cheap place where the produce of my trinkets would support me for a year or a year & a half till the first search & the first rage of Mr H— should be over & I could claim the annuity. They entered into my project with the most benevolent Zeal & one of their friends, a woman of fashion who was then on a tour of pleasure, found & took for me a small cottage in Glamorganshire between Neath & Swansey & for which Mrs ——— insisted on paying the first year in advance.

She makes her escape and then begins a blissful interlude. I was to have one rather less so. I had already made considerable advances in my research, even though it had been barely two weeks since the discovery was made, but there were gaps in the typescript I prepared, certain words which, no matter how hard I teased them, resisted decipherment. Whose property, I wanted to know, should have sunk in the Bay of Bengal? Which Roman Campo was depicted on the fresco of a certain bedroom? Who was the Frenchman the guillotine took away from Charlotte? Whose house was supposedly in flames? I passed the manuscript to my colleague, John Byrne, who is an expert in autograph materials and whose eye is much sharper than mine. Meanwhile, I had written to the three Heavisides in the London telephone directory, asking them if they could supply me with any biographical information on this figure who might have been an ancestor of theirs. Surely, I reasoned, Heaviside was not a common name. I may have gone too far, but my fascination was such that I was now willing to go trampling through the private gardens of complete strangers. Only one Heaviside answered: "Thank you for your letter. I am 71 years old, born Londoner. My father was originally born

in Durham City. His father was in a wealthy iron business in Darlington. He, like the prodigal son, left home & came to London about 1900. He married an actress. They had a son. She died, then he married my mother. Yours faithfully, _____."

Monday morning I was back at work and found myself wading through the silences of my colleagues. There was something they were not telling me. A few minutes later John Byrne walked in and all was made clear. There were cuts and bruises all over his face. The previous Thursday evening he had been brutally set upon in Pimlico Road and left bleeding in the middle of the street, and he had had taken from him the black leather bag containing the original of Charlotte's manuscript. This was, in terms of what matters to me, a loss beyond loss. It seemed a mocking irony that from the violence of one century Charlotte should have disappeared violently into this. My wife drove around Pimlico in a futile attempt to find a discarded black leather bag. She even peered into the courtyard of one of the nearby housing estates. I sank into a kind of despondency. That week I dreamed about the manuscript, it must have been several times, and in those dreams I saw only the written pages, nothing surrounding them. I struggled with a memory of the shaped peculiarities of Charlotte's hand, and one night a *P* turned into a *V* and the word Vaccino came into focus. The next morning I consulted a plan of Ancient Rome, something I should have done in the first place, and there it was, the Campo Vaccino through the frescoed representation of which Heaviside made his dramatic entrance. Still, despite various other small mysteries I solved that week, there was the underlying knowledge that gone forever was the proof that such a manuscript had existed in the first place.

I had resigned myself to the loss of Charlotte, and I had even persuaded myself that recent events were merely a continuation of the same evil that had befallen her. The mind constructs its own mysteries—it does so for the sake of coherence

sometimes—and in a curious way I found myself not wishing to find the manuscript. I was to feel the same way when later I fretted over who Charlotte might be. Would I be puncturing the mystery? I think in both instances I was proved wrong, for no sooner is one mystery solved than another is made. The detective story with all its loose ends so neatly tucked in is for sophisticated simpletons. The truth is always odder.

Charlotte, now aged twenty, describes a period of peace:

> I lived in a sort of enchantment & there was nothing great or glorious which my fancy did not ascribe to you—& this is so true that your image is even now as much connected with the Bay of Briton Ferry as with the scenes in which I really saw you—in which I first loved you. It was here too my habits or order of arrangement & study were formed such as they still continue—my homely breakfast of herb tea or milk and bread was always decorated by mountain flowers—& the repast which I called dinner & which was seldom anything more than Potatoes an Egg or Oysters was served with all the ceremony of a dinner *en règle*. I dressed regularly with as much neatness as though I were to be seen—rose as early as though I had a thousand occupations & bathed in all weathers twice a week—in this inoffensive way I lived above a year— the poor people were much attached to me, for though I had nothing to give I worked for them & when they were ill often cured them by simple remedies—I met with no sort of evil or embarrassment, the natural energy of my mind kept me from ennui & I had a good collection of books—Johnson's Poets— Hume—Gibbon, Robertson & many of our best authors both in History & ethics. But alas a Cloud was fast approaching which must soon change this serene sky to gloom.

Charlotte is down to her last ten pounds, her father and Mr. Beaufoy, both perhaps under the influence of Heaviside, no longer support her, she speaks not a word of Welsh and

although she could teach she cannot bear the idea of being "surrounded by *dirty* children." She returns to Peterborough House where she is placed under the protection of Heaviside's mother who stipulates that her son remain in Kent. Arrangements are made for her to go abroad to a convent. Soon enough, however, her oppressor returns.

> Moreover the ungovernable passions of Mr H— rendered the House often a scene of nightly disorder—for in these frenzies he would break open the doors—get in at the windows & commit all sorts of outrages—so that I was often obliged to make one of the maids sleep in my room.

At last, and here I will spare the reader the complexities relating to her obtaining an annuity, she makes her escape. "Thus, my dear General, I have brought you through the most melancholy part of my History … my residence in the Convent— my Marriage—& all the subsequent events you may (if I live) learn by degrees—." The ending is not wholly satisfactory, all sorts of loose ends are left dangling in the air, but then this was never meant to be literature.

A week after the loss of the manuscript, John Byrne received a phone call at work. It was Westminster police station. A policeman discovered a black leather bag in an open space in the middle of a housing estate just down the road from where the mugging took place. It was the very place where my wife had a brief look. It had been lying there for several days in the rain and not a single person was curious enough to investigate. I heard John Byrne ask after the contents of the bag. The bag itself was in a sorry state and all the papers inside had been either torn to pieces or else seriously damaged by water. Well, *almost* all of them. Charlotte's manuscript, because it had been tucked in between a copy of *The Times*, and because it was written in iron-based ink on handmade paper, was barely affected.

Quality is a passport to permanence.

3

—at last it occurred to me that if I could see a file of news-
papers I should learn if any Ships had arrived—

WHILE, DURING THE FIRST MONTHS of their separation,
Charlotte was going through experiences that would forever
alter the course of her life, the young man who left her was
going through various twists and turns that would forever alter
his. To explain how will require a certain amount of backtrack-
ing and also, on the part of the reader, a submission to the
curious workings of fate.

Ochterlony was born on February 12, 1758 in pre-
Revolutionary America, in Boston, in the very house where,
some years later, Paul Revere would pause on his famous
ride. His father was in the merchant service. At some point
David senior fell in with one of London's underworld fig-
ures, Laughlin Macleane, "distinguished in his day, it is said,
for great abilities and lax morals." There is even a school of
thought that he might have been the author of the extraordi-
nary "Junius" letters. An associate of his would later write, "If
he involved others he only did to them what he did without
mercy to himself." Macleane's biographer[1] writes:

> He was a scoundrel with a host of faults, but a likeable
> scoundrel; and his courage was beyond doubt. The key to
> his character was his stutter. It drove him on, and, at the
> same time, held him back. Unlike Burke and Wilkes, who
> could dominate large gatherings with their golden-tongued
> eloquence, Macleane was almost inarticulate. With such a
> limiting affliction he had no hope of succeeding in the wider
> political arena, and so he exercised his talents in the shadows
> of the underworld.

[1] James N.M. Maclean, *Reward is Secondary*, Hodder and Stoughton, 1963.

Macleane had gone to America, perhaps to escape his associa-
tion with a highwayman, his very distant relative, James, who
was hanged at Tyburn. His biographer notes, "People added
two and two together and made five." In America, in the com-
pany of his enormously fat and dumpy wife "devoted to a lap-
dog of swollen proportions which waddled along in front of
her," he took up the role of military surgeon and was not a
bad one at that. After all, who, back then, needed experience?
It was during Macleane's American period that he borrowed
money from Ochterlony's father. David senior died suddenly
in 1765 leaving his family almost destitute, and Dr. Macleane
was seen no more.

Soon after, the young Ochterlony went to England where
some years later his mother remarried. He went to work for his
stepfather, Sir Isaac Heard, at the Herald's Office in London,
although there he could "never give his mind to the art and
mystery of blazoning coats of arms." Somehow he came
into touch with Macleane, who by now had become Under
Secretary of State and First Commissioner for the affairs of
the Nuwab of the Carnatic. Although he still did not have the
money to discharge his old debt, he offered to place the son
of his creditor in the service of the above Prince at Madras.
Ochterlony, eagerly accepting the offer, was taken for a short
time into the Commissioner's Office in order that he might
learn the forms of Indian business. It was during this time,
one supposes, that he met Charlotte. On July 15, 1777, he
sailed out of Portsmouth on the *Lord North*. Some eight or
nine months previously, Macleane had gone ahead to Madras.
It is here that I invite the reader to fix his eyes on the globe,
imagining the *Lord North* on its journey from England and
HMS *Swallow*, the naval sloop Macleane was on, making its
journey from India. The two ships met up at Cape Town in
November. It was a fortuitous meeting because there Macleane
furnished Ochterlony with recommendatory letters to the
Nuwab and other people of influence. One might well ask

why Ochterlony had not been given these before, for they were absolutely essential to his welfare. Anyway, Macleane would appear to have made good his promise. And it was there, in Cape Town, that Macleane had an uncanny premonition of his death. "Considering the Perils of the Seas," he immediately sat down and made out his last will and testament, a gloriously eccentric document in which he makes provisions not just for his wife but for Margaret and Jane Satterthwaite, one or both of whom, sisters presumably, were mothers to his children. The HMS *Swallow* set sail on St. Andrew's Day and bobbed upon perilous waves while, in London, Charlotte swam against another tide. On June 10, 1778, Laurence Sulivan, MP, sent a letter to Lord Hastings: "All hopes of Macleane are now at an end, as we have heard from the Brazils and all parts of America, but no account of the *Swallow*. At first I lamented his loss as a heavy misfortune, to myself particularly. I have now some reason to change that opinion, and perhaps his death has saved me an increase of misery ... I built too much on his remembering what he owed me." Hastings wrote to Elijah Impey on August 10, 1778, "Poor Macleane! It was believed in England that the *Swallow*, a crazy ship, foundered in a great storm in February." As his biographer writes, "In the end it was not a man but the wild elements that defeated the tough, brave, corrupt old roué."

Ochterlony, meanwhile, quite unaware of his shady bene-factor's fate, sailed on to Madras. And it is here that Captain Thomas Smith, in his *Narrative of a Five Years' Residence at Nepaul*, picks up the story:

A Chief Justice, who happened to be his fellow-passenger, accommodated the cadet on landing in the East; but falling in with another young officer (afterwards the Honourable Sir Thomas Maitland), they visited some place of public resort of that time, which was probably not as respectable as the modern clubs and hotels at the Indian presidencies,

since it is certain that the destined conqueror of Nepaul there had his pocket picked of the letters which the commissioner [Macleane] had written to get him established, until he should make his fortune in peaceful employment.

Ochterlony, so quickly a novice in the ways of nautch girls, went to the various offices of the Nuwab, at which he was informed there was no need for his services. The letters of introduction were forever gone and so too, although Ochterlony was not to know this, was Macleane. The only thing left for him to do was to proceed to the Bengal where he would await a fresh set of letters from England. In the meantime, so that he might survive, he joined the army of the East India Company. Little did he realise that he would wait forever. It is extraordinary to consider how Macleane, even in death, had been the determining factor in both Ochterlony's and Charlotte's lives.

<center>4</center>

On some fond breast the parting soul relies,
Some pious drops the closing eye requires;
E'en from the tomb the voice of Nature cries,
E'en in our ashes live their wonted fires.
 —Thomas Gray, *Elegy written in a Country Churchyard*

THE SEARCH TO DISCOVER Charlotte's identity was not an easy one. At one point I had her eloping to Gretna Green with the notorious seventh Earl of Barrymore (a worthy successor to Heaviside). I never did get to the bottom of that blank Gretna Green marriage licence. I contacted the Bristol Record Office to find out who lived at 7 Pritchard Street and was informed that it was a Mrs. Rachel Biggs. This, I assumed, must be the relative Charlotte mentions in her narrative. "B—" was for *Biggs*. A friend of mine, Wendy Saloman, confounded matters

somewhat by turning up a will in the name of Rachel *Charlotte* Williams Biggs. The path from one Charlotte to another is too labyrinthine to retrace, especially in an age abounding with Charlottes, and, quite frankly, I could not have strayed further in my researches.

A couple of months later, I checked the British Library Manuscript index under "Biggs" and found an entry for some letters from a Mrs. R. C. Biggs to William Windham (1750–1810), who was a leading statesman and secretary at war under Pitt. When the letters arrived at my desk, I saw immediately they were in Charlotte's hand. So the Rachel Biggs at Pritchard Street *was* indeed Charlotte. I suspect that after she made her final escape from Heaviside she reverted to her original first name as a kind of subterfuge. She may have been the Charlotte Williams, daughter of John and Mary, who was baptised at St. Sepulchre, Holborn, on December 10, 1761. There were Williamses everywhere, and nothing regarding them is absolutely certain, but a John Williams paid rates in Lambeth and a Mary died there in 1780.

The letters to Windham date from 1800 to 1806 and their contents are not immediately arresting. "I have hitherto been so fortunate as to live in a domestic retired way," she writes, "and nothing would distress me more than to be thought a Person of literary pretensions by my neighbours." The address she gives is Farrington House "at least eight miles from Wells, & out of every road except that to Bristol," and the correspondence begins, unpromisingly, with a proposal that gamekeepers' licences be raised. I shuddered to think that between her and the days of Heaviside there had been only acre upon acre of rural stuffiness. This was not the way for my story to go. When I got to the third letter, however, something wholly unexpected began to emerge.

> The character of a female author, or female politician is not in my opinion calculated to create favourable impressions &

it is certain that the situations I have been placed in, and the circumstances of the times only, could have tempted me to engage in pursuits of so unfeminine a nature.—It was impossible for any thinking person to witness (as I have done) the effects of the french Revolution, without feeling a deep & animated hatred against the principles which produced it, & in endeavouring to inspire others with the sentiments I had imbibed myself, I have neglected no duty, & have only devoted those hours to my country, which I am at liberty to devote to amusement.

She then describes how, on her return from France in the summer of 1795, she made attempts to get a manuscript published.

I apply'd in consequence to Mr Stockdale as a person I understood to be favor'd by Government, but I received only an impolite & repulsive answer and my work which I had exposed my life in writing, after having been discovered & detained at Dover, as probably seditious, & rejected with disdain by the bookseller as anonymous, was consigned to obscurity.—Alarm'd however at the supineness I observed in the rich, & indignant at the seductions practiced on the poor, & with a spirit perhaps imbittered by what I had recently seen & suffered in France, I devoted my leisure to conveying through the public prints such facts & reflections as I hoped might (tho' in ever so small a degree) tend to counteract the attempts then making to corrupt & ruin the Country.

During the course of her correspondence with the *True Briton* newspaper, she mentions having come to the notice of John Gifford.

John Gifford (1758–1818) has done rather poorly in the literary stakes: he has been described as "a dull dog" and "a feeble scarabaeide," and his massive political life of Pitt gathers dust on library shelves. He was born John Richards

Green, but after squandering a huge inheritance fled to France where he changed his name. When he returned to England he became a government pamphleteer and, later, founder and editor of the *Anti-Jacobin Review and Magazine*. As a reward for his political services, he was made a political magistrate. It is a particularly cruel fate to be remembered as a bore, and redemption, however slight, must come to him who took up Charlotte's cause. I rushed to the British Library Catalogue of Books but found nothing under Biggs to fit the description of a book about France. I then checked under "Gifford, John" and there I discovered *A Residence in France, during the Years 1792, 1793, 1794, and 1795; described in a Series of Letters from an English Lady: with general and incidental Remarks on the French Character and Manners, Prepared for the Press by John Gifford*, published by Longmans in 1797. Charlotte, it appeared, had escaped Heaviside only to be caught up in the French Revolution.

The reason she gives for not putting her name to the book is that she fears for the safety of those people she knows still living in France. While there is little doubting her integrity in this matter, I cannot but suppose that anonymity must have suited a woman so deprecating of her own abilities. When she writes to Windham of the mediocrity of her talents, there is, I suspect, rather more here than just the usual apologia of the age. Although the book went into a third edition in the same year, its reputation did not survive beyond this final round of applause. Subsequently its authorship has been attributed to Helen Maria Williams, a lady of distinctly Jacobin sympathies, and in some instances to Gifford himself, although it is obvious that his blue pencil barely touched its pages.

"Most of these letters were written in the situation they describe," she explains, "and remain in their original state." It was then fashionable to address a subject in the form of letters, and here the artifice, if that is what it is, works to great advantage. Charlotte writes in a style that is immediate, and, as the

Jacobins rise to power, the French scene she describes gradually darkens. "Our society consists mostly of females," she writes, "and we do not venture out, but rather hover together like the fowls of heaven, when warned by a vague yet instinctive dread of the approaching form." As the printed text runs to almost a thousand pages, concealment of the manuscript must have been a problem. In one extraordinary episode, during which armed men search Charlotte's room, she distracts them "with the sight of a blue-bottle fly through a microscope" while a servant removes some letters which had been lying on the table. She manages to keep writing even through her imprisonment in Arras—yes, she comes close to losing her head—but this is a story which needs to be repeated in her own words elsewhere.

If the writing palls at times, it is because Charlotte constantly analyses. She is motivated above all by a duty to explain to the English people the causes and effects of a revolution they might be otherwise tempted to imitate. As such her remarks are a testament to her mental vigilance, but the sense of *being there* is conveyed to us most vividly in those passages where she simply observes.

> The belief in religious miracles is exploded, and it is only in political ones that the faith of the people is allowed to exhibit itself.—We have lately seen exhibited at the fairs and markets a calf, produced into the world with the tri-coloured cockade on its head; and on the painted cloth that announces the phaenomenon is the portrait of this natural revolutionist, with a mayor and municipality in their official scarfs, addressing the four-footed patriot with great ceremony.

Her analysis of the French psyche borders on the tedious at times, but she manages to make those who are her companions come alive. Madame de———, "who rouges, and wears lilac ribbons, at seventy-four," tries hard not to look like an aristocrat.

She dons revolutionary attire, but is unable to travel anywhere without her pet canaries, some exotic plants, a lapdog and a cat, and two servants to take care of them. I rather hope she survived. Despite my reservations, and these are probably of a meanness shaped by literature, the book is, in many respects, remarkable.

I sought some kind of link between these experiences and her earlier ones, and found it in her mention of the convent she went to after her final escape from Heaviside. She is imprisoned in Arras with a friend whom she says she first met some years before at the Panthemont in Paris. This, according to one source, was one of the most aristocratic convents in France, "*un immense hotel garni' ouvert aux femmes de la première distinction.*" It was inexpensive, had a huge library, and it was undoubtedly there that Charlotte furthered her education. Much mystery still surrounds Charlotte. Only once, in her correspondence with Windham, does she mention a husband: "Mr. Biggs has been lingering above eighteen months & is now in so deplorable a state that my only hope of his surviving the Winter is taking him to a milder climate … There was a time when Peace with the French Emperor would not have been remembered in my orisons, but I confess I am little of a Heroine & think more of my Husband than my Country." The correspondence with Windham stops there, with this one and only mention of the husband who for now must remain a shadowy figure. Six years later, on 15 May 1816, presumably widowed, she is in Paris throwing a ball in honour of Ochterlony. What was she doing there so soon in the wake of Waterloo? Was she one of the fashionable ladies who followed the war almost to the brink of battle? In 1821 she is in Pritchard Street, Bristol, and the only other record I have found is that she died in a Versailles lodging house on February 24, 1827.

Not too long after he had been constrained to resign his high political office, and while planning a return to England,

Ochterlony died in Meerut on July 15, 1825. One account has him turning against the wall, muttering, "I have been betrayed." Richard Heaviside died in 1815. A couple of years after the discovery of Charlotte's manuscript, while wandering through Bath Abbey, I noticed a tablet on the wall dedicated to the memory of Richard Heaviside.

HUJUS COLUMNAE SEPULTUS EFT AD PEDEM, RICARDUS HEAVISIDE ARMIGER. IN AGRO DUNELM NATUS, QUI BATHONIAE OBIIT 12MO APRILLIS, A.S. MDCCCXV. AMUM AGENS LXII R.I.P.

Bristol, Bath. Mr H— had remained geographically close.

A Meeting with Pan Cogito

THE ANTHOLOGIST AND I went to Oxford in May 1980 to hear Zbigniew Herbert give a reading of his own work. There was, of course, no guarantee Herbert would do so, for he was of a famously contrary nature. Christopher Middleton told me of a reading he had attended in Berlin, where Herbert, instead of reading his poems, pulled a passport from his pocket and then recited its contents page by page. He did read his poems in Oxford, rather dully, I thought, almost with disdain for them or perhaps for himself or even for his audience. So flatly did he read, there may have been in him a distrust of the lyric voice. Also he might not have been in the best of health for he moved slowly and with what appeared to be considerable pain. We sat with him for a while and then, barely raising his eyes, he muttered, "Here comes my worst enemy. He claims I am his friend." It was the Marxist philosopher Leszek Kołakowski with his famous glass walking cane, who seemed to me a human ant bearing an enormous crumb of intelligence. I understood then that Herbert was a difficult man who made enemies with the greatest of ease. We separated, the Anthologist arranging that we should meet again, a couple of days later, at Flask Walk in Hampstead, where Herbert would be staying with his friend and early advocate, Al Alvarez.

We walked down the hill to the pub, a distance of not more than a couple of hundred yards. I can't say much of

our conversation stays with me, other than Herbert objected strenuously to the Anthologist speaking of him as a poet from Eastern Europe. "You mean *Middle* Europe," he thundered. "What is this *Eastern* Europe?" It was true, of course, for many Poles, that to be labelled thus was to be pushed beyond the concerns of the West, into an East that was for them historically and culturally alien, and to be ghettoised as a community for whom, politically speaking, nothing could be done. After all, the West had done precious little to act upon its sympathies. Herbert also looked darkly upon the fact we both had been to the Warsaw autumn poetry festival, where he said only literary hacks went. Slyly, though, he made an exception of us, suggesting we had been duped. We sought to persuade him otherwise, saying that we knew the best Polish poets were excluded from the event but that it provided us with opportunity to say so. Herbert was not overly impressed by our argument. It was not a promising start, but as the evening went on he warmed up. We spoke of matters not terribly serious, which seemed to be what he required just then. "Marius, *not* Sulla," he kept saying to me, as if he had long ago taken sides in that ancient conflict. "Sulla was in the wrong." Also he spoke of his American acquaintance Zbigniew Brzezinski, National Security Advisor under Jimmy Carter: "My friend is a complete idiot." Another Polish casualty.

Afterwards, we made the painful journey back up the hill towards Alvarez's house, Herbert waddling like an injured porpoise. We were almost an hour getting there, during which time he disappeared into the front garden of one of the Georgian houses. When, after ten or fifteen minutes, he returned, a wry smile on his face, all he said was, "I very much admire your English architecture." It is not for me to say what occurred during that absence. We sat on a bench for a while, Herbert sweating and barely able to move. "I have my God and I believe in Him, of course," he said, adding with exasperation, "but we do have terrible fights sometimes." We had to

physically support him home. It was the last time I ever saw Herbert but it was not the last I would hear from him.

A huge parcel arrived one day containing a book he purchased in Berlin, where he had been living for a decade. It was Michael Ruetz's *Auf Goethes Spuren*, inscribed, "My dear Marius best wishes and love for you and yours Zbigniew." He had covered over an earlier inscription with a drawing of a mountainous landscape. Herbert was not one to miss a symbolic gesture, and the accompanying note, written just as he was leaving Berlin for the last time, on New Year's Eve, marked what for him would be one of the turning points of his life, the return of the exile: "In a few minutes I go home—direction Poland ['Solidarność']."

Over the next year or so he would occasionally phone, usually after midnight, which was when his working day would begin. One of those conversations was particularly memorable.

ZH: Marius, are you my friend?

MK: [*silence*] What would you like, Zbigniew?

ZH: First you must answer my question.

MK: You already know the answer.

ZH: In that case, if you are my friend you will give me your bank account number.

MK: Look, Zbigniew, if you want me to send you books, just tell me what they are. I'll send them to you and we will settle up in heaven.

ZH: Marius, you will give me your bank account number NOW!

MK: Alright, alright. Barclays.

ZH: Sorry?

MK: Barclays Bank, Zbigniew.

ZH: I don't understand. Please, spell it for me.

MK: B.

ZH: B? You mean *bey*? *Bey* for, for—

MK: Byron.

ZH: Ah, Byron! Good, *dobrze.*

MK: A.

ZH: Ah for Akhmatova.

MK: R for Rilke.

(*We poeticised our way to Y.*)

MK: Y for Yevtushenko.

ZH: No, no, that is *Ja.*

(I remembered then that there is a built-in resistance in the Polish language to the letter Y coming at the beginning of a word, and that the Polish J covers the Y sound. I sought an alternative.)

MK: Y for Yalta, where Poland was betrayed.

ZH: No, no. *Ja!*

(*This was Herbert phoning long distance from Warsaw, and here we were, fishing for a Y.*)

MK: I think I've got it, Zbigniew. Yeats.

ZH [*screaming*]: Yeats, Yeats! I'm a fool! Yeats! Forgive me. I kiss you, I kiss your wife's feet, I kiss your children's, too. Yeats, Yeats!

Herbert wanted above all the Loeb Library classics, among them Arrian's *Anabasis* and *Indica*, several volumes of Plato, Hesiod's *Homeric Hymns*, Lucian, Cicero's letters to Atticus, Curtius's history of Alexandria and the letters of St. Jerome. This was the period of Herbert's late poetic flowering, and also of his terrible mental and physical decline, when he had become like one of his Roman emperors, grandiose and impossible. At the same time he had become the spiritual leader of Solidarity, although its members would no more be able to contain him than could the Communist regime. After Cardinal Wyszyński died, at his funeral Herbert stood in a queue for an hour or more with the many thousands who had come to pay their last respects. They offered to let the ailing Herbert move ahead but he refused, saying he would wait in line like everyone else. This was the heroic Herbert, the poet

who would sooner place his poems in the darkness of his desk drawer than make compromises with a detested regime. Or did he? The rumblings are that he did publish poems under another name. Who are we to judge? Miłosz had already made his escape, but others who shall go unmentioned here felt a small lie might enable them to utter bigger truths. This "small lie" included their contributing to a little-known anthology published in celebration of Stalin's birthday. Not Herbert though. The fact is that he judged his fellows harshly. Sooner or later he made war on everyone, even Miłosz.

After Herbert died, in 1998, some of them took revenge. I met one of these literary people, the editor of an important Polish literary journal, who came to England. He visited me because as manager of a poetry bookshop I had been put on his poetical fact-finding agenda. We argued over the various merits and demerits of contemporary English verse, and I shuddered at the names of those upon whom he bestowed lavish praise. Soon, maybe sensing my discomfort, he let it be known he had more important people to meet, among them the very poets for whom I'd expressed profound distaste. "Then I must not keep you," I told him. I had recommended various poets whose work he should look into, W. S. Graham, Geoffrey Hill and Christopher Middleton, but of these he took no note. Recently I read an essay by this same man, in which he grudgingly praises Herbert and then goes on to dismantle his reputation. I was in fact rather delighted by the negative portrait he gave of Herbert in his last television interview. When Herbert was asked why he wore a yarmulke, which he did indeed wear to the interview, he replied it was because it kept him warm.

The vermin can dance on his grave all they like.

A delicious tale concerning him came to me from a friend in Israel. Herbert had gone there to accept the Jerusalem Prize and, because of his terrible health, much care had been taken to ensure his physical welfare. After being fed a regime of drugs to counter the effects of alcohol, he managed to give a reading

of his poems interspersed with much chat, and he even fielded questions from the audience. The following morning, however, when his translator David Weinfeld went to collect him from the hotel, he was gone. Moreover, nobody had seen him leave. An alarm was raised and for the next few hours people searched for him in the drinking holes of Jerusalem. "Where is Herbert?" was the question du jour. Worry turned to panic. Finally, at sunset, he was discovered walking alone, along the edge of the Dead Sea. On what was the hottest of days, somehow he struggled up the slopes of Masada, clutching a bulky volume of Flavius Josephus. Herbert was silent as to how he had got there.

I was relieved to be spared Herbert's wrath, which took increasingly bewildering forms, even against close friends and his translators. He had simply ceased to make contact with me. What must be said in his defence is that by then he was a very sick man. Close to the end of his life he wrote, "I no longer have time to compensate the injured nor apologise to all those whom I have wronged" ("Prayer"). A poet's reckoning can never be softened with lies. When I caught sight of his obituary in *The Times*, I was not shocked by his death. Actually I was amazed he had survived as long as he did, but I did feel a terrible sense of drift, that gone out forever was one of the stars in my poetic constellation. I will not say he was an excellent poet always—silliness occasionally grabbed hold of his muse—but with such works as "The Envoy of Mr. Cogito" and "Elegy of Fortinbras," he gave us some of the best poems of our times. And, after all, one must thank a man for what he has done and not condemn him for his failures.

With Herbert there was, I believe, a fine line between a foolishness brought on by drink and that born of arrogance. He shared with W. S. Graham what the latter's widow, Nessie, told me was a prime ingredient for any poet—"a necessary sense of the ridiculous." I suspect, too, there was, as in the case of Graham, an element of shyness that, when caught unawares,

became animal aggressiveness. And Herbert was, as was doubly true of Graham, one hell of a drinker. If I link these names it is because they were both, in my view, *complete* poets, for whom poetry was more important than the recognition it might bring and for whom the making of a poem was not just an exercise but *a necessary act*. This is not to say they were not both ambitious, sometimes brutally so, but there was, coupled with their arrogance, an essential humility. I believe that in any artist worthy of the name there has to be, in equal measure, both humility and arrogance. Whatever his faults, and they were many, far too many, one thing to remember is what he told his friend Adam Michnik: "If you have the choice between two paths, an easy one and a difficult one, you must always choose the difficult one."

RICHARD STANYHURST, DUBLINER

JAVIER MARÍAS HAS ASKED ME, in my capacity as Poet Laureate in the English Tongue, to compile a list of the ten greatest poems in the language.[1] I have been put in an awkward position because I do not know which nine poems of mine to choose. What I shall do instead is concentrate

[1] I should relate how it was Javier Marías and I first came to speak, although we had met quite a few times before. When, in the late seventies and early eighties, I was working for the antiquarian booksellers, Bertram Rota, I always insisted my desk be at the entrance to the shop, where I could be sufficiently far enough away from my colleagues and yet close enough to anyone of interest coming in off the street. A number of lasting friendships were made there, in that sacred space of mine, where, unobserved, I might dawdle a while. I sat in the shade of an indoor tree that occasionally shed leaves on me. For almost a year, perhaps two, this young man, Mediterranean in looks, dressed in a dark blue he calls "*azul marino*" and with all the arrogance of a bullfighter, would come in and always, as he passed the desk, glare at me. Sometimes he would stop there, in profile, as if challenging me. And from behind the Alhambra of my huge manual typewriter, I would glare back at him. It was a measured hostility such as usually exists between two wild animals straying into a new, unpissed-upon space. This has very little to do with actual dislike, and probably a great deal to do with forces of attraction. We walked metaphorical circles around each other for perhaps two years. We never, as far as I can remember, actually spoke.

I would notice the books he purchased and, for the life of me, I could not get an angle on his literary tastes. A bookseller can do this usually and act upon that knowledge but not in this case. Clearly, though, he was going down some of literature's more hidden avenues. At one point he was buying the works of John Gawsworth, a poet wholly forgotten to the world, whose heyday, if he ever had one, was in the 1940s. (I should add that Gawsworth had been, in the past, a familiar figure in the shop and probably benefitted more than he should have from Bertram's kindly nature.) A German woman said to have been his girlfriend once used to come into the shop and sell me the occasional book. We always spoke, but I sensed in her such a world

upon the tenth, which is not an original English poem at all: Richard Stanyhurst's translation of the first four books of Virgil's *Æneid*, published in Leiden in 1582 and of which only two copies, both imperfect, appear to have survived. A slightly revised edition was printed the following year, in London, by Henry Bynneman. The copy in the Bodleian Library is described as being in gatherings loosely sewn together, not bound, but protected by a vellum wrapper made from a leaf taken from a handsome twelfth-century edition of the *Æneid*. Christopher Baswell writes, in his *Virgil in Medieval England* (Cambridge University Press, 1995), "Whether this combination—the English translated book and the wrapper in its original Latin—occurred through an elegant accident of history or the inspired agency of a Renaissance wit, we shall never know."

as I would not dare intrude upon. We discussed opera and books instead. She threw a steady beam of intelligence. I wonder now if she and my Spaniard were ever in the room at the same time.

Here, in this foe of mine, was somebody I could at least respect for being a true book collector and for whom literary fashion was of absolutely no consequence. As a customer he was and still is wholly inscrutable. One day Javier Marías (I knew his name by then, as a buyer of literary curiosities) walked into the shop and instead of going to look at the books he came up to me and spoke. He told me that he had been living in England for those two years and now he would be returning to Spain, and that he did not want to go without saying goodbye to me. I was, of course, wholly disarmed. What's more, I liked him immediately. I had no idea he was a writer, of course. It was only later, when glancing through an anthology of new writers, that I chanced upon a short story of his. And in the story, although given the name of George Lawson (who was, in fact, one of the directors at Bertram Rota), there at the front desk of the fictional shop called Bertram Rota was my fictional double. It was not a particularly flattering sketch of me, although naturally I was delighted to be cast in a villain's role.

A couple of years later, I read his first novel to be published here, *All Souls*, which has at its centre a poet, a real poet, almost forgotten to the world, and whose death mask, reproduced in the text, was taken from the cover of a pamphlet Javier purchased at Bertram Rota's a few years before. The poet of this "fiction" was, yes, John Gawsworth. All the while, then, Javier had been moving in a direction that probably he himself did not recognise. I have always maintained that the air is full of connections waiting to be made, that coincidence is only a smaller aspect of our existence. I think Fate is too strong a word, though, for that which we ourselves may change. Gawsworth, whose death mask impresses more than his poetry does, was King of Redonda once, a title he inherited from the first king, the novelist M. P. Shiel. Shortly before he died Gawsworth passed the title to Jon Wynne-Tyson who, after reading

What Baswell does not mention is why this extraordinary work might have been an object of mirth in the first place. It is quite true that after the publication of this volume, Stanyhurst was not encouraged to produce more. The book's earliest known critic, Thomas Nash, accuses Stanyhurst of "a foule lumbring boystrous wallowing measure." In 1617, Barnaby Rich of Dublin speaks of him as having stripped Virgil "out of a Velvet gowne, into a Fooles coate." I will pass over a couple of further unkindnesses. The eighteenth century is silent on the matter, which, with the likes of Mr. Pope in the vicinity, is rather a shame. In the nineteenth, Robert Southey wrote, "As Chaucer has been called the well of English undefiled, so might Stanyhurst be denominated the common sewer of the language." Later, C. S. Lewis describes his language as "barely

All Souls, passed it down to Javier. The fact that Javier is the present king, something he could never have imagined for himself, is due to his having pulled the memory of Gawsworth from the grave. I should add here that there are pretenders to the throne, one of whom, a certain "King Bob," charters boat tours to Redonda. I offered to have him assassinated, but the dignified King Javier would prefer to rule in peace.

All these twists of fate comprise the theme of his recent, fascinating book, *Dark Back of Time*. I was on the tube the other day relishing his Chaplinesque description of entering the Titles Bookshop in Oxford and of not knowing where to put his seeping bag of grapes. The proprietor, the rather flinty Mrs. Stone, suggests he place them in the umbrella stand where, it being a sunny day, they will be perfectly safe. Ten pages later, a friend whom the author had previously arranged to meet there ("Freud's granddaughter") walks into the shop and plunges her dry umbrella down through the bag of grapes. I was hugely enjoying this passage when a massive black woman sitting next to me on the tube bit into her green apple, and a spray of juice flew across the left page of my book. Quickly I applied the sleeve of my sweater, mopping up the fluid before the ink began to bleed. I was quite prepared to disembowel my neighbour right there and then, but realised in time that such an action might be construed as having a racial motive, whereas in reality it would have been a bibliomaniacal one. The apple exploded several times more. She was quite oblivious to my murderous glares. Soon I found myself adopting an absurd physical posture, leaning almost into the lap of the neighbour to the other side of me, my cupped hand shielding the book from further pluvial salvoes. I wonder, though, about these odd intersections where meet a Spaniard and a Pole, a dead poet and a living one, Redonda *y Londres*, apples and grapes.

We remain on affectionate terms, the King and I, and just over a year ago he appointed me "Skelton," Poet Laureate in the English Tongue. I am not required to fulfil any royal duties and he does not assign any; I do not accept enquiries from the public.

English" and as recently as 1996, in the pages of *The New Criterion*, D. S. Carne-Ross writes that Stanyhurst is "representative only of himself, for his manhandling in uncouth Tudor hexameters of the first four books of the poem is a *monstrum horrendum* unparalleled in the annals of translation." A sly defence comes from the pen of Edward Arber who edited the 1895 edition of Stanyhurst's Virgil: "One may say of him, that he, at any rate, had the courage of his convictions; that he, at least, had not the fear of man before his eyes, when he set to work to torture the English language."

Such is the tarnished reputation of the man who slips into my list at number ten. There is hardly a person left who remembers who Stanyhurst is. It is thanks to Arthur Uphill—former colleague, bibliophile and aficionado of Amanda M. Ros—that I owe my first acquaintance with this misjudged masterpiece.

This is how the poem begins:

> I that in old season wyth reeds oten harmonye whistled
> My rural sonnet: from forrest flitted (I) forced
> Thee sulcking swincker thee soyle, thoghe craggie, to sunder.
> A labor and a trauaile too plowswayns hertelye welcoom.
> Now manhood and garbroyls I chaunt, and martial horror.

And here is how it ends:

> Streight, with al, her fayre locks with right hand speedelye snipped:
> Foorth with her heat fading, her liefe too windpuf auoyded.

The stuff in between is quite beyond the reach of even our deepest analyses.

I am intrigued to learn that, in later years, at Antwerp, Stanyhurst practiced alchemy, taking it upon himself to make gold. And not coincidentally, in my view, he became a Catholic, took holy orders and went to Spain where he is said

to have become a physician. Conversion of one sort or another seems to have been in the man's blood. I happen to know an alchemist, a holy fool from Damascus, who also practices a kind of medicine, for there is, in his mind, a logical connection between the curing of metal and the curing of the body; also he is the most profoundly religious of people. And, if a fool, certainly he is no dunce. Sulayman gave me a specimen from one of his many attempts to produce gold, saying perhaps it would afford me a loaf of bread in London. It is not gold, I'm sure, but whatever it is, it's like no other metal I have ever seen. I have heard recently that he has cracked the problem he has been trying all these years to solve, and that he has confounded even the jewellers in the *souq*; and now he promises to send me a ring from the gold he has made. There is nothing to compare with his sheer drive. Where it will take him, of course, is another matter—I hope it is neither prison nor bedlam.

There is a connection here. Stanyhurst's two great intellectual adventures, which involve, on one hand, brute language and, on the other, base metal, are one and the same. What he seeks to achieve, first with hexameters and then later with an elixir, may be impossible. The poetic metal he produces, however, is like no other I have ever seen, although there are intimations here of *Finnegans Wake*. There is in his madness, even when it amounts to a kind of verbal incontinence, an unruffled magnificence. Where there are no words to fit the metre he either invents them or else traumatises the nearest sound available. Sometimes he agglutinates, other times he divellicates; for the sake of a syllable he adds prefixes—"beblubbered," for example; and then (this is where he truly excels) there are those mimetic effects he produces, "Whear curs barck bawling, with yolp yalpe snarrye rebounding." Also the alliteration is that of man whose first nature is to alliterate, "a foul fog pack paunch." The words are driven in as if with a wooden mallet and made to fit an unlikely scheme. What alchemy we have

here! I once saw a man flog a mule to its face, while at the same time trying to encourage the poor creature to move forward in his own direction; the poor creature twisted and turned; and likewise Stanyhurst forces the language until it too spins about in maddened circles. I disarmed the stupid mule driver, but with Stanyhurst I stand no such chance. All one can do is crouch as before a desert wind and cover one's head with a blanket before sand fills eye and auricle. Stanyhurst is such a force of nature and, when on the loose, ungovernable. A genius such as his both blinds and deafens.

Should a man be pulled from the grave, once every hundred years or so, just so we can poke fun at him? What purpose could it possibly serve? I think perhaps there is one, in that we require some object upon which to rest the folly in ourselves. What good would it be, though, if that object were not more foolish than ourselves? As we want for excellence in our lives, so do we need its opposite; and what better than someone who can err so much better than us, who is buck-naked in his absurdities? Richard Stanyhurst is a fool's sacrifice; the altar upon which he bleeds is within our hearts. The first three books of the *Æneid*, he informs us, he wrote at his leisure; the fourth he "huddled up" in ten days. What joy he must have experienced, to have run amok amid the English language, tearing it down when it was at its very height, bending it this way and that, at every turn committing verbal atrocities. Yes, one may well imagine his howl of delight as he wrote, "a cockney dandiprat hopthumb, / Prittye lad Æneas ..."

We should join him where he is, at least for a while.

Synchronicity & Tobacco Smoke

YESTERDAY, ON THE TUBE, I smelled tobacco smoke. Actually, it was pipe tobacco as opposed to cigarette, a distinction every bit as fine, say, as that between port and wine. I asked my wife if she could smell it and, no, she couldn't—it had to be in my imagination. She says sometimes I make real what I imagine. We were on the District Line returning from the Lucian Freud exhibition at the Tate, which establishes once and for all what a great painter he is, not always, but most pointedly so during this past decade. Admittedly I do not much care for the lineage. I have no truck with the grandfather's voodoo, whereas the grandson seems to have found a more profound psychological truth in surfaces. Although I have never met any of them, I knew all the people in his portraits, and the one of a young woman with bare shoulders, which made me feel her nakedness beyond the frame, haunted me. Anyway, I smelled smoke.

This happened to me once before, when I was on the Piccadilly Line. That time it was tobacco of a variety soaked in apple juice that comes from the environs of Latakia on the Syrian coast, reputedly the best weed of its sort, and which one smokes with the *nargileh* or water pipe. I used to smell it all the time in the Damascus cafés and just occasionally I would indulge, with the consequence that I'd leave with my eyes dangling from a couple of springs. I'm not a smoker.

Should anyone think me a fool and a *green* fool at that, it was neither hashish nor opium I inhaled but Latakia tobacco, pure and simple. The sweet fumes, when I think of it, are inextricable from the memory I have of the clickety-clack of players at their backgammon boards. And so, smelling and hearing Damascus and feeling, just then, a terrible longing for the place, I looked up and down the carriage to see if there was anyone of Arabic origin, but no, there wasn't; and yesterday, on the District Line, there was nobody smoking a pipe.

Yesterday's smell I could trace to my childhood, when I used to bicycle to the village school each day. I would stop to speak to an elderly farmer, nearly blind he was, and always immaculately turned out in his Sunday clothes, a dark blue suit with pale stripes. He was called Deb Hare. I never knew what Deb stood for, but never once did I think of it as being feminine. Deb Hare was the stuff of which early Canadians were made—he would have been a young man in the 1880s, of pioneering stock, and so strong, apparently, he could split a log with his bare hands. So I'd heard, and seeing him powerful, even in his eighties, I believed it to be true. I often wondered why he went so early to collect the post from the mailbox that hung by one hinge, and if he ever got any post at all. At last I realised that the reason he was out there at that exact hour, smoking his pipe, was so he might have someone to speak to. The distances in that part of the world were not just geographical. His house, which was a hundred yards or so down a lane, was a wooden, unpainted citadel of silence. I think he might have had a wife in there. Actually I *do* know he had a wife because after he died, and was probably buried in his Sunday clothes, the local youths, at Halloween, would play pranks on her, showing up as ghouls at her window, hooting her, poor woman, almost into the grave. The house where Deb Hare lived all his life was only five minutes away by bicycle, but I'd never been inside, nor had I ever knowingly set eyes on his wife. Who says it was only in Damascus and such places that

women were hidden from men's eyes? There were countless women where I grew up, in rural Ontario, who very rarely made a public appearance, except, perhaps, at church, at weddings and funerals, or at jumble sales. God being a Protestant and death and marriage beyond my ken, I went only to the jumble sales. I never knew which elderly lady was which, although, most distressingly, they seemed to know who I was. They would meet sometimes to play crokinole, a game I have never seen played elsewhere. The sound of the wooden buttons, though, as one tried to finger-click them into a hole in the middle of the square wooden board, was not unlike the sound of backgammon. I wonder if I had some residual memory of this in Damascus and if Paradise is not a village hall packed with ghosts, Muslim and Christian, playing backgammon and crokinole. The smoke that hung about Deb Hare of blessed memory was the smoke I smelled yesterday on the District Line.

And now here's an odd thing. At the time, I was reading a book on the tube and only a minute or so after I smelled the smoke, I came upon this passage:

> As we came abreast of the sea-front, where the surf broke highest, Kauanui embraced the occasion to light his pipe, which then made a circuit of the boat—each man taking a whiff or two, and, ere he passed it on, filling his lungs and cheeks with smoke.

A common enough occurrence, could this have been some part of the brain jumping ahead, skipping a few lines? Was I suffering from lazy eye? Should one build upon this a theory of synchronicity? Or should one leave things be? The passage falls in the middle of page fifty-five of my 1900 edition of Robert Louis Stevenson's *In the South Seas*, which to my mind is one of the finest travel narratives ever written, and that from a list which includes *Eothen*, *The Worst Journey in the World*

and *The Road to Oxiana*. Stevenson is at his absolute best when he draws directly from life, and had he not written *Treasure Island* and *Kidnapped* surely he would be remembered for this book alone. The converted may wish to avert their eyes, but here comes a passage in which he describes the fate of one of his fellow countrymen. It is worth my typing out in full so that while doing so I might figure some way to crawl back to my theme.

> It was a pleasant society, and a hospitable. But one man, who was often to be seen seated on the logs at the pierhead, merits a word for the singularity of his history and appearance. Long ago, it seems, he fell in love with a native lady, a High Chiefess in Ua-pu. She, on being approached, declared she could never marry a man who was untattooed; it looked so naked; whereupon, with some greatness of soul, our hero put himself in the hands of the Tahukus, and, with still greater, persevered until the process was complete. He had certainly to bear a great expense, for the Tahuku will not work without reward; and certainly exquisite pain. Kooamua, high chief as he was, and one of the old school, was only partly tattooed; he could not, he told us with lively pantomime, endure the torture to an end. Our enamoured countryman was more resolved; he was tattooed from head to foot in the most approved methods of the art; and at last presented himself before his mistress a new man. The fickle fair one could never behold him from that day except with laughter. For my part, I could never see the man without a kind of admiration; of him it might be said, if ever of any, that he loved not wisely, but too well.

Ah yes, I met a woman in Paris once. She would have been a prime candidate for Freud's brush of hog's hair as opposed to sable. She was skeletal and sour on the subject of romance and her fingers were stained with nicotine. Scraggly hair fell

in her eyes. She was attractive, as women sometimes are when perched at the top of a downward chute. I'm not sure why she told me she'd had three abortions. It could have been I served some kind of purpose. There is, although I've tried to put a clamp on it, an element of the father confessor in me. She was waiting for her American lover, Robert, who never came.

This was at *La Tartine* on the rue de Rivoli, where I had been taken a couple of years before by my friend Daniel Mauroc, a writer who hardly ever wrote and a translator only when he was pushed to be. I first went to see him clutching a rose. I misheard the name of the person to whom I was to introduce myself, and went all dandified to meet a *Danielle*. "Oh," he twinkled, "and this is for *me*?" The miniscule room we squeezed into, on the rue Bertholet, was in the building next to where Jules Laforgue lived. We were in literary country, although the talk was mainly of pastries. There was only one patisserie in the whole of Paris he'd rate. Mauroc translated Gertrude Stein, William Burroughs and John Cowper Powys, and once worked with Samuel Beckett on a translation, into French, of *Watt*. This would prove to be a nightmare. The two would meet every afternoon to discuss the translation of the next passage. They would be only two or three words into the first sentence when Beckett would pause, saying the French *mot* was not the right one. An hour would pass and still Beckett scratched away at his thought while Mauroc smoked another gauloise. At last Beckett would say "Never mind, then," and move further on down the sentence. The book, in the Mauroc version, never reached publication stage. I'm not sure whether it ever reached *le deuxième chapitre*.

My late friend, for I hear now he is no more, was a most particular man, wholly Parisian in his fussiness and not just on the matter of pastries. He introduced me to *La Tartine*, saying it was the last genuine café in Paris. All the others were fakes. This, coming from him, was as gospel as the cigarette that always dangled from one small patch of his elfin smile.

We sat at the one *non-fumeur* table, which was barely visible for the smoke. The reason for *La Tartine*'s authenticity was simple enough—the owner, an octogenarian, did not allow for change. The place was decorated in *art nouveau*, was marvellous for its mirrors, and there was no great effort made to keep the repairs up to date. Suddenly a narrow door, which I took to be a broom cupboard, opened and he emerged, a bald stout man in an apron and a grimace; he shuffled about the café to make sure everything was as it had always been, and then stepped back inside. The effect was rather as if he had stepped out of a coffin stood on end. I fear when he goes, the café will too. The single, scowling waitress might have been a perfectly preserved specimen from the first quarter of the century, when the owner would have been a young rake. She bloomed, but bloomed as only the dead do in certain ghost movies. She walked about with a bottle of red in one hand and a bottle of white in the other, from table to table, with the nonchalant air of one who didn't mind whether you lived or died as long as you weren't found face-down in the *assiette*, covered with sliced meats or cheese. She had a Piero della Francesca mouth, eyes like a pair of garden shears and her dark hair was in a 1920s bob. She had a bosom Renoir might have been pleased to colourize. She was a "Chiefess" of a kind, but I know not of which tribe.

Clearly, and I am speaking now of my second visit to *La Tartine*, the Piero female knew the Lucian one, but there was no deciphering the signals flying back and forth between them. The woman pouring the red and the white was inscrutable, while the other, she of the scraggly hair and three terminations, stripped down to where the secret life is no more, was too shallow and too full of obstacles to be navigable. She was herself some kind of shipwreck, its framework the bones in her face. I listened to more of her troubled life, in which candour and truth, one never party to the other, covered different sides of the globe. She considered Brazil the best country in the

world. She would go there, Robert or no Robert, as soon as she was able to. She seemed not at all interested when I asked her about the street children in Rio. Actually she had no time for them whatsoever. "Why *not* shoot those who steal?" she said. Such finer thoughts as she allowed in herself she sent ahead, fully packed, to sparkling white beaches. I followed her as one might some tale of the macabre. We went to her apartment for coffee, when suddenly, even before the kettle had a chance to whistle, she pulled me close, saying, "You smell like Robert." I replied, "And you smell like cigarettes." She showed me the door. I couldn't stop laughing, all the way to the Gare du Nord where I caught my train home. I speak of laughter, but really it was sadness of a barely comical species. The next time I smell smoke, it might be she who spooks me, perhaps on the Central or the Victoria Line.

THE BOOK OF ORDON

1

I AM READING A TYPESCRIPT, 443 pages in length, which is the autobiography of a man whom nobody remembers. As far as I can gather, its author left behind no family and such acquaintances as he had are mostly gone. A single blurred photograph, which accompanies an indifferently written obituary notice, is just about all that survives of this shadowy figure. And, of course, his words, quite a few of them, which hardly anyone will ever see. The book he wrote is not in his native tongue, which was Polish, but in English. "The red plague rid you for learning me your language!" cries Caliban, and well might the author of this have taken heed. The clumsiness of the prose, the abrupt shifts in chronology, the suspected "borrowings" here and there, a disregard for chapters, a poor ear for voices—these are just some of the factors that will ensure his writing never finds an audience. The book (I will call it so, even in its rudimentary state) was written in Canada, in 1948 roughly, when its author was about sixty and, if one skips to the final page, evidently weary with life. "I think I might as well stop here," he writes. Sadly, he concludes nothing happened to him in Canada that would be of any interest to a reader of his reminiscences. I can imagine Canada in the forties because I remember how stuffily the air hung there in the fifties. Oh, and I should have mentioned something else about the

typescript: it is utterly compelling. It would *not* have been so had it been actually published, in which event a book so poorly written would almost certainly have entered that bibliographical necropolis where the searching eye switches automatically into lazy mode. Anyone who haunts second-hand bookshops the way I do will know by the smell alone their "dead zones." And who's to say this prose of mine, describing another man's prose, will not suffer a similar fate? So why, then, the superlative? My answer is this: the author's voice, although at times insufferable, comes not so much from the page as from a place where the material is worn through on the arms of an old settee that sags in the middle. The sense I get while reading the manuscript is of being a private audience. There is, for all the poverty of the prose, a wealth of direct experience.

The writing of this book can be read, on one level, as a testament of failure. Why did the author write in English, when surely the only audience he could have hoped for was a Polish one? I will hazard a guess and suggest he was rejecting his past as being a place too full of tentacles, but did so, alas, for a present in which there would be no interest in him at all. A North American audience, especially at that time, was largely indifferent to the fates of people from remote places. The mental attitude of a Pole in exile, during the Communist regime, was either to see his country as the crucified Christ, a weight he had to carry at all times, or else to push it away from his thoughts as far as possible. Whichever path he chose, he was doomed to failure. The Pole travels badly, unlike the Dutchman, say, who can grow his tulips anywhere. The Slavonic mind is already seeded in the Cimmerian; only occasionally, as in the case of Joseph Conrad, will it flower in the dark.

2

THE TITLE AT THE HEAD of the typescript I have before me is *The Winding Trail*, which, although true to the book's contents,

isn't exactly memorable. The dusty banner is perhaps indica-
tive of the author's early ambition, partly realised, to become
a cowboy in the American West. The author's name is given as
George Nicholas Ordon, which was not his real name. Ordon,
though, *is* a Polish name. It is redolent of Słowacki's poem in
which the castle of that name is the stronghold where the Poles
held out against the Russians. There was also a Polish cabaret
singer of that name, but she came later, too late to be of any
influence. Another, more sensible, reason for the name is that
it sounds better on a horse. There are no fatal consonants such
as might preclude one's election to the presidency of Stany
Zjednoczone. (Curious, is it not, how the United States of
America fails to translate recognisably into Polish.) A short
curriculum vitæ is supplied at the beginning of the typescript,
but there is no mention in it of the author's real name. Ordon
is the *nom de plume* I will refer to, although soon enough,
when it is convenient for the sake of this prose to do so, I shall
reveal his real name.

If the life glimpsed so far is a touch unusual, odder still are
the circumstances surrounding the typescript coming to me.
When I was in Tunisia in 1973, in the coastal town of Gabès,
I made the acquaintance of a mad Hungarian who had been
living there for some decades. A figure of the streets, shabbily
dressed, speaking Arabic and sporting a turban at times, this
man in his fifties walked with a limp and, as is often the case
with lunatics the world over, he carried with him a bundle
of old newspapers. If I remember correctly, he used a ciga-
rette holder. He spoke English in the clipped manner of a
foreign aristocrat in a B-movie, sported a small goatee, and—
now *this* I clearly remember because it was the most impor-
tant thing about him—he claimed to be the rightful heir to
the Hungarian throne. I doubt the *Almanach de Gotha* will
shed any light on his pedigree. A couple of months later, just
before leaving Gabès, I decided to give him some books I had
brought with me. *The Thief's Journal* by Jean Genet was one of

them. I made enquiries as to where he lived and finally found him in a humble abode with a retinue of Arab youths, who grabbed at me in a most intimate fashion until he shouted at them to stop. With barely a word of thanks, he took the books from me, clearly distressed that I had discovered him in such a debauched state. And I, from my side, somehow felt bad for having exposed him as a pederast in his own lair. I wish now I had taken note of his name.

A few months ago, I was asked to write a short memoir of my stay in Gabès for an anthology of writings on North Africa. This was to be one of the most difficult pieces I've ever had to write. After all, I was writing at a distance of almost thirty years, and from a perspective that I would like to think is a bit more informed than that of the callow figure I then was. My thoughts kept returning to the Hungarian, and to a curious incident which, until recently, I had never bothered to investigate. I have already mentioned the bundle of yellowing newspapers. When the Hungarian was apprised of my Polish surname, he undid the string holding the papers together and, removing the top issue, a copy of the *Daily Mirror* dating to the early 1950s, said to me, "Isn't it terrible, the news about the Polish countess?" The headline, which I only glanced at, told of a woman's murder in a small hotel in London. It never occurred to me to ask him why he had been carrying this newspaper around with him for all those years. Anyway, it was none of my business. I do remember telling him, on the other hand, that the case rang a faint bell with me.

It was only recently I tried to get closer to the source of that tinkle so that I might authenticate as much as possible the story of my Hungarian, who had begun to make more than just a cameo appearance in my Tunisian prose. A mere detail will often support even the tallest tale. At best I could discover who the murdered Polish countess was, the manner of her death, and then squeeze this information into a single line of prose. I went to the London Library and pored through the

Times indexes, looking under "murders," "Poles" and "countesses." Admittedly, I did not feel much inclined to make the long journey to Colingdale, in north London, where the British Library newspaper archive is, to see if there were any copies of the *Daily Mirror* there, not when all I really wanted was a small note. I found nothing whatsoever. I was beginning to wonder if the newspaper article were not a figment of my imagination, something bred beneath a hot Tunisian sun and nourished by too much rough Tunisian wine. If so, how much else of what I remembered was accurate? It struck me that the story was something I had heard as a child at home, in Canada. I telephoned my mother who lives over there. She remembered that very issue of the *Daily Mirror*. My English grandmother used to send her the newspaper in bound weekly volumes, in yellow covers—a tenuous link with "civilisation" if ever there was one. Still, it was a rather better paper than the one it has since become. My mother could not remember who the murdered countess was, but recalled how startled she was to read in this article that the victim had been married to a man named Jerzy Giżycki. There was good cause for her surprise. This very Giżycki had stayed with my parents and my uncle three years before, in 1949, in a farmhouse near a village of several houses called Burritts Rapids, deep in the heart of rural Ontario. There he paid fifty cents rent per day, which even then was not a considerable sum. I should add here that my family was in extremely difficult financial circumstances.

A writer and an artist, Giżycki's efforts at both were, according to my mother, execrable. He showed her a typescript, written in English, based on his earlier experiences in Africa, in order that she might make corrections to it. The pseudonym that Giżycki later adopted for this work was George Nicholas Ordon. When my mother attempted to improve his grammar he retorted, "I did not write this for an English audience but for an American one." Attack a man but never, never criticise his prose. There was an old woodstove in the house, with a

grate that the hot ashes sometimes fell into, and sometimes bounced onto the floor. Giżycki expressed his fear that the house might burn down, taking with it the only copy of his masterwork. After some months, he got into an argument with my uncle, accused him of not being a host sufficiently in the Polish manner and left with no forwarding address. He was not heard of again until the article in the *Daily Mirror*. At no point during his stay of almost a year did he mention having been married.

The following morning I went to the Polish Library, which is close to where I live, and there I began to tell the librarian, a woman with an ironic smile, the story of "the rightful heir to the Hungarian throne," a murdered Polish countess and a man called Giżycki. I'm not sure if I offered this information in the most logical sequence. The librarian, Irena was her name, asked how she might help me. I said the Polish émigré newspapers of the time must have been full of the story. "Hmm, yes, a *cause célèbre*," she added, again with an ironic smile. She said it would be hard work going through the Polish newspapers of the time, especially as I didn't speak the language. When I suggested there might be older people about who would probably remember the case, she promised to make enquiries.

She kept her promise.

When I got home, about a quarter of an hour later, there was an urgent telephone message waiting for me. Would I phone a certain Mrs. Wazacz as soon as possible. Mieczysława ('Sławka') Wazacz turned out to be an extraordinary bundle of enthusiasm, always jumping ahead to the point one is about to make. She is a filmmaker, and the reason the librarian, Irena, contacted her is that there was something in my story that seemed to connect to a film that she was planning to make. The project, one that has preoccupied her for some years, is a documentary life of Krystyna Skarbek, one of the most celebrated SOE (Special Operations Executive) agents of World War Two, and dubbed by Sir Winston Churchil one of his

favourite spies. Skarbek, born a Polish countess, half Jewish, later went under the name of Christine Granville, which is why I had failed to locate her in the *Times* indexes: I was not expecting to find an English name. After the war, during which she acted with a sang-froid that saved not only her own life but also those of others, she was awarded an OBE and the Croix de Guerre. Sławka asked if my family were in Canada, which took me by surprise. She was so enthralled by her subject, there was no avenue too small to explore. She knew Jerzy Giżycki had gone to Canada after the collapse, during the war, of his marriage to Christine, and now she was hoping that I might be able to supply her with details of his life there. I told her what little I knew about him and mentioned the typescript he had given to my mother for correction.

"Yes," she replied, "I know where that typescript is."

A Polish poet living in America, Alexander Janta, now deceased, donated the typescript to the Polish Library here in London. When I told Sławka the story of the Hungarian in Gabès she was quick to make the connection, saying that for a brief but intense period Christine's espionage activities were centred in Budapest.

"You see, your Hungarian may well have known her."

Suddenly I saw things in a fresh perspective. Who was this peculiar man so much of whose life was a restricted zone? Why was he so obsessed by the news of Christine's murder that twenty years later, in a small town in Tunisia, he was still carrying about a copy of a newspaper featuring the report? And from where did he get that issue, for heaven's sake? What was the cause of his limp? Moreover, *what was he hiding from*? My supposition that he *wasn't* a collaborator is based on the most slender evidence, a chance remark he made, which for some reason has stuck with me. He said I was to avoid going to a certain restaurant in Gabès because its owner had served German officers during the war. Here was a man who, thirty years later, knew precisely which side he was on. I suspect that

he escaped the Communist authorities with more in his port-folio than we will ever know. Physically and mentally he had begun to deteriorate. There are many such figures in tropical climes. I have recently made enquiries as to his whereabouts, sometimes going to absurd extremes, but I expect he will remain forever a lacuna in this story. And in any case does any-one ever know much about eccentric people, especially those who spend much of their lives on the street, other than what they choose to reveal of themselves? A man may be so public as to be almost invisible.

3

THE STORY OF THE POLISH countess is recounted in Madeleine Masson's *Christine: A Search for Christine Granville* (1975). Masson writes very well indeed, although I wonder at times how she manages to project herself into certain scenes. Still, if she embroiders, it is out of love for her subject and not for the sake of mere style. Also the lives of biographer and subject darkly intersect at one point: in May 1952, Masson took a steamer from Cape Town to Southampton. While on board she was attended to by a stewardess who made a deep impres-sion on her, and who seemed to be the possessor of a hidden life. When the ship arrived in England on June 13, she went to say her goodbyes, but the stewardess "with the shiny nose" was indisposed at the time. A couple of days later, on June 15, Masson picked up a newspaper—perhaps that very same issue of the *Daily Mirror*—and read of the murder of Christine. A member of her ship's crew, whose advances she had rejected, stabbed her to death at the small London hotel she always stayed at, only a few minutes away from the residential hotel where I lived when I first came to London. The murderer was subsequently hanged. It was only when Masson picked up the newspaper that the extraordinary life of this woman

was at last, if only partially, revealed to her. And it would be another twenty years before she decided to act upon her initial impulses and discover who this Christine really was. And here I was, another thirty years down the line, trying to splice together an increasingly large number of loose ends, all for the sake of a measly note.

A streak of Polish fatalism runs through me, which not even Chinese medicine can cure. If I am reading Ordon's typescript with such intense curiosity, perhaps it was determined that I should do so, many years ago, in a small town in North Africa, where I had settled down to write a book of my own, a work of surrealist prose. I was aiming at *literature*. Ordon did not make this mistake. What he wrote, however clumsily, is a record of things he saw and experienced, and consequently much of it is of value. If only I had done the same. Should anyone wish to investigate the connections he makes, there is considerable work to be done. One could spend years following up the many leads in Ordon's book, but this is unlikely to happen because, as I have said before, fascinating though it is, it does not warrant publication. The typescript is not without its problems for me, chief among these being that nowhere does it bear my mother's hand-written corrections. All I can suggest is that Ordon retyped the section of the book dealing with his experiences in Africa, which is the part my mother remembers, probably incorporating the many corrections she made. What strikes me is that here, amid the sleeping crocodiles, the *English* fares rather better than in the rest of the typescript. That it is substantially the same book my mother saw, I have little doubt.

The outlines of Ordon's life, as presented by him to the would-be reader, are roughly as follows. After finishing university at Halle he went to America in 1914, a few months before the outbreak of war. Chicago he did not like, so he took a train to Cheyenne in Wyoming where he tried his hand at punching cattle. The question is, can one be a cowboy for only a few

months when being a cowboy means being a cowboy for life? Ordon's youth speaks loudly here, which is most evident when he slips into a pseudo-Western genre: "'Well, we are in a nice pickle!' Tex Preston muttered angrily, digging with his huge Mexican spur rowels parallel little trenches in the sand warmed by the fire round which we sat." Soon after, Ordon became chauffeur to J. D. Rockefeller Jr., driving "a huge six-cylinder Lozier car," during which time he met Mackenzie King, the future prime minister of Canada. He became a prospector in Colorado, where he narrowly escaped death several times. There are, if one pans through the silt of his prose, nuggets of gold scattered here and there, such as the story he relates, as told to him by a Métis called "Rooster" Wilson.

> The valley below me looked like a pot full of milk ... A half an hour later we were in the valley. Through the drifting snow I could see some vague shapes—houses, corrals, sheds over the mineshafts. Instead of perking up Lobo began to drag his feet. I had to spur him on. Something was fishy there. Then I understood: although we were going against the wind there was no scent of smoke in the air. At last we were among the first houses. Not a sign of a living soul. We pushed through a couple of streets filled with snow drifts— not even a dog. In a small square, over a pretty big house, there was a sign: "Lucky Strike Saloon." And below that: "A dry throat is dangerous to your health." I dismounted, shoved away the snow from in front of the saloon door with my boots, and went inside. On the shelves behind the bar sat some empty bottles. The floor was covered with a layer of broken white and green glass. The mirror between the shelves was broken—probably by a bullet, and on one of the remaining larger pieces someone had written with a piece of soap: "To hell with silver—let's get some gold!" ... I felt mighty uneasy. Wanted to get the hell out of that dead town. But it would have been suicide to leave at night and ride into

the storm. I got out of the saloon, untied the horse from the hitching rail, and led him towards the stables, where my Lobo would have some shelter from the wind. I had a hell of a time moving the pile of snow from in front of the door. Finally, I could open it. At that moment Lobo jumped back, tore the reins from my hand and, in a moment, was lost in the blinding storm. It would have been crazy to run after him. I never saw him again. Probably the wolves got him, or he died of cold and starvation … Right [on] the other side of the threshold there was a horse skeleton.

Or was this pinched from elsewhere? I feel it was.

Afterwards Ordon drifted to Hollywood, hoping that his ability to ride a horse might earn him a role in the movies. This was not to be, although he did meet Charlie Chaplin. The description he gives is suggestive of a famous man seen at a distance. Still, what young man will not allow himself a measure of hyperbole? When war broke out he joined the American army, but was not sent overseas. After this, from 1918 to 1923, he worked for the Polish Embassy in Washington where he met President Harding, and from there, bored with the diplomatic life, he went to France as Secretary of the Polish National Olympic Committee. The Polish team, much to his disappointment, performed disastrously, due to its collective enthusiasm for French women and wine. Now begins the next great chapter of his life, the years spent in French West Africa, first as a cameraman and general dogsbody to the writer Ferdinand Ossendowski and his wife, both of whom he clearly disliked. There is a sweet irony here in that he accuses Ossendowski of "colouring" his experiences. If people enjoy descriptions of big game hunting, which I don't, then they might care to linger over the corpses of elephants, hippos, lions, crocodiles and antelopes. The odd snake gets it in the neck too. Again, on several occasions, he narrowly escapes death. There is one disturbing passage that ought, perhaps, to

be brought to the attention of the police. Ordon is waiting for a ferry to cross the river when his companion, Godin, relates the story of one of his acquaintances:

> Lavoisier had a closed car. They came to the river. Lavoisier drove the car onto the ferry. He got out but his wife stayed in the car and began to order him round: "Close the windows! And don't open the door. Do you want me to be bitten by the tsetse flies and so on?" Lavoisier had a brain wave. He began to walk up and down the ferry and "accidentally" kicked the piece of wood they had put behind the rear wheel. It was during the rainy season, the water was high and the current swift. When they got to the other side the ferry hit the bank with a bump. The well-pumped-up wheels threw the car back; it rolled off the ferry and into twenty-five or thirty feet of water. They never saw the nasty bitch or the car again. But the car was covered by insurance, so that part of it was all right. Of course, that part of the event was fine too.

At its best, the African section of the manuscript is a savage indictment of the French colonialists, and, for a while, in his depiction of the sad lot of the natives, Ordon wins our sympathies. Those experiences he later fed into a book, *Biali i Czarni* ("White and Black"), published in Poland in 1934, and now largely forgotten. The African section of the typescript is for the most part a translation of that book.

The final part of the book, devoted to the war years, is the sketchiest, probably the most hastily written. Christine is the only reason several people, most notably Sławka, came to the typescript in the first place, but then Ordon's own activities were not negligible. If he provides a woefully inadequate account of Christine's wartime activities, this is probably due to the natural reluctance of a Pole to dwell in the shadow of his wife. Also, during the period of her greatest escapades, she became involved with another man. After further adventures

in the Middle East and in Istanbul, he got a serious case of food poisoning and went to Canada in order to recuperate. But we know from Masson's book that the main reason for his leaving Europe was that he was mortified at his wife having left him, this woman he never mentioned once in the presence of my family. This, effectively, is where Ordon's book ends, when he moves from where there is a surfeit of history to where there is almost none at all. I wish that he had written another chapter, detailing his stay with my parents, but it's my opinion that the writing, as it stands, was substantially completed *before* meeting them in 1949, when Ordon would have breathed over my cradle. Why, though, would he have drifted to such a remote part of Ontario? My guess is that there might have been some old family connection, possibly dating back to the Polish Ukraine.

Should one believe everything he writes? Scepticism is the best prophylactic. Still, if one were to arrange in chronological order and condense the events of any single life, how believable would the picture they make be? Actually the problems I have with this text are not of a factual but tonal nature. Sometimes the voice *booms* a little. I prefer to dwell on the smaller tales, particularly those from his childhood, for there is a sense in them of something absolutely vital having been preserved. I am thinking of those lives whose memory has been swept away in a much larger historical tide. What of the elderly Jew he saw as a young child, whose face an officer's orderly smashed to a pulp with a stone "the size of an orange?" The old Jew's crime was to have sold candy to some young girls outside a school playground when he had been ordered not to. What shocks so much here is the casualness of a brutal act that would later feed Ordon's nightmares. And who could forget the passage where he describes how as a child he slinked, unobserved, into a cowshed and saw the coachman making love to one of the milkmaids—"like all Ukrainian country girls of those days she didn't wear any panties"—while the housekeeper sat

on a milking stool, watching them. And then, in 1907, at high school, there is the incident relating to a sixteen-year-old Jewish boy of fledgling revolutionary sympathies, who was arrested when the bomb he was experimenting with blew up prematurely and removed his thumb. The boy was due to be sentenced to hard labour in Siberia, so Ordon and his classmates devised a plan for his escape, which involved his climbing over a wall to a getaway horse waiting for him on the other side. What they had not taken into account was the accident that had led to the boy getting arrested in the first place. With his heavily bandaged hand he was unable to get a firm grip at the top of the wall. One of the Cossacks guarding the boy shot him in the back, and another slit his throat. These stories have a solid ring of truth to them.

<div align="center">

4

</div>

ORDON WAS BORN JERZY Nikołaj Giżycki on May 18, 1889, and he died on May 20, 1970 in Oaxaca, Mexico, where he had been living for some years. We will probably never know the nature of that final adventure, although there is mention in his obituary, published in a Polish émigré paper in Toronto, of his having pursued his "ethnological" interests there. The tone of the obituary is cryptic to say the least, for if one reads between the lines the portrait that emerges is of a man who was insufferable, who had to win every argument small and large, and who was in a bitter feud with his very existence. In Mexico, perhaps, where the gods bay for blood sacrifices, he finally shed those feelings of boredom and disappointment that mark the closing pages of his book. Ordon was good at escapes.

I shall end my story where his begins, with a passage in which he relates his earliest memory, which would date to the beginning of the 1890s. Ordon's parents had moved from

Bessarabia to the Ukraine, where the Poles, like my father's family, were mostly *szlachta*, aristocrats of a kind who would soon lose everything that defined their lives. "One day we were returning home from a drive in the country," he writes:

> We were in a large open coach, pulled by a pair of those beautiful Anglo-Arabian horses, which were the pride and joy of Polish estate owners in the Ukraine. The coachman drove into a tunnel-like passage, piercing the house and leading into an interior court where the stables and servants' quarters were situated. When we were halfway through the dimly lit passage a large ball of fire leisurely drifted in, passed between the wall of the passage and the carriage, almost touching one of the horses, continued into the yard and into the open door of the janitor's quarters. As we drove on I could see the ball drift here and there inside the room, come out the open window and disappear over the roof.

I saw something like this in Nikita Mikhalkov's film, *Burnt by the Sun*, dedicated, incidentally, "to all those burnt by the sun of the Revolution." It is a film worth anyone's while. I took the floating ball of fire in it to be purely symbolic, a special effect, which of course it was, except that I have learned since such things actually do occur in nature. What Ordon describes, although never by name, is "ball lightning," a rare natural phenomenon for which there is as yet no scientific explanation. So rare are its occurrences that for a long time such sightings were relegated to the doubtful area of the paranormal. An international conference on the subject of ball lightning was held in Tokyo in 1989, and since then it has become a reputable area of research. Although varied in form, ball lightning is usually of spherical shape and about the size of a football. It can materialise within confined spaces and may have a duration of anywhere from a few seconds to several minutes, and it either disappears silently or with a loud

bang. The sphere often appears to have *a definite sense of direction*. It is to be wondered if this was not the fiery chariot the prophet Elijah saw, or the "burning baskets" in tales of the Apache. Only rarely have people been injured or killed by ball lightning, but the potential power contained within is so great there is reason to believe it might have been the cause of the biblical destruction of Sodom and Gomorrah. Actually, ball lightning seems to have had a special predilection for Russia and its sorrowful empire. Chekhov might have made much of the subject had he been so inclined. As an image of man's life, of how fleeting it is, of how it is buffeted from place to place, scalding what it touches and sparing all else, and, finally, of how it rises into the air never to be seen again, yes, I think we could do worse.

A Voyage through Ormsby's *Araby*

ERIC ORMSBY'S ARABY: I'm not sure where it is, but I know I've been there.

The geographical clues sprinkled throughout the remarkable verse collection of that name are sufficient to place the reader somewhere in Saudi Arabia, although, in truth, the Araby of Ormsby's poetic imagination is wherever one happens to be. It's the sheer delight in language, and what it sparks to life, that makes an actual journey not absolutely requisite to an understanding of these poems. This said, Ormsby sets a scene, and for those who have had experience of the Islamic world, there'll be much to recognise. Although it has been some years since he travelled there, the impressions he creates are as vivid as if he'd just stepped off the plane, desert sand still on his shoes. It could hardly be otherwise. There is something in the quality of the light and how it plays upon both town and landscape that renders the Arab world unforgettable, that makes one silly with nostalgia at times, such that even a whiff of fruit-soaked tobacco on the Edgware Road in London is enough to sling one back into an earlier frame. A snippet of Arabic music from a passing car does the same. These poems would be equally at home in Tunis, Cairo or Damascus, or, more to the point, any of the places in between, where so often beauty and ugliness occupy the same plane.

Araby gives us both moonlight and grease.

Smell is said to inform the oldest of memories.

Ormsby, ever the sensualist, treats us in the opening lines of the book to "the odor of roasting coffee"—coffee which, once ground and steeped, produces an aroma somewhat less familiar to Western noses. "Scent of cardamom wheedled the hard-edged air." I must inform the uninitiated just how appropriate that word *wheedled* is, even though it remains just beyond the reach of logical interpretation. What one smells is the sound that word makes. Cardamom, incidentally, is an acquired taste. The first poem is full of autumnal promise, for not only will "the fattening rains begin," but with them the making of new verses. In lines that are equally complex and simple, the poet Jaham, who puns on his own name—*jaham* means "clouds"—sounds the chord that propels the work through to its very end.

> I drive the syllables
> before me, I call *hâb hâb* to the clouds
> of my words, I gather them in tumultuous
> corrals. The colts of my sinuous vowels
> tug against the leather of my consonants.

Hâb hâb. Say the word twice, quickly, if you want to get anything to move. Allow for only the briefest pause—it should not be noticeable. *Hâb hâb.* This is the call with which the herdsman moves his flock, and that was the utterance I think I once heard a farmer make while driving goats through a village in the north of Syria. I'm not sure I really heard him, though, because there is a photograph I took of that scene, an old man in white *jalabiyyeh* and skullcap, seen from behind, surging forward, almost ready to topple, the back of his head thick enough with character for one to easily imagine his weathered face, its silver stubble, and his left foot raised just high enough for one to see the sole of his sandal; and,

ahead of him, to the right, also seen from behind, a woman in black, the negative to his positive, one arm horizontally raised; so very still she is, so statuesque—something Hellenic there, Phoenician maybe, as if she were standing before the sea, waiting for a ship to come home, rather than inside this arid landscape which water hardly ever reaches; and several feet ahead of them, staring into the camera, a girl of fourteen or fifteen, wearing a long-sleeved gingham dress over cotton trousers, her hands behind her neck pulling her scarf close to, so I might not glimpse or, even worse, photograph her hair which is still just visible on her forehead (which is for her future husband alone to see); and, inside the familial triangle these three people make, the goats, four or five of them, intelligent creatures, looking as though they are about to make a dash for it over the stone wall to the left of them; the white one, the shaggiest of the drove, its front legs already scaling the volcanic rock that's been standing there for centuries, its companions taking note, sniffing revolution in the air; and the old man on the ball, always quick to move, some bit of him knowing in advance what goats think when they want not to follow a straight line—and now, some ten years after I took the photo, I wonder if I actually did hear the man make that cry or whether it is only Ormsby's verse that makes it seem so. *Hâb hâb.*

ARABY, IF READ AS A WHOLE, is a broken narrative. It is episodic in nature, and whole areas of information are not allowed admittance. And probably best so. The main characters are Jaham, a poet and car mechanic, and his oldest friend, Bald Adham, "a sleek grease-monkey from Jizan," a virtuoso with the wrench, as much a poet in his world as Jaham is in his. We never get to know the *hows* and *whys* of their relationship. Actually it's amazing they are friends at all: Jaham has little time for his somewhat dim sidekick's pleas to join Jihad, and is far more refined than Adham, but he loves him with a

tenderness the physical manifestations of which are permissible in Arabic society, and which people in the West all too easily mistake for homoeroticism.

> He wiped the sludgy sweat from Adham's brow
> until his old pal's baldness glimmered like a dome
> at dawn resplendent with sweet truth, a minaret
> emerging from the dubious clouds of night.

The poet as car mechanic is not just possible but probable. Arab poets are *everywhere*. I once asked a Bedouin in Palmyra whether he might direct me to any poets in his tribe, to which he replied, dryly, "Perhaps it would be quicker if I were to find who among us is *not* a poet." Once upon a time, when Arab poets could recite eighty-thousand lines from memory, the desert was a place where they would go in order to purify the language. (Abu Tayyib al-Mutanabbi, the real-life subject of Ormsby's earlier, and, I believe, his first, poetic excursion into the Arab world, was murdered there, some say because of a misunderstanding caused by one of his verses.) The Bedouin were said to speak the purest Arabic. Also there is, among Arabs of such persuasion, a belief in the mystical transference of great knowledge, and in "An Old Poet Bites," Jaham acquires "the mystic mantle of his poetry" from a dying master who sinks his teeth into the boy's lips, "working the poison well into his skin." Jaham we will return to. Bald Adham in "his bandoliers of grease" is a fanatical Muslim, albeit a clownish one, and here we are presented with a splendid dichotomy in that his livelihood comes of what the infidel supplies:

> Adham saw the infidel in every wing
> nut and sprocket, sniffed the heretic
> in air filters rounded by idolatry,
> in barbaric typefaces on air-couriered crates,

blind steel impressed with bestial anagrams
in the Beelzebubic lingo of the Yanks.

And he even falls for a Christian girl, Black Mary, an Abyssinian "thick with fleas of heresy and ticks of doubts." It is a measure of Adham's generous nature that he is prepared to make allowances:

> *Glory glory be to God!* Bald Adham stammered
> as he mounted Black Mary and then entered her,
> a drugged bee asprawl in a nectarous rose.

Adham has got sex on his mind for much of the time, and in "Adham Sings of Internal Combustion," which is an arresting bit of verbal horseplay, a species of Dixie rococo, Ormsby bends junk metal into sculpture:

> The crankshaft slides the piston through the cylinder
> and enters in and occupies and salves
> the block with dizzy vapours from the chamber
> where lightning-frictioned sweet combustion tinders
> the spark plugs' effervescence of ignition.
>
> I love the vaporous and thrummed cognition
> the engine block surrenders as it comes
> to full exhaustion in the flywheel's spoke.

While Adham gets himself into one theological tangle after another, Jaham sees theology as "a tumour of reason;" he is a mystic who takes his reading from "the groins of dunes" and who puts his trust in "the alphabet of stars." Although the poems are not unduly burdened with religious matters, it may be remarked that Jaham's leanings towards Sufism, and towards particular branches of Sufism, would not sit well with the beliefs of his fellows, who being Saudi

would be of the ultra-orthodox Wahabbi faith. When Jaham prays, it is best he does so in private. A man such as he may lose his head otherwise. The God he prays to in the poem "Jaham Praises" is "not only in the disprized pig but in the shit that cakes its trotters and its rump." It is a poem that needs to be read with some care, and preferably not in the company of the same mob that called for the burning of *The Satanic Verses*, for it is driven by the mystical notion, which originated with the Muʿtazilite school of theology, that even the most unsavoury aspects of existence reveal Allah's infinite goodness. "The Egyptian Vulture" is a rather more baroque variation on the same theme. It could well be, of course, that Ormsby, twisted Elizabethan that he is, takes delight in the crude.

If Jaham occupies some spiritual hinterland in the imagination, where the Pleiades are *always* clearly visible, the jinn enter this zone, wolves too, and there blows an occasional pre-Islamic breeze. The poem "Jaham at the Ruins of Recollection" recalls the Seven Great Odes of the so-called Age of Ignorance (*Jahiliyyah*), whose pagan poets, by the way, are still considered incomparable. Ormsby pays them homage in these beautiful lines.

> I grieve for Mulaybid
> now a scramble of ruins.
> …
> I grieve for the voices lost
> in the sift of recollection,
> beyond Mulaybid where the harsh
> ever-seething ridges of the Dahna rise,
> past Wadi Hanifah where the wild
> goats browse, past the smudge of storm-
> strewn campsites whose inscriptions now my eyes
> cannot decipher on the fire-scrawled cooking stones.
> I grieve for the moons we once together watched,

I grieve for the moon
the unremembering sun has bled to death.

Death steals its way into *Araby*'s final scenes. With barely a
warning note, we are presented with Adham's fever, and within
a few lines he is gone: "Adham turned into a salt flat where the
sun / hacks its mirages out of dead men's bones." After he
is buried the angels Munkar and Nakir, a kind of religious
mukhabarat, come to interrogate him in the grave. Stumped
when asked by them to speak of God's attributes, he is given a
good working over, "kidney pokes and left hooks to the ribs,"
and then, after being awarded only a D+, is granted delayed
entry into Paradise. This is followed by Jaham's Job-like lam-
entations and then his own demise. His last words, which are
his epitaph, "I love everything that perishes, / everything that
perishes entrances me," are a response to the two lines from
al-Mutanabbi's poem, which form the epigraph to this work:
"Who has not loved the world from of old? / And yet, there is
no way to be one with it."

The English are probably crazier for desert places than are
the Arabs themselves. An Englishman finds pleasure in what
the Arab must endure. Ormsby is a rare Yankee. A childhood
stuffed with Shakespeare may serve to explain his particu-
lar malaise. Also, he speaks fluent Arabic—which reminds
me: I have had a long-standing appointment with him at the
Nofara Café in Damascus. (It is not all that it's cracked up to
be. I favour the café opposite.) A hunger for the exotic barely
enters the equation, and, as anyone who has ever spent time
in the Middle East will tell you, one of its perils is a powerful
dose of *taedium vitæ*. Something there puts one's brain in a
sling from time to time, and it's all one can do just to rise
from a rock-hard mattress and breathe the traffic fumes. It's
not all bejewelled navels, fancy turbans and aromatic spices.
Was it ever? Anyway, Orientalism is not my concern here.
That's student's fare. The figure of Jaham, it has to be said,

is a dying breed within his own culture. There are few poets today who'd recognise the Pleiades. Ormsby's *Araby*, which represents a remarkable interlude in an already remarkable poetic oeuvre, is a nod in the direction of all that we stand to lose.

THE PEBBLE CHANCE

ONE NIGHT IN ROME, not fully a week ago, I lay awake, my thought ensnared upon a spray of sculpted marble leaves. And there, trapped, as it were, I peered through the gaps between the leaves into creamy white space, feeling all the while a sense of growing disturbance. At last sleep freed me, at about five or so, after which I had one of the worst nightmares of my life. I will not say what it was; it shall remain in the locked cabinet of the unspeakable.

When I enter one of these mental loops, usually it is a strand of music that keeps me awake, sometimes a single bar played over and over, and there is no remedy for it, not even listening to another, vastly different, tune. There's no saying *which* music it will be, although invariably it is something whose effect is circular, feeding constantly into itself, such that I am trapped inside the piece: one of Björk's aural landscapes, for example, the barcarolle from *Les contes d'Hoffmann* or, worse still, the *Liebestod* in *Tristan und Isolde*, when Teutonic sex and Teutonic death entwine, there is no cure. Melody, malady. This time, most unusually for me, it was a visual image that wouldn't quit me—the laurel leaves sprouting from the fingers of Gian Lorenzo Bernini's Daphne, part of the sculpture called *Apollo e Dafne*. Admittedly I had not known of its existence, which is tantamount to confessing an ignorance of the *Mona Lisa*

147

or Ovid or Shakespeare. When, earlier that day, I came upon it in the Villa Borghese, I couldn't tear myself away, and when I went to bed that evening it was with me still, or, rather, what stayed with me was a spectre of marble leaves.

The story of Apollo and Daphne is most famously versified in Ovid's *Metamorphoses*. Daphne, fleeing Apollo's advances, escapes by turning into a laurel tree, which in the Greek language still bears her name. But it is probable that Bernini drew his inspiration from a secondary, fuller, telling of the legend, Giambattista Marino's poem *Dafne*, published in 1620, two years before Bernini began work on his sculpture. Apparently the skilful prosodic unfolding in Marino's eclogue is closely followed in Bernini's sculpture. I've never been sure about these arguments, though, because I don't think creative osmosis is anywhere near as direct as critics would have us believe. The object of influence is usually at a remove, if not a *double* remove. Originally the sculpture, which was never meant to be viewed fully in the round, was placed against a wall, close to the door, so that one approached it from the side, seeing first the material flowing behind Apollo, suggestive of the great speed at which he moves, and then, as one walked to the front of it, the bark of the laurel tree closing over Daphne's lower anatomy, forever sealing her from Apollo's sexual advances. The transformation is completed in the circumnavigating observer's eyes. And there the couple remain, in a split second of frozen time. Whatever the purists say, I am not overly bothered by the sculpture being in the middle of the room. I appreciate getting a peek at the motor that drives the engine. The flowing lines of the sculpture are diabolically simple, such that their execution verges on the impossible.

Bernini, only twenty-three when he started work on it, appears to have invited upon himself every challenge the medium could offer. Having pushed fully against the limits of the physically possible, he never again attempted another sculpture on the same scale. I can only imagine that *Apollo e Dafne* was produced in a state of terror and elation, for a single slip of the chisel would have wrecked the whole. Consider, for example, the weightlessness of Daphne's flowing hair, what an incredible artistic feat that is. So fine is the execution, in fact, that almost immediately one takes it for granted. The whole burden of the sculpture seems, at first, to rest upon Apollo's right foot, while Daphne's almost fully naked body is boosted into space, held back only by Apollo's hand upon her belly. Daphne's fear is such that she does not yet notice she is turning into a tree, and Apollo, although his face registers the shock of what he sees, is still physically caught in the ardour of the chase. What we see in his face is not lust anymore, but the surprise of one who sees into

eternity more deeply than he'd care to. The Greek gods, splendid company though they were, were fundamentally shallow creatures. One has to applaud Cardinal Scipione Borghese, Bernini's early patron, for having admitted so much pagan atmosphere into his house.

Sleepless in Rome? Why not settle instead on the terror in Daphne's face, or on the tragic sense of loss in Apollo's? Or on these finely chiselled fingers turning into leaves? And now, dwelling upon the hallucinogenic qualities of the work, every element of which Bernini willed into place, it strikes me that in order to have seen those leaves, from that particular angle, I would need to have been raised three or four feet above the floor and positioned about six inches away from the marble. Who, though, does not fly at times?

Some years ago, I had been to the spot where, allegedly, Apollo's pursuit of Daphne took place. The gardens that to this day bear her name are a few miles south of Antakya in the Hatay province of Turkey. Antakya is the ugly offspring of Antioch, the city fabled once as "the fair crown of the Orient." I caught a *dolmuş* from there to Daphne. There is a local legend concerning the origin of these gardens. When Daphne made her escape, Apollo, in his grief at the loss, shot all his arrows, an act psychologically odder than one might first suppose. The tip of one, with his name on it, embedded itself in the earth. When hunting in these parts, the Macedonian Seleucus found the arrowhead, or rather his horse did when it churned the soil with its hooves. After reading the inscription Seleucus dedicated the area to Apollo, planted a cypress grove, and built a temple near the spring in which the oracle of Apollo was supposed to reside. As the grove of Daphne was considered sacred, it served also as a sanctuary to debtors, criminals and runaway slaves. They could not be touched within the ten-mile circumference of the grove. And it was in these gardens where, much to the disapproval of the Christian orator Chrysostom *and* the

pagan orator Libanius, the inhabitants of Antioch took their pleasure. So infamous did those gardens become as a place for sexual licence, the city nearby was sometimes mockingly referred to as "Antioch near Daphne." In 351, Caesar Gallus, in an effort to combat paganism, had the remains of Saint Babylas, Bishop of Antioch, who had been martyred almost a hundred years earlier, moved from the Christian cemetery at Antioch to a spot in Daphne near the Temple of Apollo. (This, incidentally, is the *first* recorded instance of a saint's translation.) Julian the Apostate, whose shortcomings were magnified at the expense of his many virtues, sought to reverse the Christian tide. When, in 362, he came to Daphne he was informed of "bodies" in the neighbourhood, whose presence "blocked" the oracle. After a purification ceremony, the relics of Saint Babylas were moved back to Antioch, his stone coffin escorted by Christians singing from Psalms 97:7: "Confounded be all they that serve graven images, that boast themselves of idols!" (This, presumably, is the *second* recorded instance of a saint's translation.) Julian then ordered the restoration of the Temple of Apollo at Daphne. When he went there to celebrate, expecting much pomp and circumstance, all he found was one priest (pagan, of course) together with a goose that he had fetched from home for sacrifice. A contemporary describes Julian's eyes as being at once terrible and full of charm.

Daphne is today a pleasant spot, and although much of the area is given over to cafés, all one need do is close one's eyes and listen to the sound of natural springs, the same that lulled the Antiochenes. A sound of melancholy Turkish music fills the air where once there were Roman, then Arabic, refrains. I left in the branches of a laurel tree, perhaps the very one that Daphne had turned into, or a descendant of the same, some verses written by a friend of mine, who, unable to move any distance from his bed, desired that I should leave them there. Almost every wish of his is a dying one. Such is their number,

though, and so rarely are any of them realised, that they will ensure, I hope, his survival for a long time to come.

A FOX PEERS THROUGH THE WINDOW of the room in which I write. No metaphorical creature, it comes presumably from somewhere along the Thames, where there are quite a few of them these days, city foxes, so brazen they slink right past one. This one would need to have crossed busy traffic to get here. Moreover, access to the backs of these houses is not easy, nor can there be any particular object in slipping through barricades. The garbage goes out front, the squirrels stay in the branches, and the cats keep their distance. I can't imagine what it is doing for sustenance, although the lady next door, a veteran of the Soho sex club scene, is putting out scraps of food for it. Anyway, it is the same fox that gave a sickly cry the night I got back from Rome. The sound is that which a vixen in heat makes. I dimly recall a line from Janáček's opera, *The Cunning Little Vixen*, about how he who partakes of a fox's tongue becomes invisible, which is how I feel in relation to the silhouette outside. I may as well not be here for all it cares. I wonder what the purpose of its visit is and, if it's true that all things have a purpose, whether it has anything to do with this prose.

ANOTHER KIND OF DISTURBANCE COMES, a more sober one, which I believe may be connected to my own continuing poetic silence. I have been waiting for a breeze, an unbidden factor, a gondola painted in red and blue stripes. Would that it were true, what friends say to me, that I am secretly composing verses. Admittedly my inclination is to say nothing at all that would persuade them otherwise: I should like to believe something is going on inside me, if not actually on the page, a mustering of creative forces. What is the writing of this prose but an attempt to plug the holes poetry's absence makes? I do not especially want to put myself on centre stage here, but I

begin to wonder whether this poetic silence is not connected to my deeper fear that our civilisation is acting upon a suiciding principle, in the face of which, in the same way others might doubt the efficacy of prayer, I call into question the apotropaic powers of verse. Did not seeing the *Apollo e Dafne* and, later that night, as though sent to torment me, its sculpted leaves, revive that crisis in me? Was Bernini not cushioned by certainties, which peevish minds would now dismiss as the arrogance of his age? And have we not swapped bigger for smaller absolutes, so that all that the world has left in its cupboard now are weak ironies and surrogate moralities? A friend rumbles me, reminding me that poets of all ages have spoken of and despaired of the decadence of their times. What I am looking for, he tells me, is an easy way out, whereas, really, what I need to do is probe deeper and to touch, even obliquely, whatever it is that is consuming me. I struggle against my own reluctance. I cast about for a missing word, one that will shift the onus from civilisation's discontents onto mine, and which will allow me to quit the stage with a modicum of grace. And then, hearing my friend's scolding yet kindly voice, suddenly it sails into view, the word I had been looking for. *Paralysis*, then—mental, spiritual. A brilliant critic, Walter Jackson Bate, speaks of "the burden of the past," although I wonder if that phrase ought not to be accompanied by "the burden of the future," the millstone in the brain that comes of too much knowledge. The scientists say *all is finite*, which is what the Qur'anic inscription on my wall says, which I purchased from an elderly calligrapher in Damascus. The best reeds, he had told me, come from the marshes in Iraq, which now a tyrant has destroyed along with its people. This same man was working on a calligraphic computer image. A shudder runs through this prose. Will nothing survive? One day even those marble leaves, signifying, as it were, a wink of eternity, will shatter into a thousand pieces. And the Eternal City itself will collapse. I wonder, then, how, between the burdens of past and future,

one is supposed to be able to move. Surely, though, I am mistaken in my doubts—to produce a line is, in a sense, to purge oneself of uncertainties, or, to put eternity in its proper place, to situate past and future within the *now*, which is what the mystics teach us. Still I wonder if I am not right to be wrong, whether wrongness is not a means of getting at what's true.

What became of the ancient gods? At the time of their demise, were they like snuffed candles in people's minds or did they flicker for a while? I suspect they were kept mentally in reserve, just in case God, the God of the Jews and the Christians and later the Muslims, failed to be anything more than a passing phase. It could be, of course, that, once demoted to the commonplace, the gods simply had to amuse themselves. When I left the Villa Borghese, heading in the direction of the Via Veneto, I found them, at the very edge of the grounds, a group of elegant, regular, white-haired Roman gods playing the ancient game of *boules*—although, this being Italy, they were not playing *boules* but *bocce*. Same game, same rules. The beauty of the game lies in the fact that so much depends upon the wedding between skill and chance. One must seek to absorb within oneself the irregularities of the world's surface so that, when pitched with intelligence, one's ball might come as close as possible to the *cochonnet* or, this being Italy, the *pallino*. A tiny pebble can alter its course. The direction in which the ball then goes may be the wrong one— equally, it may be the right. There is, I believe, an element of the religious in the game—the penalty for even the smallest misdemeanour is harsh, a player may be sent into exile, and because strict observance of the rules is required, and with it, as in prayer, much concentration of mind, one must not disturb the atmosphere. That afternoon in Rome, storm clouds gathering in the skies, the players—the gods, I mean—were artists making what they could of their givens, their *materials*, while at the same time vying for the kindly attentions of the Muse. Suddenly one of them, who I think may have been

Jupiter, aware, perhaps, that the weather was about to change, took a bold gamble. Somewhat ostentatiously he threw the ball overhand so as to effect the necessary spin for the drop shot that in French is called *la portée* and for which, alas, I do not have the Italian. As the curve of his ball cracked down hard upon the curve of another, simultaneously he performed a pirouette, that is, he did so *before* he knew what the result was, and, with one arm raised, a finger pointing to the clouds above, and with a grace impossible to describe, for just a frozen second or two his stout but not at all plump body was boosted into space.

Apropos of the above, I have just finished editing a series of conversations I recorded with the poet Christopher Middleton, much of which is given over to the process of writing, and there is one passage in particular in which he speaks of the wedding, in language, between skill and chance:

> *And you try things out.* It looks final when you've got it out there, but, while you are composing, the intrusion of this unbidden factor is an odd thing out of the blue and you get stuck, wherever the blue is, for a word nudges its own way into position. You know it's wrong, but it's getting in the way for another one and then *finally* the right one, unbidden, nudges that other one out of position and there you are, you have it, though you couldn't have excogitated that word, but it's somehow seeking company with the others because it is anomalous in their company, normally, but under these conditions it belongs there with them and often, I think, it's the musical or *quasi*-musical, the phonic qualities of the whole ensemble which, as it were, welcome that one missing word into the company of the others.

Suddenly they are interchangeable, the one word nudging another out of position and the random shot, the wild particle that surely is more than just a fluke. It is the breeze one

has been hoping for, which will make one's boat move. And it's what makes marble flesh, the fur on an animal's back rise. Oh, and I have seen that Roman before, in some painting, I believe, but I can't remember which one. All I can say for sure is that in it he is seen from behind, leaping upwards, solidity not a hindrance. As with Apollo and Daphne, time has not caught up with him, and, without his yet knowing it, a redundant god brings into play art's unbidden swerve.

THE *POETICAL REMAINS* OF
MADGE HERRON

S HOULD ONE WRITE AT ALL, while struggling against the past tense, of a person who is still alive? Certainly people speak of her still, sometimes affectionately, at other times with tightness in their voices. Sadly, the woman who dismayed and enthralled us no longer communicates. If words alone keep our souls pegged to the line, what goes when language goes? She slipped first into the Irish Gaelic of her childhood, sloughing the English in which she wrote, and then into silence. We shall hear from her no more. What remains, though, are echoes of her remarkable verses. Somewhere, in one of her poems, God knows where, a mole comes to the earth's surface, on a hill above Belfast, and asks, "What's the latest word on spectacles?" An IRA man makes a troubling appearance at the end of another poem, such that we cannot be sure what the author's attitude towards him is. And in another, God rides on a bicycle through the air over Kentish Town, dropping a ladder, inviting the old ladies to come out of their houses and to climb heavenwards. She does in words here what Stanley Spencer did in oils, which, I believe, makes her, in an area where so often bad passes for good, a genuine primitive. The above examples, by the way, are paraphrases: there are no published versions to which one may refer and reset one's ear. As for the life, *her* life, a time for anecdotes will surely come, and, when placed end to end, they will produce

a remarkable picture. They will make a testimony to the irrepressible. Against one's natural reluctance to bury one's fellow in *the coffin that words make* is the desire to do with words what they have always enjoined us to do, which is to keep memory alive. Still, it is not her biography that concerns me, not yet, but rather the ticklish business of her verses.

I first encountered Madge Herron in 1975 at Poetry Round, a weekly poetry workshop that was held at the old Poetry Society premises in Earls Court Square. The high-ceilinged room was witness to some terrible scenes of psychic, bordering on physical, warfare. What kept it from getting that far, although there were evenings when it got awfully close, was the chairmanship of Roger Chinery, who briefly I wish to memorialise here. There were in fact two chairmen, the other being Dennis Doyle, who I will allow to speak for himself should he care to. They took turns and were both, in their separate ways, perfectly capable. The first was, in his quiet fashion, one of the world's zanier people. A sizable area of his home was taken over by rows and rows of shelved box files, his "Brain" as he called them, and into which went anything of interest, literary or otherwise. The only problem is that he seemed not to know where things were. The man wanted for an index. "Ah yes," he'd smile. "As I was saying, yes, *um*, the file on volcanoes is not *quite* where I thought it would be." This was the case too with snakes, UFOs, church architecture and, presumably, the many files he kept on, and the recordings he made of, the people who regularly attended Poetry Round. I made a tape for him once, which with luck posterity will erase. I suspect he may have made one of Madge Herron too. If so, if such a tape exists, it may well comprise the greater part of her *Poetical Remains*. I employ a near obsolete term deliberately here, for poetical remains are what they would most certainly be. There are just a few poems that she wrote on scraps of paper, which she gave to people she trusted *at the time*, and there are, as far as I know, only five that were actually published. Otherwise

they may exist nowhere but in the sealed mind of she who composed them. As for Roger Chinery, the news, I fear, is of his sad and lonely demise. As for his presence during those years, his was, I believe, the authority of the truly humble. I wonder, not a little selfishly, what became of his Brain. And I wonder too what became of his verses, many of which he would labour over for decades at a time.

I shall return now to the Round and to the lady whose work I celebrate. I write this in a week when I have received J. G. Nichols's marvellous version of Giacomo Leopardi's *Pensieri*, its title just a little weakly translated as *Thoughts* when *Pensieri* would have done just fine. There is a lengthy passage in which Leopardi speaks of the "vice of reading or performing one's own compositions in front of others." He goes on a delicious rampage, although I suspect he protests a little too loudly in his solitude:

> This is an ancient vice which was tolerable in previous centuries because it was rare, but which today, when everyone writes and it is very difficult to find someone who is not an author, has become a scourge, a public calamity, one further tribulation for human beings. And it is not a joke but the simple truth to say that, on account of this, acquaintances are suspect and friendships dangerous, and that there is no time or place where an innocent person does not have to fear being assaulted, and subjected on the very spot, or after being dragged elsewhere, to the torture of hearing endless prose or thousands of lines of verse, no longer with the excuse of wanting to learn his opinion—an excuse which for a long time it was customary to give as the reason for such performances— but solely and expressly to give pleasure to the author by hearing them, apart from the inevitable praise at the end.

Our Wednesday evenings were dedicated to the practice of ancient vice.

A Scotsman came once, whom nobody had seen before, who looked like a Gaelic Alighieri, with his God-furrowed brow and philosophical nose. If a poet could be measured by appearance alone, here surely was the author of some master-piece. When called upon to produce a verse, he, with a slight nod of his brooding profile, reduced the room to silence. The sense of expectation, when the expectation of most people was only for themselves, was palpable. The stranger read a short lyric called "The Rose," which at first left us speechless. It would be no bad thing to remember how it went, for the poem was, I believe, a worthy candidate for *The Stuffed Owl*. It might have made a tolerable valentine. A laugh that began as an asthmatic whistle, expanded to a wild cackle and then faded back to a whistle came from one seat of the circle.

"By Jaysus," Madge Herron cried, "I never heard the like since I was a girl masturbatin' up top of a haystack!"

(The reader will have to decide whether she was speaking in "stage" Irish here or in the voice of a generation who are now said never to have had that voice. Modern sensibilities may be a touch sore but, by Jaysus, this was as she spoke.)

I think even the Scotsman was amused, although we never did see him again. When it came her turn to read, she did so with her whole body, her eyes closed, the words driven by sheer physical force. She could hold the stage with an intensity rarely seen in literary circles. Always she read from memory, or perhaps from somewhere even deeper than that, from the soul's furnace where poetry is made. A poem was rendered as if for the first time. She would constantly *surprise*. She is not a poet for the page, I suspect, and in any case, even when she was able to, she hardly ever committed her words to paper. It might even be argued that she is not a technically accom-plished poet, but she is a remarkable one all the same. She burst the pod of regular verse. She did tend to read the same few poems over and over, but there were considerably more. This I know because I attended a reading she gave at the Poetry

Society, and certainly there were enough to fill three-quarters of an hour. That reading, incidentally, was a triumph, but her greatest performance was yet to come, in the 1980s, at the Abbey Theatre in Dublin, an event especially poignant for reasons that will become clear. As early as the mid-1960s she entranced poets such as Derek Mahon, George Barker, Dannie Abse, John Heath-Stubbs, Anthony Howell and Dinah Livingstone. Eddie Linden posits the notion, a convincing one at that, that in a sense she translated herself out of the Gaelic, which was her first tongue. Certainly she carried within her the oral poetic tradition of her home, which was the mountains of County Donegal, close to Fintown. Linden's memory is of her being able to recite whole swathes of early Gaelic poetry. "She is a born poet," he says, knowing full well how rare that is.

The curious thing is that across the Irish Sea there were those who, until recently, would have said she was a born actress. It seemed to be in England—in Kentish Town, to be more precise—that she let go her poetry side. The poetry was at first news to the Irish, for it was as an actress she was remembered. She had been with the legendary Abbey Theatre in Dublin and it was there, apparently, she met and quarrelled with George Bernard Shaw. Another version of the story places the altercation in London. Reportedly Louis MacNeice brought her to England to play a leading role in a BBC Radio production of one of Brian Merriman's plays, *The Midnight Court*. This is part of a hidden history of which she let slip only a detail or two. All has yet to be properly confirmed, and such errors as the reader may find here are mine alone. The mystery is why she ever quit Ireland for the hard life she pursued here. She scrubbed floors and at times was close to destitute. She became a familiar figure on the Kentish Town Road, with her dogs and the pram in which she pushed the more infirm of them. If she could be considered a dividing line between those who were more privileged than her, which comprised most of the human race, and those who were less fortunate, then may she be saluted for her compassion towards the latter. She was affectionate towards the Irish navvies, and although she puzzled them with her eccentricities, they returned her affection. She took *on* people; others, kind souls, she booted into the outer darkness. There are stories to be told, some of which might amaze. At Poetry Round once, she wept aloud for the IRA hunger striker, Bobbie Sands, not for any political reason she'd care to state, but for what she too must have experienced from time to time. "Have none of youse here," she sobbed, "ever felt the hunger pinch?"

She had many offers of publication, mostly from magazines. I, for one, as chief editor and sole proprietor of the Earthgrip Press, whose printing works, when not inked and cursed at, lived beneath the kitchen sink, would gladly have printed

a pamphlet of her poems. She never even went so far as to decline, for my invitation was a preposterous one. I think too she would not approve this piece, nor would she approve any written a hundred years hence. She professed a horror of her poems being stolen, but distrusted the very means that would have made of them her intellectual property. There were various schools of thought on the matter. One was that, yes, she feared her poems would be stolen by other people. Another was that she looked upon publishers as thieves. Still another was that she was the most pure of poets, firmly rooted in an oral tradition, and felt that to put her works onto the page at all was to compromise the Muse. Oddly enough, five poems did slip the net of her reluctance: two of them in *Pillars of the House: An Anthology of Verse by Irish Women* (1987), another two in *The Poolbeg Book of Irish Poetry for Children* (1997) and one in the very first issue of *Aquarius* (1969). Another, written partly in her hand and partly in mine, is elsewhere, and I'm ashamed to confess I know not where. One evening she began to write out a poem for me in that strange childish hand of hers, and then, when her fingers would no longer move, she asked me to complete it while she recited the rest to me. She swore many a time she'd take her poems to the grave with her. I have suggested three reasons for her refusal to publish, two of them pathological in nature and the third perhaps a shade idealistic. I wonder, though, if it were not something else, if she were not denying the world against which she rages the only thing that was truly hers to give. I should like to deny her, in the room where she now is, that dubious pleasure.

Note: I discovered this morning, just after I put the finishing touches to this piece, that three months ago, on June 19, 2002, the Bicyclist flew over the rest home where Madge lived.

C. M.: A Portrait

I WAS IN BED WHEN Christopher Middleton first entered my life. I had been sequestered there for almost a month with a refractory spine. The drugs I took, pure codeine at one point, were such that I wept through the whole of World Championship Darts, so moved I was by those Apollonic figures, a band of ogres really, on the flickering television screen, and also by those sacrificial helpings of chips, sausages and baked beans that the audience consumed at their beer-towered tables. It was an aspect of English life that had completely bypassed me. The doctor, finding me in this blissful state, instantly put me on a duller regime. I was forced back to poetry. My literary life, insofar as I was able to pursue one, for my eyes swam all over the page, comprised a small pile of Middleton's books on the floor beside me. It was, in truth, my earliest acquaintance with his work, in particular the handsome 1969 Fulcrum Press edition of *Our Flowers & Nice Bones*. (Oh my, he's got a brain for titles.) I do not wish to give the wrong impression here, for Middleton is primarily a man of words, of words exquisitely bound together, but in my drugged state I was peculiarly receptive to his poem "Birth of Venus," which reads in full:

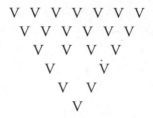

 Could I really have been pondering the absence of that single *V*, finding in this something at once symbolic and full of erotic promise, when my wife came in and dropped in front of me a letter postmarked Austin, Texas? I looked at the sender's name and address and then I glanced at the volume beside me. This, surely, was proof enough that I'd reached a purely hallucinogenic stage of my existence.

 I do not wish to beat on about the *Zeitgeist* or the want of one, or about how whatever it is we're slumming our way through now is notable for its absence of generosity, especially in literary matters, but here, giving me succour when it was most needed, was a letter from a stranger full of kind words about a poem of mine he had read in a magazine. The impression this made upon me, especially in my physical state, was incalculable. One should not make too much of a man's age, but it is rare to find poets of Middleton's years and stature giving unsolicited encouragement to poets younger than themselves. I think this also has to do with Middleton's own youthfulness, which, in his work, is characterised by restlessness, a desire to stake out new territories. Age does not deter him—juvenescence excites. Could he be one of the few to have properly understood Pound's injunction: MAKE IT NEW? I believe so, for what he writes is a matter of what he requires; it is born of necessity: there is no concession to prevailing modes.

 The letter marked the beginning of a friendship whose rewards, for me, have been immeasurable. A few months later, in the summer of 1992, Middleton came to England and to supper at our place. I shall record these first impressions of the

physical man because, to some degree, they mark the interior one as well. There is a curious manner to how he walks, almost as if he were wearing bedroom slippers, a sort of floating aspect to him, and, quite frankly, the impression he made was one of a rather cool dude. A medallion hung around his neck and the belt buckle he wore was as large as a horseshoe. Well, I might dissemble a little. If the man who soft-shoed into our lives was a Texan of one's imagination rather than of the real world, the manner and voice were English in a way most English people no longer remember how to be. I have never had the opportunity to observe him in his adopted milieu, of course, so perhaps I am mistaken. It may be that he orders his glass of milk with a drawl and that tumbleweed does indeed tumble through the streets of Austin. What a strange and equally *not* so strange place for him to be.

I am sorry to dwell at such length upon a man's attire and how it conceals the man inside, but I think there is some aspect of this in the writing, the precise *English* that comes of a fine education, such as this country offered once upon a time, dressed up in some fairly exotic clothes. If the ability to speak in perfectly constructed paragraphs, with an audible carriage return in the voice, is one of his many gifts, I do not wish to give an impression of him being an academic. Although he was for some decades attached to academe, the experience has never, in the way it so often does, starched the poetic voice. Wisely, perhaps, he has steered clear of teaching English literature. The immense intellect comes always with a twinkle. Middleton is the only person I know who can get up in the morning, light up a cigarette at the breakfast table, and say "I had an interesting dream last night," and instantly have his listener enthralled. I can never think of him coming to any subject other than from a unique angle. Indeed, to be in his company is to partake of an alternative view of the world, and by this I do not mean one that is flaky or Daliesque or manufactured, but one that is deeply scrutinised. The poetic vision

is likewise. Though this makes him a hugely difficult poet to place, and the tendency has been to dump him somewhere in the middle of continental Europe, where he can do the least damage, I would claim for him a species of Englishness constantly at war with itself.

> And I wanted not that Englishness;
> I wanted deliverance from you so soon,
>
> From the sticky stuff you weltered in,
> Leaf, branch, and bole in your shade they dispensed
>
> The glue, the fragrant glue, but your blossoms,
> Lady, they did provide the pleasure of tea.
> —from "The Lime Tree"

The fact he is a polymath does not undermine my case, for the best and the *most* English poetry, from Chaucer on, is that which has fully absorbed foreign influence. In Middleton's case, of course, one must add big American skies, and perhaps it would not be too fanciful to include Turkish ones as well, beneath which he has spent many a season. Could it be he goes there in order to divest himself of both Old and New World stodge? There is something most liberated and liberating in those poems of the Ottoman landscape. I think too the "American" voice contains within it much from south of the Rio Grande. As I've said already, his essential Englishness puts on some fancy clothes.

I'm not sure if the critical language that might bottle the essence of Middleton's prosody is or will ever be there. This is not to discourage any attempt to do so or to denigrate those already made, but merely to say that the work is, in both the poetry and the prose, mercurial and not easily captured. I have rarely known a mind to move at such speed and yet hold in such tight rein the forms its speculations take. There is so

much going on in any one poem of his, a word may be so heavily freighted with meaning, for instance, that at times, I believe, he is disappointed by the failure of others to grasp a particular point. On occasion I have tried to tiptoe past him, but always he catches me. Against such public indifference and private reluctance he poses a serious challenge. Historically, I believe, he has his precedents—Beddoes, for example—figures who loom hugely at the sidelines.

I have noticed that with many writers there is an adjective they will frequently use, a verbal tic even, both in their speech and in their prose, that points, probably unwittingly, to some dimension of their own work. With Geoffrey Hill, for example, it is *exemplary*; with W. S. Graham it is *wow wow*; and with Middleton it is *abstruse*. It is important here to note that the dictionary defines the word as not only "hard to understand" but also "profound." This is precisely where Middleton diverges from so much poetry being written, in which despite its claims to newness the seemingly abstruse is merely *obtuse*. With Middleton, on the other hand, one's efforts to understand are hugely rewarded. One's comprehension of any poem of his is never complete, for in the best of them, which, for me, are often the most apparently direct ones, such as "Dead Button" and "The Old Tour Guide—His Interpreter," poems that one *thinks* one has got a handle on, there is, ultimately, something in them quite unfathomable. All I can say is thank goodness, well done. It means, too, that the poems one keeps revisiting are never quite the same as they were the day before. They take off and they put on clothes. I shall return to the poetry, but first allow a moment's pause in which to consider other aspects of his literary activities.

The essays collected in *Jackdaw Jiving* are, many of them, the finest in existence. There is in each of them the sense not only of an object being scrutinised but also of our being able, at the same time, to observe a mind at work, at the very moment of its discoveries. What we get in effect is a double unfolding.

And just when one fears a nod towards academe, suddenly the direction of the argument changes and the reader is swept to a place where he could never have expected to be.

> All this time I am chewing something, as in a dream; it is not cake, but fat. I sit down at a table, opposite me another man is sitting, ordinary, without features. I start to spit out lumps of fat, turning politely aside. Nauseous, the feel of them in my mouth, soft and cold, but some pieces won't come out. I spit four times or five, and still a last piece sticks in or behind my teeth. I am ashamed, disgusted, the grief is seizing me now, I say something to the man opposite, he turns away with a shrug, not a word, but he (who is I) cannot help me. Then I stop spitting, I put my hands to my head, lower my head to the table and say, only for myself, weeping now, slowly: "The terrible suffering."

This is a poet's prose, sharp and concise, as opposed to the blur of poetic prose. As for his essays they are the gathered-in harvest of a man who has learned his trade; there is not a poet alive who can afford *not* to look at them. They are the chapters of a secret literature, a secret book that we all yearn for.

There are many things that can be said of his translations, but for me the most important is that never once does Middleton the poet interfere with Middleton the translator. He fully surrenders himself to the poem he translates, ever mindful of the form of the original poem, so that if it is a German or French sonnet, an English sonnet is what he will produce. There is a basic humility in this, that one of the most experimental poets of our time should set aside his own voice. My own favourite translations of his are those that perhaps he himself was most surprised to have made, the lovely Andalusian poems, which come via Spanish translations of the Arabic. I think it may be the only time he has translated at a remove, but the results feel magically close.

Petition for a Falcon

O king, whose ancestors
 were noble of mind and blood,
To whose favors, a rope of pearls,
 my throat has responded,
Adorn this hand of mine
 now with a falcon.

With a falcon honor me, one
 with shiny wings, feather
Ruffled by the wind, Proudly,
 hand at play with the wind,
I will launch it at sunrise, capture
 the free with my captive.

 —'Abd al-'Aziz ibn al-Qabturnuh

Which, among many valuable lessons, is the most important he has ever given me? I struggle to remember the exact words he used, which had to do with what it is to *actualise* in the making of a poem, to make a word work in the poem as it would in real life. I will focus on "Gelibolu," not only because my wife and I are its proud dedicatees, but also because he wrote part of and indeed completed the poem at our place.

For the seven minutes it will take, at most,
To slant these figures over their borderlines,
Surprise yourself: Be the lank waiter
Waving his tray in Çanakkale.
 Along the Promenade
People dawdle, arm in arm. He feels a cooling,
Feels in the air a cooling, and he knows—
A multitude of Greeks, Armenians, and Jews,
How they felt it ninety years ago.

Would it be insensitive of me to inform the reader, in case he doesn't already know, that Gelibolu is the Turkish for Gallipoli? Middleton is not about to give us too much of a helping hand over the top, although the clues are there. "Slant these figures," he writes, and here the words themselves, as transformed in the brain, assume the profile of soldiers marching up a slope. We remember that silhouette from somewhere, perhaps from the cover of a paperback novel about the Great War or a still from a film archive. Consider, though, the scene and how much in the poem is set against the banalities of a holiday existence. We are taken thrillingly through the boredom of an end of day's chores. We hear even the background noise, the intrusion of Afro music, Western really, against which the Turkish "jangle of an oud, / Squeal from a clarinet" scores a victory of substance over noise. The sound of the parasol coming down, "a snap, a shrug," takes the waiter to thoughts of a woman presumably nowhere other than in his desires. "Will the lady have taken everything off?" Of what else do waiters think? And so he finishes his chores, "plucks the iron stalk / Of each dismantled flower from a socket." Comes now a moment of great sensuality.

Nonchalant now he stands and sweats,
 Sinister hero,
Hearing the gulls cry, a little dazed
 By so much clarity,
The last moment, sweetest when it comes—
Over the thud of ferryboat engines, a whiff
Of grilling fish delights his nose,
 And here she rides,
The schoolgirl, on her bicycle. She brings
For him her smile. And from one handlebar
She has unhooked her twitching fish bag.

Twitching: is that not a happy choice? The poem turns on that single word, where the fish gasping for air—we are never told

so but the image is implicit—anticipates the gasping of the soldiers whose ghosts, according to local legend, still haunt the environs, "asking for water, water"—note that repetition, how the words themselves reach for the hip flask. And so, in the actual time of the poem, the seven minutes it takes to reach the end, where do we arrive?

> Can I lift, now the waiter downs his tray,
> A last glance, even, to the hills?
> Convex craters,
> Ivory on dusk, the honeycombed efficiencies for him
> Have no possible interest, constructed there
> Some distance from the graves,
> A more or less decent distance from the graves.

Is there not something quietly devastating in that "more or less," when, almost a century away from the exactitudes that huge tragedy demands of us, we are numbed into the approximate? Day by day, I watched as Middleton struggled for the right words, the ones that would "actualise." The *jangle* of the oud—we did argue over that word and the many that stood in its place—is not exactly right except where it most matters, in imagination's ear.

What the hell, though, why come all this distance if not to divagate a little? The man's a friend, after all, and not a literary exercise. The poems speak for themselves, are there for anyone wanting to surprise himself before Christmas comes. A sense of worth, though, demands coinage. Silver's the path I'll take, gold my excuse. We were eating fishcakes in Cambridge. Yes, those and cricket are two elements of England he is not prepared to waive. We had just attended a poetry conference that afternoon and later that evening he was to give a reading of his own work, which would include "La Morena," "the dark one," the poem in which a white and rather voluptuous cow figures.

She will eat dry bread if there's none better
My white cow who tastes always of oranges

My white cow who goes one better than the snow
Her quim is heaven for whom she pleases

A celebration of female sexuality it may be, but it was not so, or perhaps it was *too much* so, for a small band of feminists, one of whom later fought back with a white cow poem of her own. I quite like the lady who wrote and subsequently published the piece, but I think, sadly, she failed to grab the subject by the horns. Anyway, back to the fishcakes—I had had my fill of the afternoon session and Middleton, who must have registered my struggle for oxygen, pulled from his pocket a coin, which he held like a talisman between his fingers.

"What do you make of this?" he asked.

Since childhood he has been collecting coins, and it was here, in a Cambridge market, a few years before the war, that he purchased his first coin. A passion for numismatics, Roman in particular, has followed him all through life.

"It's from Antioch," he continued. "Whoever minted this coin may not have spoken the language. If you look here, you'll see he made a spelling mistake."

I collected stamps once, and remembering how the old, immaculately engraved ones were like small windows opening onto strange worlds, I was able to observe, as though my old enthusiasm were being mirrored back at me, the wonder in his eyes. Now, wonderment surely is the most contagious of all mental states and Middleton is, as anyone who has ever been in his company for a while can testify, a lethal carrier. Soon after, inspired by his example, I began to read everything I could find about Antioch, "the fair crown of the Orient" (*Orientis apicem pulcrum*), whose streets were positioned at such an angle that they would catch the breeze blowing off the Orontes. What a thing for a whole city to be a poetic device. A year later, when

I was about to make my second journey to Syria, in order
to complete a book of my travels there, I decided I'd go via
Antakya, the greyly modern Turkish equivalent of Antioch. I
was, perhaps, canvassing for an ancient breeze. Shortly before
I left, Middleton presented me with a third-century bronze
coin from there. A superb piece, it bears the finely engraved
image of the emperor Diocletian, whose bullish profile, he
told me, would befit a captain of the Bulgarian football team.
On the reverse side is Tyche, the goddess of good fortune, who
presided over the city, but whose benign presence could not
save the place from eventual destruction by earthquakes and
Mongol hordes. The coin travelled with me. I showed it to
Padre Domenico in his parish in Antakya. "Ah," he mused,
"very fine! Very fine!" I think dazzled by the metal he tem-
porarily put into shade any memory of Diocletian, who was,
after all, extremely brutal towards his Christian antecedents.

Some months later, I came across an obscure mid-
nineteenth-century account of Antioch in which its author,
F. A. Neale, describes floods that come down the mountains
with such force "stones that ten men could barely move, have
been rolled past my door, with a booming sound like thun-
der." Also, many antiquities were disinterred, including "an
incalculable number of valuable coins," the majority of which
were swept into the Orontes. Afterwards, children with sieves,
sticks and brooms would go through the gutters, looking for
coins and ancient jewels left behind in the mud. What they
found they sold for a pittance to a Turkish dealer in antiqui-
ties called Hadji Ali, who in turn sold them to English trav-
ellers at an immense profit. So avaricious had Hadji become,
it was only a matter of time before he himself would become
unstuck: Hadji possessed a magnificent emerald "which pre-
sented the striking device of seven distinct heads, on being
turned in as many directions," and which he refused to sell
on account of its great value. A visiting Turkish official want-
ing to deprive Hadji of this treasure, most flauntingly NOT

FOR SALE, had him accused of dealing in antiquities without a government licence. Hadji was deprived of his emerald, given the bastinado and sentenced to several months in prison. When released he had to start up his business again from scratch, presumably giving the children even less than before for their finds. I fancy my coin, which must have passed through many hands, Christian and Muslim and pagan, later passed through Hadji's, and then, over a hundred years later, through Middleton's as well, and finally, finally into mine.

A SINGER FROM FERGHANA

ONÂJÂT YULTCHIEVA HAS DUENDE. She has more of it than any singer I have seen or heard in recent times. She sings into being whole landscapes. She is Uzbekistan incarnate, or, rather, Uzbekistan's sweeter side, an Uzbekistan without its Tamerlane. One day, perhaps, I will be wafted there upon a woman's voice. The songs Monâjât performs come out of a centuries-old tradition that is at once courtly in substance and mystical in essence. The aesthetic core of this music is the *Shash maqâm*, the repertory of Central Asian classical music, much of which builds upon the works of the great poets such as Nawâ'i, Fuzuli, Hafez and Jami. The relationship, in the Orient, between poetry and song is absolute. A Naqshbandi Sufi, Monâjât lives up to her first name, which may be translated as "prayer" or "supplication" or "ascent towards God," although, in truth, I have been given to understand, usually with an approving hum in the voice of whoever is telling me this, that it describes a state of grace close to untranslatable. She herself has spoken of how its meaning has made her attentive to every plea there is, and also of how it infuses her songs and the manner in which she performs them.

Almost as hard to render in prose is what her music does to me. I may have found a key, however, and appropriately it is situated at a meeting point between European and Oriental cultural traditions. Occasional Daliesque flourishes, overblown

metaphors and molten similes aside, Federico García Lorca's "Play and Theory of the Duende" remains the finest approach to any discussion of a subject that may be said to hinge on the inexpressible. When speaking of duende Lorca comes at it from various angles, not defining but alluding rather to its properties. Manuel Torre, after hearing Manuel de Falla play his own *Nocturno del Generalife*, remarked, "All that has black sounds has duende," and Lorca goes on to say, "These black sounds are the mystery, the roots fastened in the mire that we all know and all ignore, the mire that gives us the very substance of art." I am hesitant to add to what is already a poetic synthesis, but another property of duende is that it penetrates us so that it becomes part of our inner, wordless language. Or, rather, it reaches through to what is already there, fully prepared to receive, the soul as receptacle. Our junk culture has been responsible for producing a great deal of static interference. The channels are blocked with cheap surrogates, and, if one looks at popular culture in particular, the tendency now is to *emote*, to pull deeply from surfaces, which, for a second or two, are provided with an illusion of depth—an idiotic shriek masquerades as profundity. The danger here is that too much static may spoil forever our appetite for the pure.

Lorca names some of the great artists of his time, all of whom had duende, many of them voices we can scarcely imagine, while others have been preserved on vinyl, although even here we are dealing with aural facsimiles. Duende depends to a great degree upon physical presence, and although it is to be found in every culture, in every genre, nowhere is it more readily discernible than in musical performance. One knows it is there, not with one's mind but with one's whole being. Certainly duende cannot be willed, and even the most technically skilful musician may lack it. With commercial pressures brought to bear, a great number of performers have not been allowed to ripen naturally and have therefore been robbed of the possibilities of duende. They are forced to become their

own aural facsimiles. Also, duende is the one term by which it is possible to encompass quite different, sometimes opposing, musical genres. Dinu Lipatti, when playing the third movement of Chopin's *Sonata in B minor*, demonstrates duende. Maria Callas, when she leans over the body of the man she has just stabbed to death, most tellingly with a single stroke, and sings, "*E avanti a lui tremava tutta Roma*" ("And all Rome trembled before him"), demonstrates duende to a degree that has not been repeated in that particular opera since. The great blues singers have duende. Bob Dylan, when not mugging his own silences, has duende. Billie Holiday, whose voice, a friend of mine tells me, "scrapes heaven, scrapes hell," has duende. So from where does it all come? Again, Lorca, citing an old maestro of the guitar, writes: "The duende is not in the throat; the duende climbs up inside you, from the soles of the feet."

I first learned of Monâjât Yultchieva in Theodore Levin's *The Hundred Thousand Fools of God* (Indiana University Press, 1996), which is not only an invaluable record of his musical researches in Transoxiana but also a superb travel narrative. Tucked in, at the back of the book, is a CD of recordings he made of the singers and musicians he met on his travels. It was a single track, "Bayât-i Shirâz Talqinchasi," a classical rendering of a poem by the sixteenth-century poet Fuzûlî, which led me to Monâjât's two major recordings. At first the music was difficult to listen to, seemingly spasmodic in its architecture, but there was something in the alto voice that haunted me. Certainly there was nothing that smacked of "world music"—a doubtful category at the best of times. There was virtually no concession to Western taste. Several hearings later, the apparent discontinuities were either gone or had entered, and enlarged, my musical vocabulary, making this a sound I would henceforth *need*. I am reminded here of my first hearing of a very different music, Arnold Schoenberg's setting of Stefan George's poem beginning "*Ich fühle luft von anderem planeten*"

("I feel an air from other planets blowing"). If Schoenberg's *String Quartet no. 2 in F-Sharp minor* opened onto a rather chilly universe, the door itself was lovely to pass through. The thrill of the new is an experience that becomes, with age, increasingly scarce. I consider Monâjât's concert at the Purcell Room, on June 13, 2004, and my subsequent meeting with her, one of the great aesthetic experiences of my life.

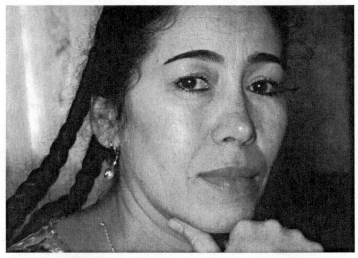

The musician and specialist in Central Asian music, Razia Sultanova, who lives and teaches in London, arranged for me to interview her compatriot. Monâjât suggested we meet at 8.30 a.m., which startled me, and, quite frankly, I expected, at best, an audience of twenty or thirty minutes. What I got instead, and in the most cheerless of London guesthouses, was three hours of uninterrupted talk. At forty-four, Monâjât is a woman of profound beauty, of a kind I have observed in many Sufis, particularly in Damascus, a spiritually informed beauty added to which both body and mind seem to be in a state of constant alertness. There is no slouch whatsoever. Monâjât is from the farm, a *kolkhoz* in the eastern province of Ferghana. A humble woman, she has travelled many thousands of miles, but with respect to her universal fame and where her true art

lies, not so much as an inch from her native region, which she considers the most beautiful place on earth.

Also present was Monâjât's spiritual and musical mentor, and head of the ensemble that backs her, Shavkat Mirzaev, a virtuoso player of the *rabâb*, a small five-stringed form of lute, which his father is credited with having introduced to Uzbek music. The story of his and Monâjât's musical relationship has been described by Levin and others, and is a demonstration of the Sufi doctrine of *silsila*, the chain of learning or transference of knowledge from master to student. I shall summarise the beginnings of her rise to fame. Monâjât had auditioned for a place in the Vocal Department of Tashkent Conservatory. She was rejected by the Western-trained examiners for singing out of tune. Mirzaev, an instructor in the Department of Oriental Music, found her in the hallway sobbing. It just so happened that he had passed the door of the examination room a few minutes earlier and recognised from the timbre of her voice a quality uniquely suited to the music that he had made it his mission to preserve. It was then that he invited her to become his student, but only on condition that she submit absolutely to his teaching. This she did, gradually perfecting her technique, and now Mirzaev is happy to be in a supportive role. When speaking of her own musical development Monâjât likens it to a baby taking its first steps, and in the same way one's parents are the first teachers so Mirzaev was hers, taking her from the mere surface of a song deeply into its inner structure. She describes the fateful meeting at the conservatoire as something God had written for her. "If that hadn't happened I wouldn't be here today and I wouldn't be performing and I wouldn't be giving this interview now."

I began by raising with her the issue of duende, saying that it was through my re-reading of Lorca that I was at all able to speak of her art, and that although duende was universal I wanted to connect it to her "Sufi voice," which she describes to Levin as being like a prayer to God. "When you sing quietly,

it's more powerful than singing loudly," she told him. "People who are praying don't pay attention to anything else." I asked her whether her ability to reach such heights was due to religious experience, in which case I wondered if one could always count on being in God's presence, or whether it was purely a matter of discipline.

"When I perform the songs, when I go into the meaning of the words, I feel something rising up from within. I am halfway between heaven and earth. The musical training helped me to realise the spiritual state, which in turn helps to convey the songs to the audience. Shavkat Mirzaev taught me how to pronounce each letter of each word in the song, and how to breathe properly in order to give them the most impact. It was during this period of training that I arrived at this stage, and then, of course, the spirituality, the power from within, and the training, both of them are mixed and cannot be separated. So I consider them as one, as coming from the same place."

Mirzaev added, "The state of losing oneself, or ecstasy, is like getting drunk, but it is not like the drunkenness that comes of drinking alcohol. A person drinking alcohol forces himself to get drunk, but this is different because it comes naturally during performance. In earlier times, it was achieved by performing *zikr*. People would connect to God and lose themselves. For the singer, the challenge is to get everything inside and to convey it from there to the people. If the singer feels it, then the audience will feel it as well. We have an Uzbek saying, 'The flour doesn't matter; what really matters is the wheat from which the flour is made.' For the singer, that wheat, that root, is physically situated in the stomach, which helps one to breathe, and also it is in the throat. There are different styles you can sing from your stomach, from your throat and from your nose, but most important is the soul of the singing itself."

A woman who has entered a predominantly male culture, Monâjât is revered by her countrymen, who are fully aware that during the period of Soviet rule, when its apparatchiks sought

to destroy or neutralise local cultures, it was, to a great extent, the women who helped preserve musical traditions. There have already been a number of great female Uzbek singers, such as Zaynab Pâlvânova, who drove their stakes into ground previously forbidden to them, namely the great classical repertoire. I wondered, however, whether, with even these distinguished predecessors, Monâjât had found immediate acceptance.

"When I came along there wasn't really that much division between male and female singers. The division was of a more local nature, within the family. My father, because we did not have any performers in our family background, at first did not want me to become a singer. It is not a job for a woman, he said, so he wanted to stop me from entering the conservatoire. My uncle, hearing my voice, saw immediately it was unique and he told my father that my voice didn't belong to him but to the Uzbek people, and that neither he nor anyone else had any right to put a stop to it. After hearing that, and because my father respected my uncle, he let me go and prayed for my success. When I first came before the audience it wasn't too hard because I was already used to performing at school concerts. I had some background as to how to act on stage, so people did not have any problem in accepting me."

"When you were growing up in Ferghana, were you aware of the classical tradition? The Soviet regime was suppressing it, right?"

"The tradition wasn't completely suppressed. It was still permissible to perform the works of great poets like Navâ'i and Fuzûlî, but any passages containing the words *mai* or *sharob*, both of which mean 'wine,' or any mention of God, these had to be removed. After all, God belonged to the beliefs of an ancient and backward people. The wine in Sufi literature is obviously not the alcoholic drink—it is the love of God, and the people are considered to be the receptacle for that wine. The Soviets didn't understand it that way, of course, and also, it was not allowed to propagate the idea of drunkenness,

even if it were a part of normal life. We had to replace those phrases with words from other parts of the song. Still, we were allowed to perform those songs. Each period has its own pluses and minuses, its own positive and negative sides. Again, going back to the Soviet era, the removal of the words 'God' and 'wine' may have been a strong form of censorship, but strangely it also helped the music. The performers were few, but all of them were of far better quality than today. It was as if by putting boundaries on the traditional songs or the types of songs that could be performed, the performers, in order to preserve their quality, were forced to choose only the best ones. That's why poor singers weren't allowed on stage. So the struggle against censorship forced the performers to improve themselves. It wasn't enough just to be able to perform on radio or television. As for myself, Mirzaev didn't let me perform for two years, not until I had mastered my technique. At the time, it upset me to think that people with less powerful voices than mine were singing everywhere, but now I realise that without his control, the self-motivation and the constant training, I wouldn't be where I am now."

"Sometimes a dictatorship preserves the very thing it tries to destroy, but when we talk about freedom, or, rather, an excess of it, the boundaries are removed and the tradition suffers from exposure."

"We have another saying in Uzbek," said Mirzaev. "'Gold remains gold—even when it is in the dirt it preserves its qualities.' The real art of *maqâm* or traditional music cannot be destroyed or controlled by any force or movement because whatever people try, whatever liberation there is, whatever happens, there are people who will listen to those new songs and other people who will listen to traditional songs. It is the same as when looking at a drawing by Raphael or Michelangelo. An ignorant person will see an ordinary picture, but in order to understand the difference between it and rubbish you need a trained eye. It is the same with music. In order to understand

its qualities you have to have a trained ear, which is why, many years ago, the children of kings and shahs were educated in music and the other arts, not because they were supposed to become artists themselves, but in order to be able to distinguish between pure and fake art. Everything depends on the training people receive."

I remarked on the fact that Uzbek pop music was now absorbing aspects of the classical tradition.

"Pop music has it own completely different route," Mirzaev continued. "It has different rules, especially as regards rhythm. Nowadays, people think that if they perform *maqâm* in their own style they will become famous, and so they try to mix pop and classical music. This is totally unacceptable. *Maqâm* is the art of performing from the throat. You have to be able to produce different types of sounds. Consider it as being like a diamond or ruby, which has many edges—the voice too must have many different edges. When you look at the stone from one side and slowly turn it, you will see the colour change. If you like the previous colour and try to find it again, you won't be able to. The more you turn this stone, the greater its variety. It is the same with *maqâm*. You never hear the same thing twice, which is what makes it sweet. You don't get this with pop music, which concentrates on rhythm. The most important thing in music is not to destroy its tenderness."

"Are we not speaking, then, of a war against silence? If you consider the silence at the centre of all great art, which must always be there, then surely there can be no art without this silence."

"The idea of a war," Monâjât replied, "as you describe it, is really a force, a necessary flaw in our lives. It needs to be that way because without it, if you had only the one side, if you didn't have any problems, economic or whatever, you wouldn't feel the need to listen to music. A person would turn into a robot if everything were fine. So all these ups and downs are actually helping people live for something."

"You are an optimist!"

"While for ordinary people silence is just plain silence, for philosophical or poetical people it goes a lot deeper, of course. As for my own personal feelings about silence, to be able to live within it, to develop within it, and to make people enjoy getting something out of that silence, is to give joy to the artist himself."

Mirzaev added, "Silence is a music itself. So when I listen to silence and someone performs bad music, I am taken away from listening to and enjoying silence."

"And to make a link to the previous subject," Monâjât added, "the fact that pop music is now entering traditional music or *maqâm* is an attempt to destroy that silence."

I had been struck by a powerful element of the erotic in Monâjât's performance, which is not to say she undulates, ululates or oozes. On the contrary, she performs with considerable restraint. Such movement as there is, is mainly in the hands, which, as any flamenco master will substantiate, is the focus of a certain kind of dance. There is not a wasted gesture. When Monâjât sings she builds upon what she calls her "Sufi voice," taking it from a position of near silence, caressing each sound as it is made, so that gradually it builds in volume, and although the sound becomes more powerful, more intense, it never loses its original softness. As I said, the effect is erotic. One has to move delicately here, but once again a Spaniard comes to the rescue. I have been looking at the poems of the mediaeval mystic, Juan de la Cruz, which, in their likening the union with God to that of bridegroom and bride, startle even modern sensitivities. Certainly one feels in his verses the presence of an Oriental breeze.

"So much of your music is mystical, a reaching towards God. I think in all mysticism, both Islamic and Christian, there is something erotic in the expression of the meeting with God. It is expressed in the language of eroticism, and certainly you get this in the poetry of Hafez and Rumi. Do you find it difficult or awkward to express this eroticism in music?"

A touch solicitous of Monâjât's virtue, perhaps, Mirzaev cut in, suggesting that the erotic, or at least the Western understanding of it, had little place in our discussion.

"Our way of understanding music is as a more intimate, spiritual feeling towards God," he said. "It is like the *Ave Maria*, which brings one to intimate terms with God rather than with the physical world, whereas to speak of eroticism is to begin on the lowest step. So we should forget about that term altogether because, even in its purest form, eroticism wouldn't match the soul of the music. Music stays high above such things and is a kind of direct connection to God."

I was quite prepared to accept Mirzaev's strictures, but I wanted to put the question directly to Monâjât, who seemed happy enough to deal with the topic.

"First of all, I am a woman," she replied. "Secondly, my goal is to convey the music in the most beautiful way possible, so that if the listener gets into a spiritual condition, it should be not only from hearing my voice but also from seeing me perform, which is why, when I'm on stage, I try to control my emotions and my spiritual state. In Uzbekistan, we have two mystical, more or less philosophical, schools, Yasavi and Naqshbandi, both of which are branches of Sufism. The first group think it is preferable to die, aged sixty-three, and to be united with God, whereas with the Naqshbandi the main idea there is for your hands to be at work and your heart with God, remaining both in this world *and* close to God. This idea grows into a philosophical rather than mystical concept, so when you speak of your beloved or your lover, actually what you are speaking of is a love of God, a God so beautiful that were one to look at something different, one would poke out one's own eyes. If I were to look at a flower and say 'how pretty,' I'd be jealous, on God's behalf, of anything that has a claim to beauty. Likewise, this whole notion of eroticism is one that is meant for God alone. In performance, the music, the voice and the words, all three of them should complete

each other, should come together, and, when doing so, they bring about that eroticism which you describe. It is spiritual, though, not physical. When I sing I feel pleasure in hearing my own voice and in feeling the relaxation of the environment. Also, when my teacher plays his instrument and the sound coming from it is in harmony with everything else, this, too, brings me joy and pleasure. And how the public accepts the music is important as well. So the voice, the music, the words and the audience—when in harmony, they induce that spiritual, erotic feeling."

Monâjât sings sometimes with a small ceramic plate, especially when performing the *katta ashula*, which translates as "the great song," a description that will be clear enough to anyone hearing it for the first time. Its performance demands the physical well-being of whoever has to perform it, for such is its power and sheer vocal range. It requires the performer's *all*, which is where the plate comes in, the positioning of it in front of the mouth acting as a kind of sound projection technique. Monâjât is the first woman to perform in this particular genre.

"Your plate, did you bring it from Uzbekistan? Is this a special plate?"

"Yes, it has a special meaning. Every artist or performer or painter, even an engineer, has his own style and image, and for me it is important to wear traditional clothes, to have my hair down as it is now, and so, to have that plate, always the same plate, contributes to the whole image. I don't use that plate in the kitchen, and I would never ask for a different plate. I do not give it to other people to use. It is part of an image I am attached to."

Mirzaev added, "For me, too, when a performer starts with something, it is important that he keep it, and get used to it, because it will become a part of the whole performance. I don't give my *rabâb*, my instrument, to anybody. I won't even let him touch it, especially before a concert, because then I'd

feel it wouldn't obey me. And the clothes I wear are especially for performance, and even the shoes I wear are the same ones I have worn since my very first performance with Monâjât. If they get rubbed down, I replace the heels."

Monâjât nodded in agreement.

"The sense of image I was talking about earlier applies to actual performance as well. Coming back to the concept of silence again, some people advise me to dress in a more western way or to come up with a different hairstyle and to be, if you like, more attractive to the public, but what they do not realise is that if I were to listen to them, I would actually destroy that silence. If I were to succumb to popular demand and adopt a different image and style, then I will have destroyed the quality of the performance."

"Okay, I promise not to steal your plate."

"Thank you!" she said in English.

AT THE BEGINNING OF THIS piece I said one day, perhaps, I would be wafted to Uzbekistan on a woman's voice, while failing to note, foolish me, that, in a sense, I have already been so. But why by this strange music in a language utterly incomprehensible to me? Which contains not a single word I could latch onto, not even the Arabic *habibi, habibi* denoting either love or love's absence. Surely my hunger had already more than enough to feed upon, enough great music to see it through eternity and a bit more. A Bach cantata might be just the ticket, or a splash of Scarlatti, preferably with Mikhail Pletnev steering it brilliantly off course. I think what I hungered for was the purity of *somewhere else*. It may also have had something to do with the contaminates in our own culture, which, falsely perhaps, make one imagine the air is cleaner elsewhere. What clinched it for me, however, was duende, which is *other* than religion and which certainly is *above* language. And which is what makes the hairs at the back of one's neck rise. All this is proof that the best art, always a powerful

transformer, even before being understood, reaches into, and colonises, new spaces. After visiting with Monâjât I went for a walk in a nearby woods, and, most unusually for me, I put on a Walkman, and I listened to her music; and there, in that most English of spots, wild enough for a nineteenth-century poet to want to tame into verse, all of a sudden the trees became foreign to me, and the flora, for which, because I am horticulturally illiterate, I never had the English words in any case, seemed to demand fresh syllables; and, just then, for those few precious minutes, Monâjât Yultchieva's radiance still upon me, two very different parts of the world began to merge. A couple of walkers, with their once-white cotton hats, walking sticks and thermoses, said hello to me, and, my brain full of the Orient, I wished I could have had for them, right there and then, the polite Uzbek response.

LUNAR

AS I TURNED THE CORNER of the street a couple of nights ago, I saw the full moon neatly suspended from the hook of a giant crane. It was one of those physical juxtapositions that happen but once, so sudden, so breathtaking, that the mind of an unsuspecting observer, if at all susceptible to visual fallacies, slips the cables of commonsense. Were I to have approached the moon from even a slightly different angle, I would have been deprived of this fleeting illusion. While I am not a fan of Magritte, finding in him only trickery where profundity should be, the effect this had on me was remarkably close to the manner in which he chose to squander his time. I have heard since—from Annie, a midwife—that this was the brightest the moon has been since records began, and certainly, had I owned some, I would have put on sunglasses. My sublunary source can testify that at the maternity ward of the hospital where she works, there was all manner of heightened nocturnal activity. One wonders what the babies will be like, whether they will become, in time, feral creatures.

The full moon that night also figured in the two short operas I was on my way to see, Bartók's *Bluebeard's Castle* and Schoenberg's *Erwartung*, in the second of which a clearly demented woman wanders through a moonlit forest and stumbles upon the corpse of her lover, whom she then,

and at some length, berates for having been unfaithful to her. A man can be nagged to death—any boneyard in the world provides sufficient evidence of this—but only rarely does he posthumously have to endure a woman's harangue. Inga Nielsen, in her slinky red satin dress, sang beautifully while managing not to trip over the debris scattered all over the stage, which may have been put there in order to suggest life's many obstacles. She could see, in any event, by the light of the silvery moon whose perfect twin I'd seen just a short while before.

As for the moon, the real one, there wasn't any hook at all holding it up in place. I might have reasoned, too, that it was in fact much larger than it appeared and that the crane would have toppled forward with the weight, quite possibly bringing the moon crashing down on my head. And then where would I be? The moon would certainly not be in this prose, nor would I have had the pleasure this evening of listening to, for the first time, Luciano Berio's *Voci* and *Naturale*, the second of the pieces being for solo viola and percussion. This, perhaps, is what Bartók would have sounded like had he been a Sicilian.

All this brings to mind something else.

Some years ago, walking near Llangollen with the Welshified French-Canadian concrete poet whose *nom de plume* is Childe Roland, and whose real name is Peter Meilleurs, I caught sight of the full moon ascending directly above, and settling upon, for just an instant, the tip of a roughly pyramidal hill. We stood in silence and marvelled at what it was to be, just then, a couple of old friends witnessing a small miracle of nature. There was absolutely no need for the sentiment to squeeze its way into language. A couple of minutes later the moon, pricked on the arse, rose, and we continued on our way, talking not the great talk people imagine when they hear of two poets, Wordsworth and Coleridge, for example, walking through Nature, but rather the talk that is our preferred mode, an unbridled nonsense.

I first met Childe Roland shortly after his one and only sui-
cide attempt, when, close to the university we both went to, he
rushed blindly towards a canal lock only to find himself, sec-
onds later, at the dry bottom of it, physically and emotionally
bruised, and probably just a shade embarrassed. The reason
for this was that his thesis, *The Alexander Graham Bell Book,*
had just been rejected by the English Department, which up
to that point had been split down the middle on the issue of
whether such a curious work was allowable. A compromise
had been offered, but it was not one he could accept. The
book comprises a handwritten "allo," the loops of the *l*'s cov-
ering a hundred pages, a hundred pages being the minimal
length prescribed for a thesis. Also it is visually suggestive of
telephone wire, and bookishly reflective of the author's argu-
ment that one of the characteristics of literature is that it takes
up space. Our mutual friend, the distinguished poet and
Icelandic scholar, George Johnston, even he, most saintly of
men, had failed to console Childe Roland in this his bleakest
hour. I wonder if the gaggle of professors had actually reached
the end of his book where, on the last page, is written the
word "Bell," so that the work, in effect, becomes an honorific

salutation to the inventor of the telephone—"allo Bell"—the *bell* on which the book concludes being an echo of the *ding-a-ling* sound that old-fashioned, heavy black telephones used to make.

My first acquaintance with Childe Roland's work, however, was a piece I saw him perform in Ottawa, in 1972, *ACK ACK*, which is dedicated to Susan, his wife. The poem evokes in pure and tender language, its meaning enshrined in the sounds the words make, the beams of light emitted from tracer bullets fired by the World War II gun of the poem's title. While he recited the piece, a stocky ballerina called Gayna danced to the gentle pianissimo of Erik Satie's *Trois Gymnopédies*, her falls reproducing, unintentionally I believe, the reports of distant gunfire. I went in amorous pursuit of Gayna once, but my designs on her were shattered when, at the greasy spoon where I declared my interest in her, a drunk in the street outside smashed the huge window, its many shards of glass narrowly missing the customers seated inside. I chased after him, unsuccessfully, and when I returned Gayna rejected me right there and then as being too puritanical in my attitudes.

When Childe Roland moved from Canada to Wales in 1979, he took with him the red granite tombstone he had specially made for himself, beneath which he plans to lie in eternal peace, and which above his familiar rounded signature bears a finely carved television screen. Childe Roland is an avid admirer of the medium and, I believe, only rarely does he discriminate between one programme and another, although his favourites are said to be nature documentaries and *Blind Date*. Childe Roland is like a leprechaun blown up to a human scale, eternally childlike, a child even to his own children who are older now than he was when I first met him. Over the last few years much of his creative energy has been devoted to a series of brilliant variations on the bar code.

When I phoned him just now to check on the details of the Ottawa performance, they were as I had remembered them,

except that he reminded me we shared the stage, filling the interval in a performance given by the jazz-rock fusion group, Weather Report. Also, when I informed him of my lunar experience, he told me that, while here at the Royal Opera House Miss Nielson bellowed her female troubles, he had been taken on a shamanic journey. According to his spiritual guide, Pip, Childe Roland journeyed from this, our Middle World, through a hole in a tree, into a Lower World landscape in order that he might meet there his "power animal," the spirit archetype that provides each aspirant with its own particular medicine.

"And what did you meet there?" I asked him.

"A moose," he replied.

A story of two moons, then, or rather, the same moon seen at different times, from separate perspectives. What human nature loves, of course, is a construction. A sense of moment is just that, an alignment between something exterior and whatever we carry within ourselves. A man staring up at the stars feels this, even if unable to articulate what he sees. Whole religions, shamanism too, have been constructed on that very premise. Stonehenge, some say, was built in order that a single moment of alignment be celebrated each year at precisely the same time. A poem is an attempt to capture, by casting several lines or more, some aspect of our fleeting existence. If we are abstract creatures that every so often need to be sated with simplicities, the opposite also holds true: we are simpletons gawking at the skies.

What was it about this composition for moon and construction site that makes it all plushy with significance? The ancients would have had a ready answer, whereas I only stumble towards one. All I have is my uncertainty, and that I'd rather hide. If I may pull the argument down from the skies for a moment, is not everything we see a construction that is wholly unique, which is glimpsed but once? Could the spectacle of two nights ago have been witnessed by anyone other

than me? Why does that joker over there offer me *his* perspective, when surely he knows I've already got mine? Why say *this* is how the world goes? One of those question marks, which the Spaniards turn upside down, will sooner or later hook me by the nose. I, too, will dangle in air, as if from a crane, moonlight iridescent upon my scales. So Annie, Childe Roland and Gayna, wherever you are, however clumsy or fine these words may appear, the perspective from which they come is wholly mine. It's all I have.

Acknowledgements

THE MAJORITY OF THE PIECES in this collection were first published in *PN Review* and it is to its editor, Michael Schmidt, that special thanks are made.

"A Factotum in the Book Trade" was first published in *CNQ: Canadian Notes and Queries.*

"Girls, Handsome Dogs & Stuffed Olives" first appeared in *Maisonneuve* (Montreal).

"'Monsieur, le chat est mort!'" first appeared in *Agenda.*

"'Do Not Expect Applause': W. S. Graham in Performance" was first published in *Aquarius.*

"The Testament of Charlotte B." appeared, in a shorter version, in *London, City of Disappearances,* edited by Iain Sinclair (Hamish Hamilton, 2006), and this, in turn, was based on a limited edition printing of the text of the original manuscript, with an Introduction and Afterword by Marius Kociejowski (Libanus Press, Marlborough, 1988).

"A Meeting with Pan Cogito" and "A Singer from Ferghana" (previously titled "Meeting with an Uzbek Princess") were first published in *London Magazine.*

"Richard Stanyhurst, Dubliner" was first published, together with a Spanish translation by Antonio Iriarte, as an Appendix V to *El espejo del mar,* Javier Marías's translation of Joseph Conrad's *The Mirror of the Sea* (Reino de Redonda, 2005). The appendices of each of the volumes in the series contain a wealth of information on the Kingdom of Redonda.

"A Voyage through Ormsby's *Araby*" was first published in *CNQ: Canadian Notes & Queries.*

"C. M.: A Portrait" was published as the Introduction to *Palavers: Christopher Middleton in Conversation with Marius Kociejowski* and *A Nocturnal Journal* (Shearsman Books, Exeter, 2004), and also appeared in *Chicago Review.*

"The Book of Ordon" is here first published.

MARIUS KOCIEJOWSKI, poet, essayist and travel writer, lives in London. He has published four collections of poetry, *Coast* (Greville Press), *Doctor Honoris Causa*, and *Music's Bride* (both Anvil Press); *So Dance the Lords of Language: Poems 1975-2001* was published in Canada by Porcupine's Quill in 2003. Most recently, he published *The Street Philosopher and the Holy Fool: A Syrian Journey* (Sutton Publishing), *The Pigeon Wars of Damascus* (Biblioasis), *God's Zoo* (Carcanet) and an anthology, *Syria: Through Writers' Eyes* (Eland).